1988

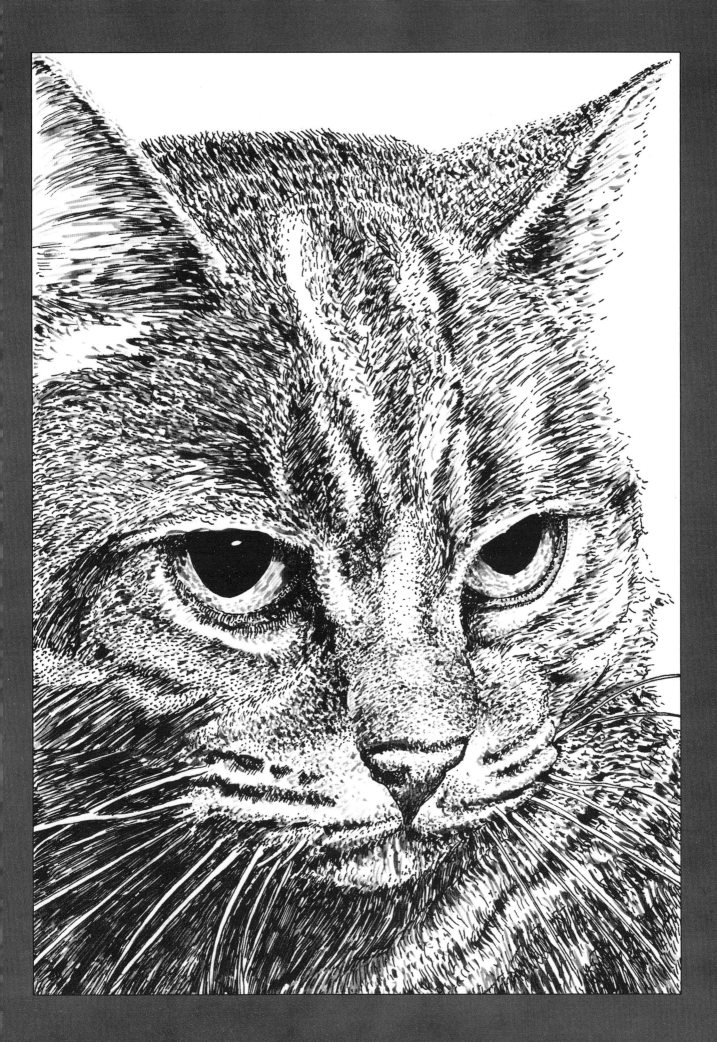

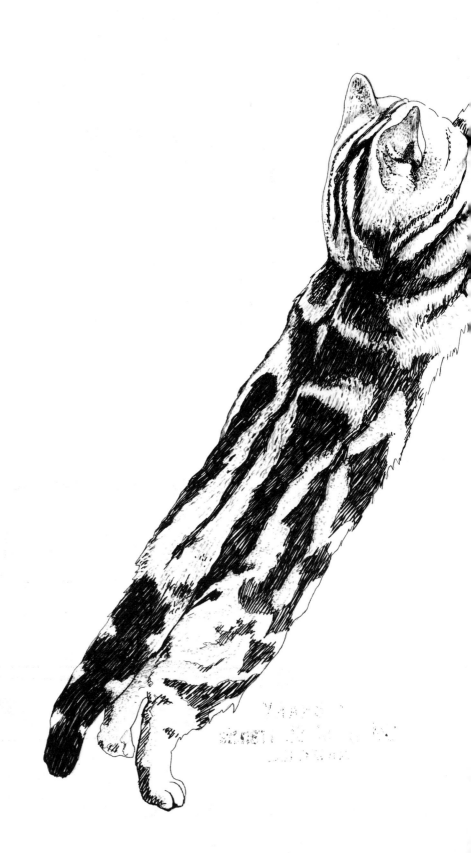

Drawing and Painting CATS

In Pencil, Ink, Markers and Watercolor

By Howard L. Cossman

WATSON-GUPTILL PUBLICATIONS/NEW YORK

To my parents, Pearl and Joseph Cossman, and my sister, Ronna,
who have encouraged my artistic pursuits for as long as I can
remember. I would also like to thank my friend, Judy Brandon,
who was kind enough to type all my manuscripts.

First published 1984 in New York by Watson-Guptill Publications,
a division of Billboard Publications, Inc.,
1515 Broadway, New York, N.Y. 10036

Library of Congress Cataloging in Publication Data
Cossman, Howard L.
 Drawing and painting cats.
 Includes index.
 1. Cats in art. 2. Art—Technique. I. Title.
N7668.C3C67 1984 743'.6974428 84-11812
ISBN 0-8230-1360-X

Distributed in the United Kingdom by Phaidon Press Ltd., Littlegate
House, St. Ebbe's St., Oxford

Manufactured in Japan.

First Printing, 1984
1 2 3 4 5 6 7 8 9 10/89 88 87 86 85 84

CONTENTS

page 36

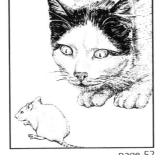

page 52

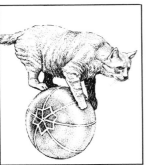

page 48

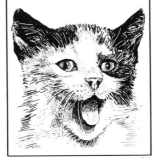

page 34

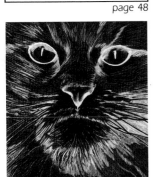

page 68

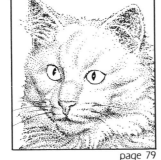

page 79

page 131

page 89

page 140

page 125

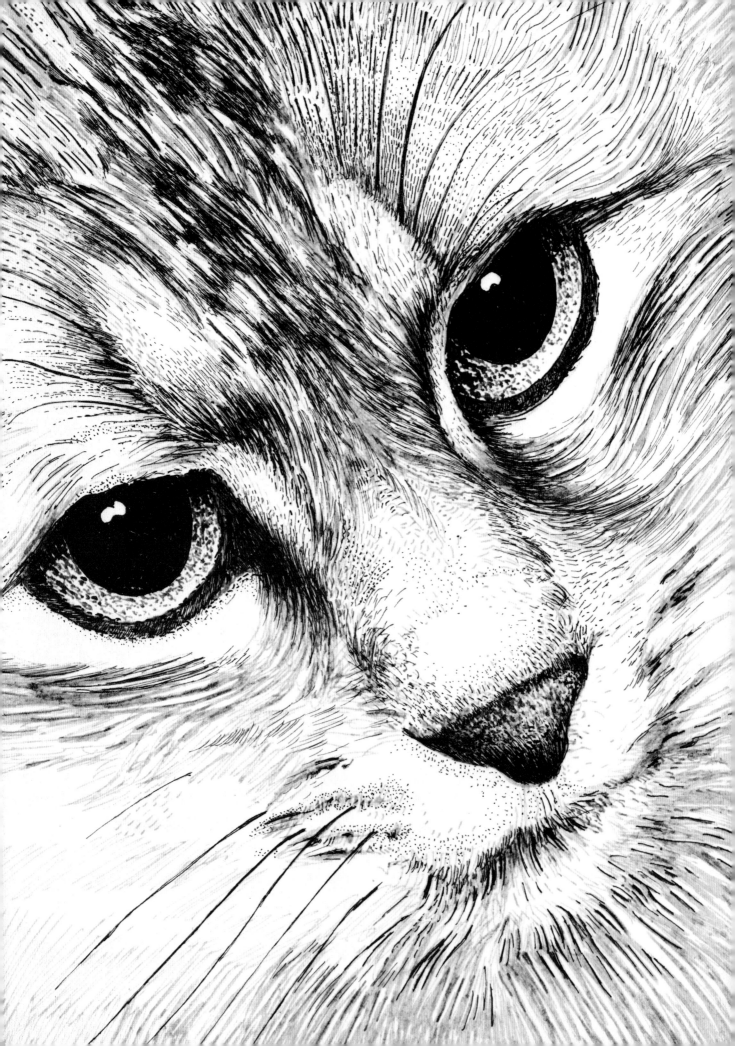

Part One
Observing and Understanding Your Subject

ANATOMY

The supreme agility and gracefulness of the cat have fascinated artists for thousands of years. And in order to understand the exterior forms of the cat, the artist must acquire a basic knowledge of the cat's anatomy. Although the cat's anatomy is very similar to other vertebrates, unique aspects of its anatomy, such as its flexible spine combined with an intricate, powerful muscular structure, make the cat one of the most perfectly coordinated of animals. It is an interesting fact that the small frame of the cat is made up of approximately 230 bones, while the human skeleton has a mere 206.

Before you begin to paint and draw cats, take a look at the ink diagrams presented on these two pages. These drawings will be helpful when you are sketching in the initial contour lines of a drawing. Remember that the cat's anatomy has much in common with other mammals, including the human being's. For example, a quick look at a cat reveals a creature with four legs, all of them essentially the same size. However, on closer inspection, a cat's front legs and hind legs are as different as a human arm is from a human leg. In fact, if you look at the diagram on the facing page, you will see that the leg bones of the cat have the same names that are used for the corresponding human bones.

Body Types

Black ink on hot press illustration board

Cats fall into three basic body types. The illustration *at top* represents the Persian type, which is short and broad-boned. The Siamese type's build *at center*, is long and slender. *At bottom*, the domestic shorthair's frame is midway between the extremes of cobby and lengthy type.

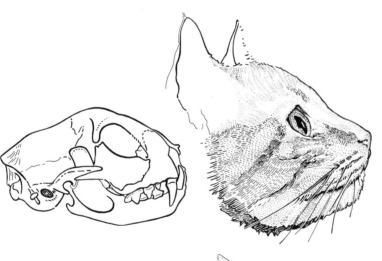

Cat's Skull

Black ink on hot press illustration board

The cat's facial forms are determined by the shape of its skull. The skull, of course, is attached to the rest of the cat's skeletal structure. The skull is often thought of as a singular form, but it is composed of several different bones, with openings for the eyes, ears and nose. The cat's skull encloses its brain; the bone here is tough and rather thick, and attached to the spinal column with strong muscles.

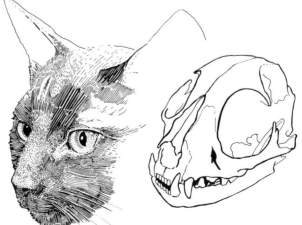

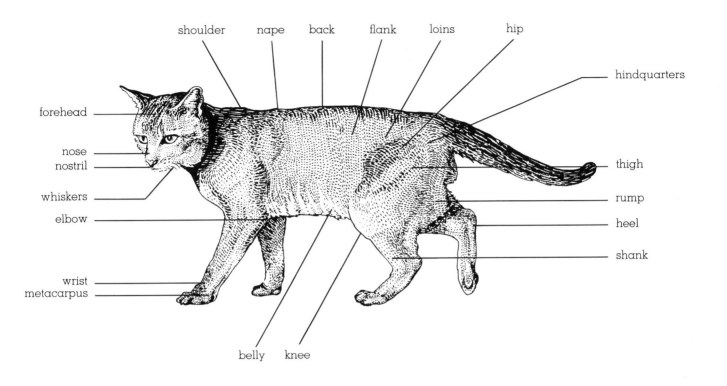

shoulder nape back flank loins hip

hindquarters

forehead

nose
nostril

whiskers

elbow

thigh

rump

heel

shank

wrist
metacarpus

belly knee

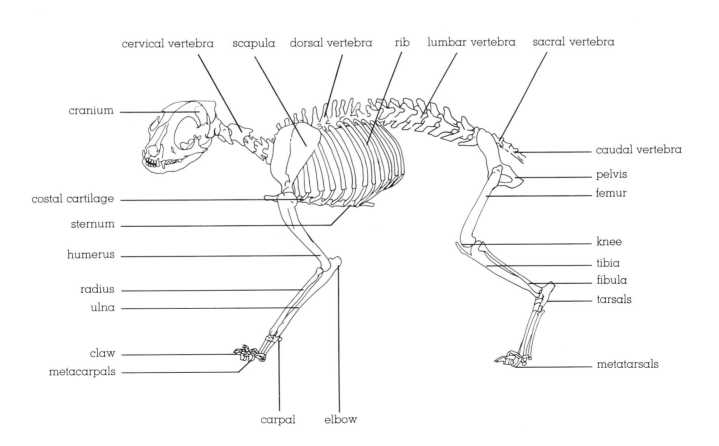

cervical vertebra scapula dorsal vertebra rib lumbar vertebra sacral vertebra

cranium

caudal vertebra

pelvis

femur

costal cartilage

sternum

knee

humerus

tibia

radius

fibula

ulna

tarsals

claw

metacarpals

metatarsals

carpal elbow

CATS OF MANY BREEDS

The following eleven pages present drawings and paintings of eleven different breeds of cats. Although there are many more known breeds than there are illustrated in this section, I felt that from the artist's perspective, these eleven represent a fair variety of facial and body shapes, colorings, markings, and characteristic body attitudes. Throughout this book, you will find many other breeds of cats as well.

Unlike dogs, which vary greatly in size, the cat's basic size and shape remain essentially the same in all breeds. However, slight variations in head and body shapes distinguish certain breeds from others. These differences are not only of interest to cat aficionados but also to us as artists. For instance, the head shapes of cats vary from the long, wedge-shape of the Siamese to the broader, rounder skull of the Persian. The ordinary domestic shorthair tends to fall between these two extremes. Similarly, feline body shapes fall into three basic categories: the Siamese, which is long and slender with a glossy, close-lying coat; the Persian, short and stocky with long, fluffy hair; and the domestic shorthair, a medium-sized cat with short, dense fur. By closely observing the variety of facial and body shapes found in the different breeds of cats, you will obtain the accuracy that you need in drawing and painting cats.

In this section, examples of these eleven breeds are rendered in a variety of media: pencil, pen and black ink, pen and colored ink, markers, watercolor, and achromatic watercolor. These are also the media that I use throughout this book. All of these media have certain advantages for drawing cats and even for particular kinds of cats. For example, I particularly like the way the pencil medium captures the strong value contrasts needed for the Siamese's characteristic markings. On the other hand, when I want to portray the muted, blurry coat of a tabby, watercolor is my preferred choice of medium. So, as you look over the different breeds of cats illustrated here, pay special attention to their distinguishing characteristics and take the time to compare the various media used to render a particular breed.

Face Shapes

Black ink on hot press illustration board

As with body shapes, cat's faces basically fit into three different types. *At top*, the Persian's head is blunt, round, and broad. *At center*, the Siamese's face is wedge-shaped and tapered. And *at bottom*, the domestic shorthair is typically a melding of the two extremes.

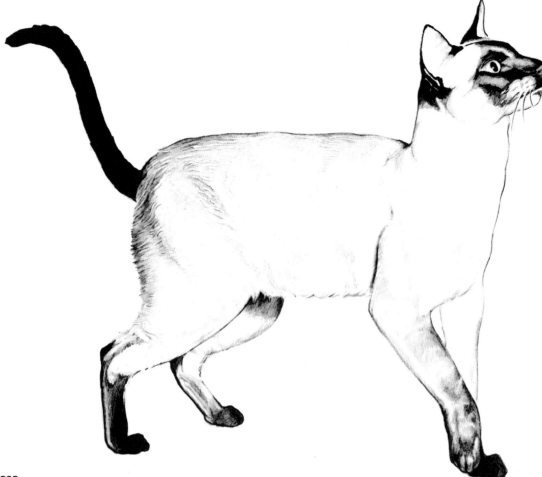

Siamese

Pencil on hot press illustration board

Appearance: Sleek, medium-sized cat. Svelte, muscular, dainty with long tapering lines. Neck long and slender. Legs long and slim; tail long and thin, *tapering to a point*. Head shaped like a long wedge. Ears large, pointed, and wide at the base. Vividly blue eyes are almond-shaped and slant toward the nose. Short, fine-textured, glossy coat lies close to the body. Breed may be one of several colors. There should be a *contrast between body and points*; points include mask, ears, legs, feet, and tail.

The Drawing: Here I want to show the elegant, graceful posture of the Siamese and to emphasize the dark, "velvety" points that define the breed. To achieve contour lines and strong value contrasts of the distinctive markings, I used a range of H and B grade pencils on hot press illustration board. The shading created by pencil works well to describe the points and markings of the breed. The hard, smooth surface of the board provides an excellent surface to work tonally, blending to create form. The harder H leads

were used to render the light-value gray tones, which explain the body contours and hair textures. The wrinkled skin at the base of the cat's neck, defined by soft shading and slightly darker toned vertical strokes, is also created by the lighter value H pencils. Notice how the combination of fine-lined wavy strokes and the varied lengths of light gray stippling create the horseshoe-shaped contour of the cat's hip. A very soft 6B pencil was used for the areas where a great deal of pencil has been laid in, such as the tail and the backs of the ears. The darker B grades were also used for those darkened areas and lines that emphasize the action and attitude of the pose. Note how the long tapering contour line of the cat's right foreleg defines its posture; and that the shading along the upper portion of the leg further suggests that the leg is lifted and held away from the body.

Detail: The darkened silhouette of the left front foot works as an effective background for the softly blended shading of the right foreleg.

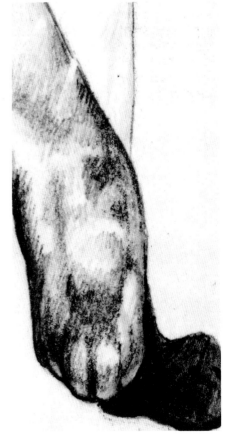

Cats of Many Breeds

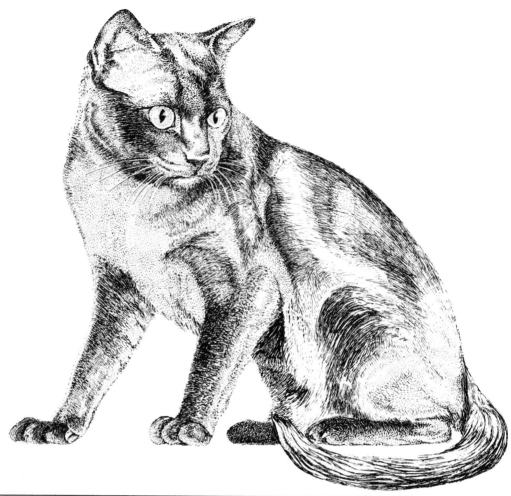

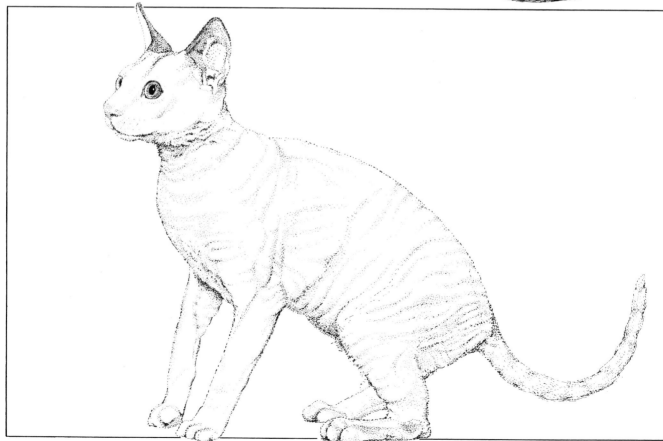

Burmese

Black ink on hot press illustration board

Appearance: A medium-sized cat. Chest appears generally rounded from profile. Back straight. Slender legs. Medium-length tail. Head slightly rounded at top, with good breadth between the ears. Medium-sized ears; broad at the base. Eyes larger and set well apart. *Short, satin-like, fine-textured coat.* Coat may be one of many colors; eyes range in color from chartreuse to amber.

The Drawing: The objective is to capture the lustre, fine texture, and length of the cat's coat, and to depict body contours by rendering variations of light on the cat's hair. I used a size 0 mechanical drawing pen on hot press illustration board; variations of black ink on white paper offer a full range of tones, and so work well for establishing the texture of hair. The quantity or density of lines/dots in a given area produces light or dark tones. Note that the cat is lit in in such a way as to show the silken sheen of its coat, indicating that it has more than one light source.

Details: In this foreleg detail at top, I've used short, quick little dashes and strokes of the pen, which are generally going in the same direction. Then, to blacken in the darker portions of this area, I came back with the pen and filled in more lines. The darkened result changes the balance of light and dark and creates an area that is more black than white. However, even in the blackest areas, I still allow some of the white board to show through so that there is a sparkle and liveliness in the drawing.

The hair in the hip area at bottom appears to be longer than in most other parts of the Burmese's coat. I wanted to produce a shaded area here that reveals a sense of contour and distinguishes the hip from the surrounding forms. The long, curved lines, moving from shadow into highlighted areas, explain the actual form of the cat's hip.

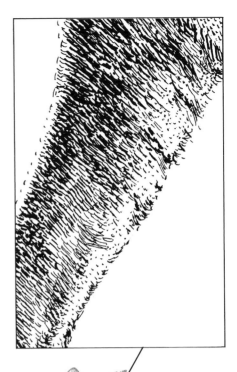

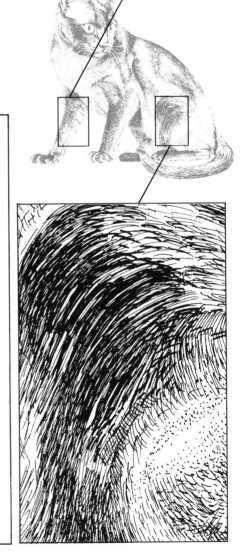

Rex

Black ink on hot press illustration board

Appearance: An agile cat; often *assumes a crouched stance.* Long, slight body. *Arched back, muscular hind legs.* Long, slender tail. Head small and narrow; neck long and slender. Large ears, wide at the base and high on the head. Eyes oval-shaped. *Short, wavy coat,* especially pronounced on back and tail. The hair length approximately half that of normal cats. Rex may be one of a wide variety of colors; eye and nose coloring dependent on color of coat. (This white Rex has deep blue or brilliant gold eyes and a pink nose.)

The Drawing: In order to show the agile posture and tight, curly coat, I used a size 0 mechanical drawing pen on hot press illustration board. This medium produces a sharp black line and can provide a great deal of visual explanation with minimal rendering. A rather simple outline describes the cat's general features and stance. Notice how the cat's contour is made up of a light stippling in some areas, such as the pattern created by the wavy coat. The contour is also composed of a series of small, broken lines—found in the outline of the tail and in the loose folds of the belly. To suggest the wavy texture of the fur, I let the stippling follow the musculature of the body. Where stress points or folds of skin are indicated, the ink is applied more densely and with short, thick lines. These areas are particularly evident in the neck, the belly, and the ears.

Cats of Many Breeds

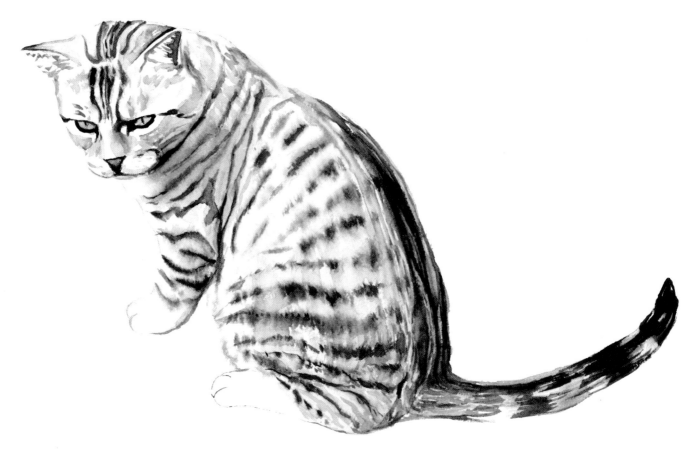

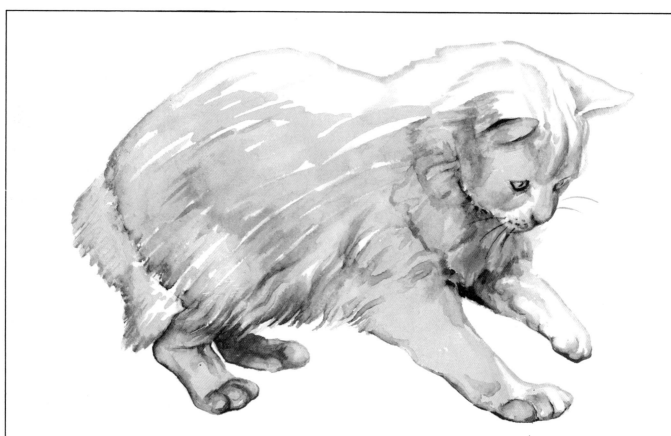

Spotted British Shorthair

Cake watercolor on cold press illustration board

Appearance: Compact, broad chest. Short, strong legs. Tail thick at the base. Head round. Ears small and far apart. Eyes large and round. Short and dense coat. Color silver with black spots, or red with red spots. Eyes green or hazel in silver spotted; orange, hazel, or deep yellow in brown spotted. *Head markings that of classic tabby. Body has numerous and distinct spots. Tail has spots or broken rings.*

The Painting: The focus here is on capturing and suggesting the rather busy design of the spotted tabby's coat. This particular cat's coat could be difficult to paint clearly without being visually confusing. I chose Gamma retouch colors—gray watercolors—on a surface of d'Arches cold press watercolor board because this medium has the ability to communicate visually with an economy of brushstrokes. Note how some areas have been applied opaquely, a unique feature of the Gamma retouch colors. In areas such as the back, I have initiated portions transparently and then come back and touched in opaque accents with thicker paint.

Details: These forehead markings at top were worked on a surface that was drier than other areas, such as the cat's back; but little portions of the forehead markings do feather because I have moistened small parts within this area. I did this so that the lines of the forehead would convey the striped markings without letting them get too soft and lose definition. Another reason that I show the markings clearer here is that the hair on a cat's head is usually short, which makes the markings have a crisper edge. Where the coat looks softer and more blurred, the markings feather out because the hair is longer and the markings aren't maintained as distinctly.

This back area at bottom has been worked on the wettest surface. Wherever the paint is spreading or feathering out to any extent, the surface was pre-moistened with a lot of water. Here, after an initial transparent application of paint on a wet surface, I add the opaque cool gray spots. Over this, I added clear water to give another layer of transparency to the painting.

Cream Longhair

Cake watercolor on cold press illustration board

Appearance: A Persian breed. Large or medium in size. Body solid and stocky. Thick, short legs. Short tail. Head broad and round; ears small. Short, thick neck. Brilliant copper eyes are large, round, and set far apart. Pink nose. Long, thick, silky coat; fine textured and flowing. Cream color with no markings.

The Painting: What I particularly wanted to capture was the cat's long hair in a state of movement. I used Gamma retouch cake watercolors on Bainbridge cold press watercolor board. This medium works well for expressing movement and tone with a few simple brushstrokes. I began this painting by laying out the form of the cat with a very light warm gray pigment, mixed with a lot of water.

This produced a light sketch that established the general shape of the cat. I then came back with a No. 7 sable brush and laid in bold, spontaneous, diagonal strokes of warm gray pigment. Note how it's the spontaneous nature of the brushstrokes that actually creates the cat; the painting is not rendered as much as it is quickly painted. After these initial bold strokes, I came back again with a No. 5 sable and picked out little areas to accent further, such as the cool gray shadow accents under the cat's neck and where the body meets the tail. (And since cool accents and colors usually recede, I try to use those tones in the accent areas.) I left the upper portion of the cat's body and head pigment-free to indicate a light source coming from the upper right.

Cats of Many Breeds

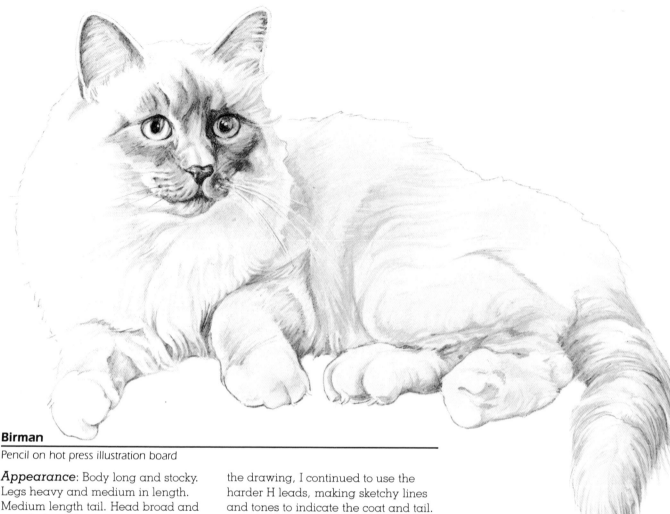

Birman

Pencil on hot press illustration board

Appearance: Body long and stocky. Legs heavy and medium in length. Medium length tail. Head broad and rounded; medium length ears, which are wide at the base. Deep blue eyes are almost round. Long, silky hair; thick around the neck. May be one of a variety of colors. *Subtle contrast between body color and points.* Points include mask, ears, legs, and tail. Nose color dependent on color point. White gloves cover the paw.

The Drawing: I wanted to create a simple sketch of a relaxed pose that captures the overall delicacy of tone inherent in the cat's coat. I used primarily H grade pencils with small touches of B tones in the darkest areas on a hot press surface. As pencil is a good medium for creating a loose sketch, I started this drawing by lightly sketching the basic shape with a 4H pencil. The 4H is a hard lead, which renders a relatively faint line or tone, so it's a good choice for initially laying out a drawing. Note the sketchy outline of the cat's back here that describes the ragged contour of the hair when the cat's lying down. To develop

the drawing, I continued to use the harder H leads, making sketchy lines and tones to indicate the coat and tail. I wanted to keep the pencil tone quite light in most areas because the cat's coat is very light and delicate; overuse of the darker B tones would create too great a contrast. However, I did use some B tones in the mask area: between the mouth and the darker left side of the cat's face. For the soft-looking ruff of hair around the cat's head and the body hair, I laid in a smooth tone, using a very sharp pencil, that is worked from dark to light. Where the tone reads the darkest indicates the thickest hair or an area where shading is prominent; it feathers out lighter in the highlight areas. Because the hair on the tail is longer and coarser than elsewhere, I defined the individual strands by using a harder, darker line. In the very lightest tonal areas, such as the cat's feet, I relied on the very lightest grade pencil—the 6H. If you keep a 6H very sharp and use only the lightest pressure, it's possible to make a very subtle transition from white to the most delicate grays.

Blue Persian

Markers on cold press illustration board

Appearance: Body thick and low on the legs. Head broad and round. Short face and nose; nose blue. Short, thick neck and legs. Tail short and full. Ears small and tufted. Deep orange or copper eyes are large and round. Long, thick, and soft hair can be any shade of blue-gray.

The Drawing: What I'm focusing on here is the character and feeling of the Persian's long, thick, flowing coat. Because the Blue Persian is a light-colored cat, I decided to use color only in those areas where I wanted to indicate shading, because the white of the board showing through should read as the cat's pale-color hair. I also wanted to show a range of textures in the drawing, so I built up the cat's coat in stages, with stippling, dashes, and eventually solid areas of color. I developed the drawing by stippling in a light blue color, cool and light in value, because its neutral tone would not dictate a rigid and realistic color scheme and would allow me to develop the color in a more impressionistic manner. After the initial form of the cat was stippled in, I began to develop the more heavily shaded areas by filling in with other colors and using longer dash-type lines. The shading here actually becomes a means of introducing color: the tan shade helps to balance the cool blue by adding a little warmth; the purple represents the hue blue might be if it were in shadow; and the high-keyed greens and oranges further develop the impressionistic quality that sets the tone for the drawing. As a final step, I built up the solid color areas, such as the multicolored shading that indicates the edge of the cat's ruff, by filling in with longer, looser strokes. Notice that some areas, such as the tail and the paws, were intentionally left undeveloped. They give a cleaner and lighter look to the drawing, complement the more developed parts of the cat, and serve as a clue to how the picture was made.

Cats of Many Breeds

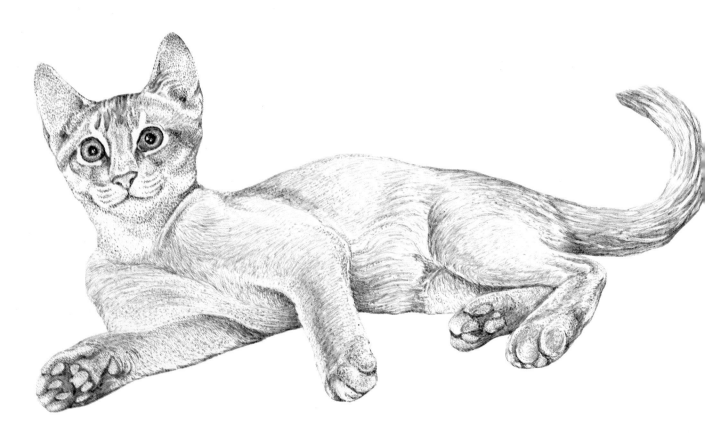

Abyssinian

Colored ink on hot press illustration board

Appearance: Medium-size cat with long, muscular, and graceful body. Legs slim and fine-boned. Tail fairly long and thick at the base. Head slightly rounded wedge shape; no flat planes. Ears large and broad; they stand up in an *alert manner*. Eyes large and almond-shaped. Rosy pink nose. Medium-length, *soft, silky, fine-textured coat*. Colors include ruddy brown, red, and blue. (The ruddy variety shown in this picture is ticked with darker shades of brown or black.)

The Drawing: I wanted to capture the alert quality of this cat, which is pronounced even when the cat is in a relaxed pose. I also wanted to convey the silky, sensual look of the coat. I used both mechanical and crowquill pens, with color ink, on hot press illustration board. This medium works well for describing texture, color, and features in a sketchy illustrative style. The drawing was sketched in minimally with sienna ink. I typically begin these early neutral-colored sketches with mechanical pens rather than crowquill; they are easier to work

with because they don't have to be constantly dipped back into the ink. In general, I use the crowquill pens for the colors that I use less often, such as scarlet or light green. Following the initial sketch, I continued with raw sienna, burnt sienna, and gray inks to develop the color and texture of the coat. In this pose, the body of the cat is twisted in an unusual way that alters the contour of the cat's fur and exaggerates the anatomy slightly. This is most apparent in the chest area, where I have used long, curving lines to develop the position. Small dashes of orange ink were used as accents, especially in the shadow areas; and a smattering of small dots of scarlet ink created a shade of pink on the nose and the padded toes. Gray stipple was used throughout the drawing to further describe the forms and contours. This is most evident on the chin and neck, where the gray stipple is used for shading—not to indicate shadow—but for contour shading to create form. Yellow, light green, and black inks were used to render the eyes.

Tortoiseshell and White

Colored ink on hot press illustration board

Appearance: A British shorthair breed. Medium-to-large-sized cat with a hard, muscular body. Broad shoulders; breadth of hip is same as shoulders. Feet and toes rounded. Tail thick at the base. Head broad and well-rounded. Neck short and thick. Ears broad at the base. Orange, copper, or hazel eyes are large and round. Short, dense coat; *brightly colored markings*. Coat is black, red, and cream, interspersed with white. Colors are broken into patches covering the top of the head, ears, cheeks, back, tail, and part of flanks.

The Drawing: The goal was to show the multicolored, lustrous coat of this breed. I worked with colored ink, using both mechanical and crowquill pencils on a hot press board. I initiated this drawing with a light coverage of gray stippling to indicate the outline of the cat and also to stipple in the tone that describes some of the subtle contours of the cat's form. (This tonal buildup is most evident in the chest and neck areas.) Following the application of gray stipple, I came back with burnt sienna and stippled in some additional form along the back leg. For the markings, I used black ink and laid in a series of strokes that describe the patterns of the markings. These strokes also indicate the contour of the cat's body, so they too help to describe the cat's form. To capture the glossiness of the cat's coat, I juxtaposed black ink strokes and white of the board to create a highlight effect, which appears as a sheen of light reflecting off the cat's back. This rich sheen is emphasized even more by filling in cobalt blue ink in the white spaces that were created by linear black strokes. Blue works well here, not only because its coolness makes it recede, but also because it has the ability to make a smooth visual transition from the black ink to the white board. Note that cobalt blue was also used under the cat's chin, where it accentuates the shading by adding a little cool color to the shadows there.

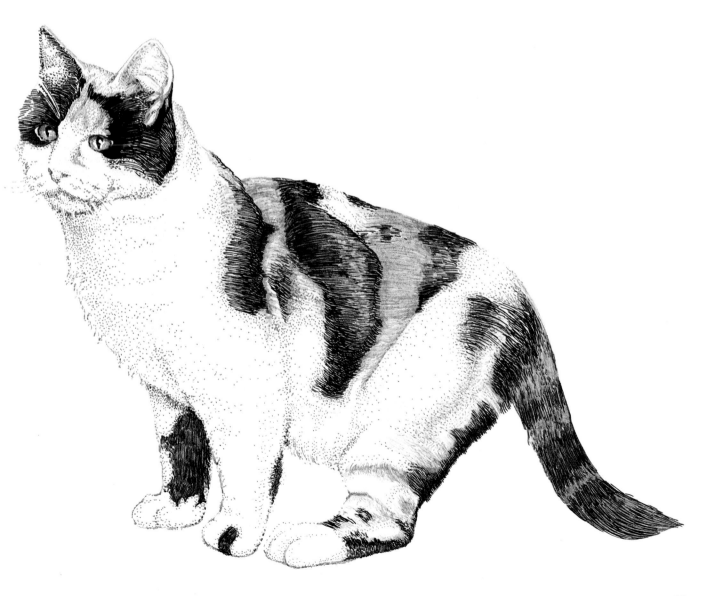

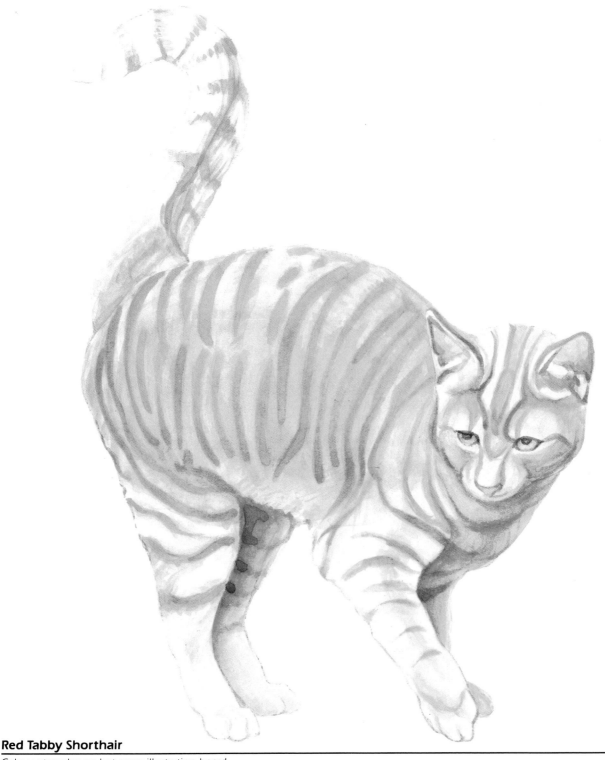

Red Tabby Shorthair

Cake watercolor on hot press illustration board

Appearance: Strong, compact cat. Full broad chest. Straight forelegs. Tail thick with a rounded tip. Head large and round; short, thick neck. Ears small. Orange or hazel eyes are large and round. Short, dense coat; red, yellow, or orange in color. Classic tabby pattern of striped markings, with an evenly ringed tail.

The Painting: The focus here is on the directions of the striped markings, which help to explain the tabby's form. I painted this cat with cake watercolors on d'Arches hot press water-

color board. Watercolor is a good medium for expressing subtle tones, which works well for the tabby's soft markings. I began by filling in the initial sketch with a light wash of yellow ochre paint and then came back with a stronger mixture of ochre to explain the markings themselves. Following this, I mixed ochre, yellow-orange, and a bit of orange and deepened the marking color. I then came back once again and hit some portions of the stripes with additional color. Thus, to indicate the contours of the cat, the markings have a variation

of color and darkness, even within an individual marking. In areas where I wanted a grayer, gradated effect, I dipped the brush into clear water and spread the paint across the length of the stripe until it disappeared. Although most of the markings are somewhat subdued, note the touch of raw orange on the cat's rear hind leg. I was able to introduce such strong color here because this area is in shadow and thus low in value, allowing for a minimum contrast that is not out of character with the subtle tones of the entire painting.

Ruddy Somali

Cake watercolor on hot press illustration board

Appearance: Basically a long haired Abyssinian; a muscular and graceful cat. Medium-long torso; rounded rib cage; slightly arched back. Brush-like tail, thick at the base. Eyes large and almond-shaped; gold or green in color with a dark lidskin surrounded by a light-colored area. *Extremely fine, dense, medium-length coat.* Coloring orange brown or ruddy with white on upper throat, lips, and nostrils; tipped with black and darker along the spine. Nose color is tile red.

The Painting: The focus here is on establishing a range of color and texture in the softly swirling coat that characterizes the breed. To do this, I chose cake watercolors on a surface of d'Arches hot press illustration board. Watercolor is an excellent medium to capture the various textures presented here, from soft to hard-edged. After sketching in a minimal outline with pale gray paint, I laid in the cat's form with a light ochre wash. The rendering was then developed by working on both wet and dry surfaces, to help portray the different textures of the coat. Several colors were used for a multicolored effect: gray, yellow ochre, burnt sienna, Indian red. Each area of the coat is worked somewhat differently, depending upon how I chose to regulate the amount of wetness on the surface. For example, in the shoulder area, a relatively larger amount of water was used because I wanted a softer looking line. By contrast, the back area was moistened only slightly because the desired effect was to show clearly the separate strands of hair on the cat's back.

Detail: The cat's shoulder is a study in the softly blended tones that are possible when working with watercolor. Because the cat's shoulder is reflecting light in this position, I wanted this area to have the diffused look of light hitting its surface. To do this, I used pale washes of gray, yellow ochre, and Indian red paint. These colors were then applied to a very wet surface, causing one color to feather out and travel into an adjacent color. Note the use of darker values used to define the contour of the cat's shoulder as it joins the body.

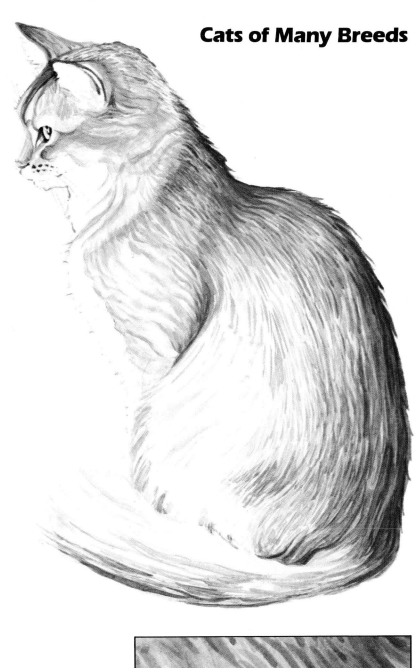

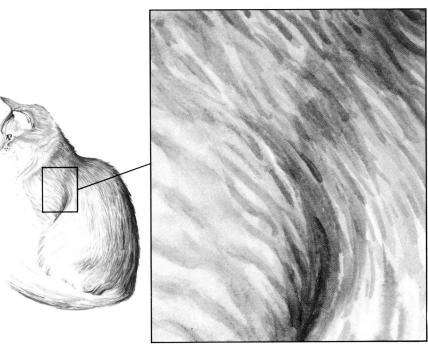

A STUDY OF EYES

Eyes are the most expressive feature of a cat. A cat shows pleasure by opening and closing its eyes when praised, alarm by widening its eyes when frightened, and anger by closing its eyes to slits when it is ready to attack. Cats are also very capable of expressing a number of refined and more subtle emotions through their eyes, such as humor or spite.

When drawing the cat's eye, try to capture the feeling of a sphere, set in a deep socket of the skull. The surface of the eye is highly reflective, and should be rendered in a way that makes glassy areas appear to pick up highlights and reflections. The cat's pupils expand and contract, depending on how much light is present. This obviously explains why the pupil appears either large and dark, or as a small slit. Notice that the pupil looks like it's floating inside the cat's eyeball, especially when viewed from profile. Also, be aware that, although the eye itself is spherical, it can appear to be round, oval, or almond-shaped, depending upon the breed of cat being drawn.

The hair and markings surrounding the eyes can affect the appearance a great deal. For instance, some breeds have dark outlines around their eyes, while others have patches of color, stripes or spots.

At night, when the pupil dilates, cats' eyes are highly reflective. This causes the eyes to appear shiny yellow, green, or red.

Eyes
Markers on cold press illustration board

Large orange eyes, such as those of this British Blue shorthair, are particularly striking when illustrated with the gutsy raw color of markers. The eyes were rendered with a combination of stippling and solid color; they contain primarily yellow-orange and red color, with touches of burnt umber and mauve. The distinct white highlights are the white of the board; their placement indicates a light source that is coming from the upper left. Black is used for the pupils. Notice that the pupils are shaped differently, a visual phenomenon created by the way light is refracted off the convex eyeballs.

The cat's eyes are complemented by the cool colors of the fur around the eyes. Because blue tones are found in this breed, I used light blue, a slightly deeper shade of blue, mauve, and gray in the fur. Since the coat is basically blue, the eyes are brought forward dramatically. There is such tremendous contrast between the warm eyes and the cool coat that I had to integrate these two opposing color schemes by distributing accents of red and orange around the eyes. This creates a sense of color harmony throughout the picture. However, even with this transitional step, there remains a very dramatic emphasis of the eyes coming forward.

To help balance the overall picture, I used a turquoise marker to make the background a little warmer. The heavy blue emphasis over the cat's left eye acts primarily as shading. At the same time that this shading is used to create tone, it also describes the strands and texture of the fur.

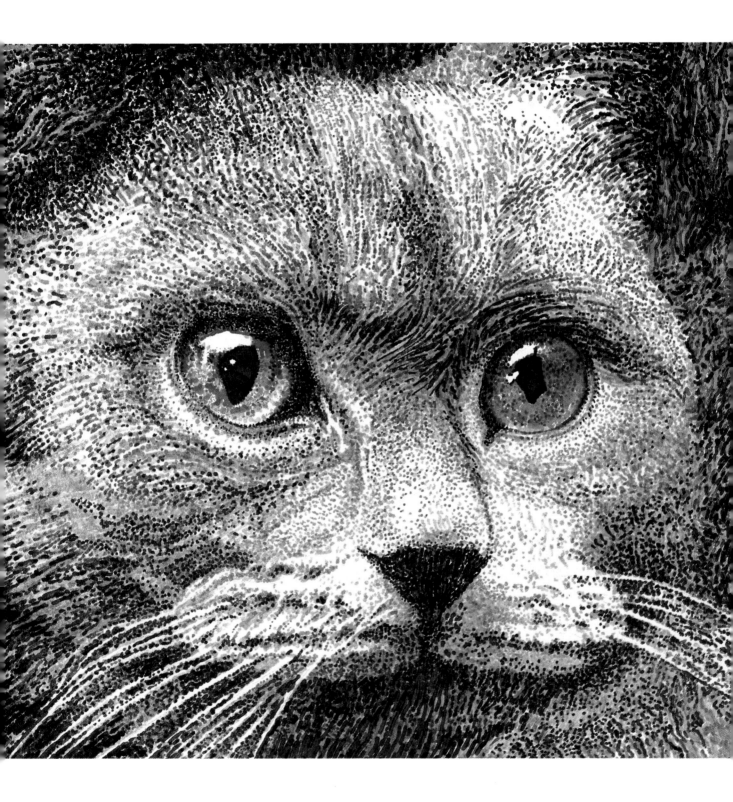

A Study of Eyes

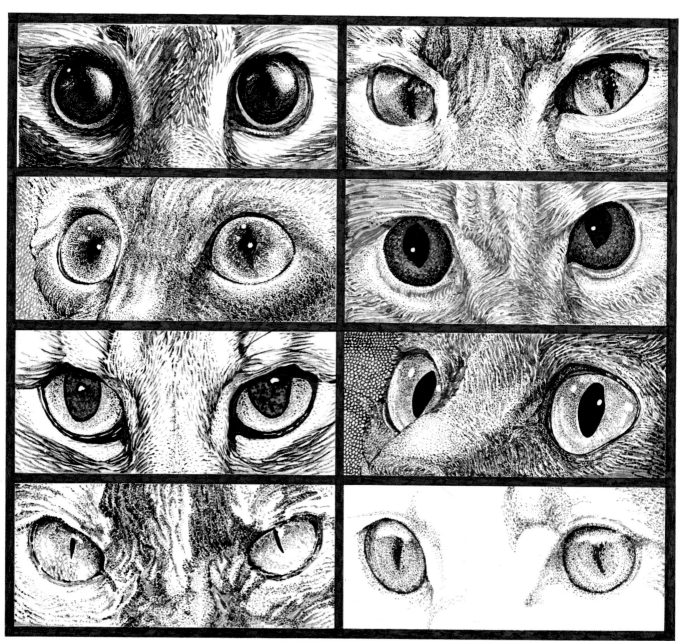

Colored ink on hot press illustration board

The large bluish pupils of this Maine Coon cat are extremely dilated, indicating a low surrounding light source. This drawing is one example of the various ways the eyes can appear based upon their different response to light. The dramatic effect of these eyes is heightened by complementing the blue glassy pupils with warm, textured, surrounding fur, where I used combinations of yellow, siennas, orange and gray inks.

The drawing of this silver tabby's eyes shows how the reflective surface can become nearly as prominent as the pupil. It looks as if you are viewing the pupil through a layer of frosted green glass. This frosty effect is the result of the natural pigmentation of the cat's eye, the surrounding colors, and prevailing light conditions. It is also the result of the very cool look of the various shades of green inks used for the eyes.

The pupils of this Siamese cat have soft edges which make the eyes look somewhat misty, and add a kind of moodiness to the expression. You can project a diversity of feelings by adjusting the contrast or softness when drawing the eyes. The soft, misty look of this cat's eyes is achieved by making very gradual transitions from one tonal area to another. Note how the violet ink merges with the blue stipple; the addition of this warmer color in the cool blue eyes adds a fuller, richer look.

Unusual eye coloring, such as that of this cream longhair, can be used to dramatic effect in a drawing. Since the eye color is so vivid, I carried specks of this same color into the hair surrounding the eyes, a technique which helps the stark colored eyes look more natural in the surrounding environment. I also used the light areas under the cat's eyes, which are caused by the lighting, to add modeling to the cat's face and help to explain its form.

There are many ways of manipulating a drawing to achieve various expressions and moods. The eyes of this tabby project a feeling of strength and determination. This feeling is achieved by introducing slightly angular lines to the brow, and darkening or thickening the outline of the eye. The green chromatic eyes against the gray achromatic fur produces a complementary effect of intense contrast.

The three-quarter view makes an interesting perspective; form is enhanced by this angle, and there is an increased sense of depth. Sometimes you can use artistic license to exaggerate and harmonize the colors. Notice how a slight purple tint on the cat's hair complements the green eyes. I also carried some of the purple over into the eyes. The eyes are reflective and should mirror some indication of surrounding colors.

I included this Tortoiseshell shorthair to show the attractive colors and markings that surround its eyes. The slitted pupils, which are responding to bright light, can sometimes make the cat's expression look mean. The glassy quality of the eyes is achieved here by the application of very fine dots, which is contrasted to the coarser, longer strokes used for the coat. Note that the addition of cool blue accents to the warm-colored coat further distinguishes the coat from the eyes.

A sense of overhead lighting and minimal rendering can result in a soft, sensitive expression. Making the eyes of this short-haired orange and white cat round and cast downward can add to this effect. Notice the distinct light highlights on the tops of the eyes. These accents indicate a light source from above. They also help to accentuate a glassy, reflective appearance of the cat's eyes.

A Study of Eyes

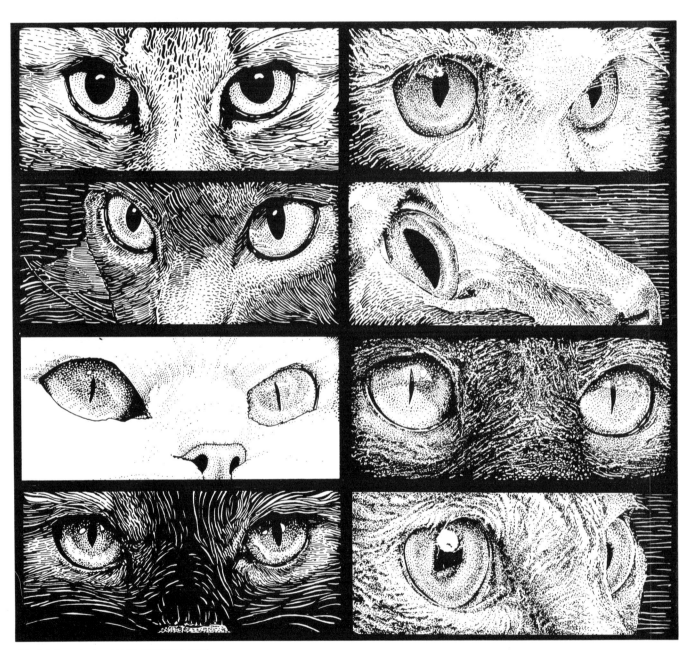

Black ink on hot press illustration board

By drawing the eyes of this silver tabby longhair as simple black shapes, the busy design of the surrounding facial hair becomes an interesting textural contrast. The markings around the eyes of the tabby are usually symmetrical in design. The eyes were drawn with solid black pupils and slight stippling on the eyeballs. The stippling is used to create tone in the eye, which greatly accentuates the white highlights.

Here, I took a more stylized approach and created a graphic, textural look with lots of directions and movement in the line. Although the drawing is basically composed of line, I used stippling for the nose and under the cat's left eye to complement the linework. Line is used here to create the forms of the cat's features and also to express the movement in the picture.

The eyes of the Chinchilla cat are large and rounded. Because the cat is white, I wanted to use minimal coverage of black ink on the fur—just little bits of stippling here and there to explain the form of the nose, eyes, and forehead. The eyes don't need to be rendered to very dark value because the cat is so light. In this case, subtle, fine stippling makes a very effective complement to the light coat.

This black Persian cat was created by using the white of the board to define the facial contours and textures. This technique is achieved by filling in the white board with black ink, leaving only those areas where white lines are needed to create the forms. Note how I used dots to render the highlights and form of the eyeballs; and a graphic approach of solid black and white for the facial area.

This bi-color cat was drawn from a three-quarter view, a perspective that allows you to see the rounded shape and spherical volume of its eyes. Notice how the shapes of the eyes are quite different from each other. The cat's partially hidden left eye is teardrop-shaped. The use of cast shadow on the upper portion of the right eye reveals the overhead source of light; and the shading in the fur area above the right eye explains the contour of the eye socket.

I drew a profile of this Siamese to show how the pupil appears as a solid object, floating in the center of a transparent spherical eyeball, sitting in a socket of the skull. I made the cat a light value against a dark background, and used dots, dashes, and lines moving in different directions to explain the various contours of the facial area. The seemingly flat darker horizontal lines of the background complement the contour effect of the cat's face.

When I drew this Chartreux cat, I was interested in showing the reflective surface of the eyes. The narrow pupils and glassy reflection on the surface of the eyeballs indicate a substantial light source. A reflective, spherical effect was accomplished by drawing three tonal levels on the eyes' surface. These light/shadow tonal levels were produced by differing dot densities. Notice the considerable range of values that have been established in the eyeball.

The shape of cats' eyes vary dramatically from different angles. Illustrating this Siamese's face from this perspective increases the feeling of depth in the drawing. Here the angle provides the opportunity to include the background area at right. The feeling of depth is further enhanced by building up the textures and the contours of the face with a complexity of dots, dashes, and solid ink areas. Collectively, all these techniques complement the glassy, spherical eyeball.

A Study of Eyes

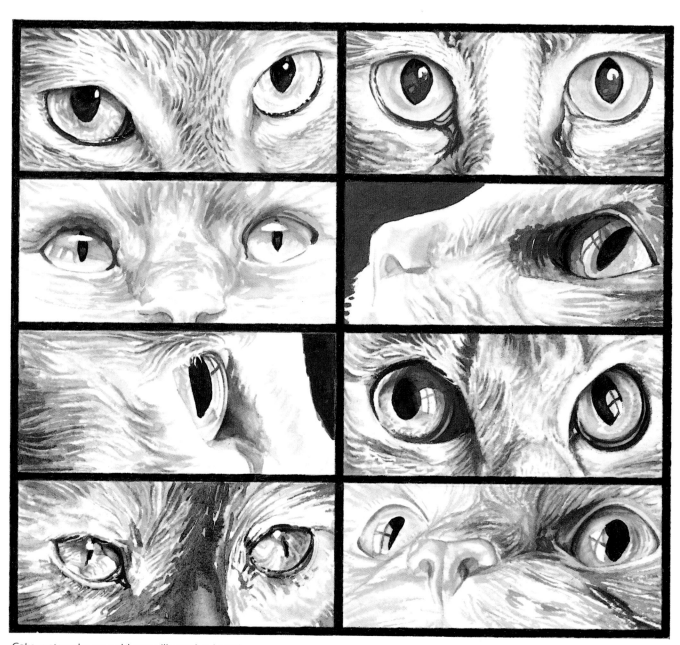

Cake watercolor on cold press illustration board

The Abyssinian's almond-shaped eyes should be accentuated by a dark lidskin and encircled by a light-colored area of facial hair. I painted the eyes of this Abyssinian at a slight angle; a small variation such as this can change the character of the cat—in this case, alert and watchful—and add a sense of movement to the composition.

This painting is an example of how capitalizing on the unorthodox markings of a mixed breed can add character to your drawing. The straight-on front view creates a symmetrical design. After the eyes were established here with a bright wash of yellow-green and pale yellow, with pupils of deep cobalt blue, I brushed in soft wet strokes of raw umber, yellow ochre, and burnt sienna, leaving the white of the board for the area between the eyes.

In the eyes of this Red Tabby, you can really see the shapes created by highlights and reflections. When the reflective white highlight on the outer surface of the eye covers a small portion of the solid black pupil inside the eyeball, the feeling of depth and transparency is accentuated. Note that when working with watercolor, it's a good idea to save the white of your board for highlight.

The eyes of this tabby-and-white cat look glassy and spherical. You can accentuate this effect by making the lines of reflected objects follow the convex contour of the eye's surface. In this painting a reflected windowpane creates this effect. Notice the several transparent layers of watercolor on the cat's eye. This layering increases the volume and glassiness of the eyeball.

Creative cropping gives a new perspective on this cat and lets us see its forms as an abstraction. Notice that the use of loose brushstrokes on a wet surface creates a soft texture, and describes the facial hair. This texture complements the smooth, hard surface appearance of the eyeball. The curved white highlights express both the contour and reflective surface of the eye.

These are the eyes of a spotted tabby. When you are drawing cats' eyes, keep in mind that the light source usually comes from above, which creates a slight shadow across the upper portion of the eyes. This shadow, which is cast by the upper lid, should be curved to show the spherical contour of the eyeball.

When I painted this Tortoiseshell cat, I wanted to capture the colors and design of the hair surrounding its eyes. To do this, I applied light strokes of burnt sienna, yellow ochre, raw umber, and gray in various directions, creating a sense of movement. The surface of the eyes is so reflective, it picks up and reflects the colors and design of the cat's own hair. Notice that a diluted touch of cobalt blue at the top of the eye adds a warm touch to the primarily cool color scheme.

The eyes of this cream longhair are rendered in three or four tonal levels. To create a highlight, it's necessary to add tone everywhere but the highlight. The tonal levels were built up with an initial weak mix of yellow ochre and then ringed with a diluted mixture of raw umber. A darker shade of raw umber was used for the shadow under the lid, and black paint was dabbed in for the pupil.

A Study of Eyes

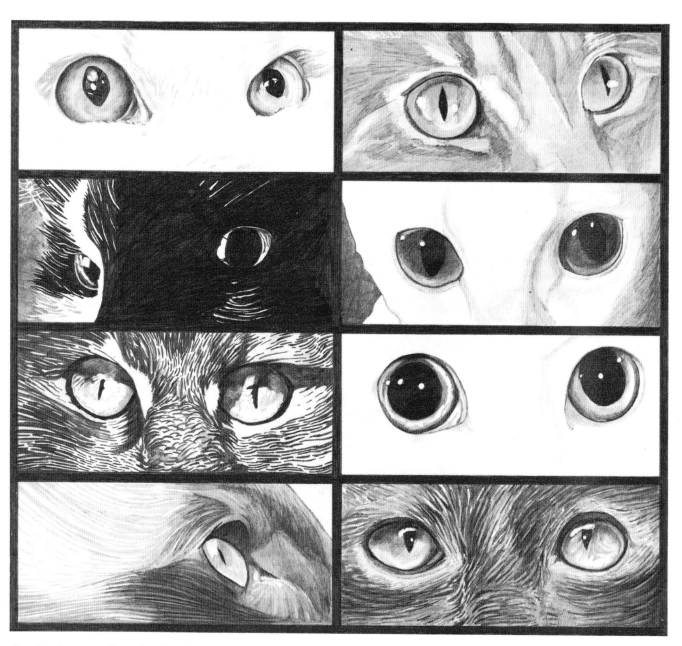

Pencil on hot press illustration board

In this drawing of a cream-colored longhair, I used a bit of loosely sketched shading to describe the fur; but the white surface of the board represents most of the hair surrounding the cat's eyes. The darkly rendered eyes stand out against the relative prominence of white space. The tonal levels found in the eye were worked from light to dark: I laid in the lightest value first with a 6H pencil, and came back with a soft 6B pencil for the shading at the top of the eyes and for the pupils.

In this drawing of a Maine Coon, notice how the markings and contours are presented as a series of rather distinct tonal planes. There is little blending of tone or subtle transitions of tone to create form. This handling is also present to a certain extent in the rendering of the eyes. Even with this different style, I still obtain the spherical, transparent glassiness of the eyes by building various tonal levels, casting a shadow with the lid, and using white highlights on the eye's surface.

In this drawing, I used a graphic, somewhat stylish approach. The stark, black side of the face was produced with a soft, dark 6B pencil. If you look closely at this area, you will notice that it is characterized by distinct variations in tone, an effect achieved by quickly laying in the tone without maintaining a constant pressure and without keeping the pencil sharpened. The soft 6B pencil was also used for the markings on the light side of the face.

A combination of darkness and transparency co-exists in the eyes of this white Rex. Although I used a relatively dark tone for the parts of the eyes that are supposed to be transparent, a proper relationship to the large black pupils and the minimal highlights maintain the transparency. This works out, because as dark as the tone has gotten, there's still enough contrast between the tone and the black pupils.

This drawing of a Maine Coon cat's eyes offers a good example of how the upper lid of the eye casts a shadow across the top portion of the eyeball. This can be done effectively with a 4H and 5H pencil, which renders a light gray tone that appears transparent when used in conjunction with light and darker tones.

The luminous, dark eyes of this white Scottish Fold cat indicate a very low light source. The enlarged, dark pupils, rendered with a 6B pencil, make an excellent background for placing highlights. These highlight areas look very crisp and white against the surrounding dark. This technique can be achieved by keeping a sharp point on your pencil.

Notice how the streamlined shape of this Siamese is accentuated by rendering the strands of hair on the face in a swooping, linear manner. The facial areas surrounding the cat's eye show the versatility of the pencil medium for rendering line, tone, texture, and contour. On the left side of the drawing, the light-valued tone was created with a series of lines; on the right, all the tone stays within a middle-value range.

The eyes of the Korat are large and luminous, with a pronounced depth and brilliance. I rendered these eyes with a great deal of transparency and brilliance, as representative in the breed. The glassiness of the eyes is complemented by the contrasting texture of the surrounding facial hair. The highlights are particularly effective, because of their contrasting placement in the shadows cast by the eyelids.

EXPRESSIONS

Cats are capable of a great range of expressions, many of them comparable to human feelings; and capturing a cat's expression is one way to bring life to your drawings and paintings. As you have observed in the section on eyes, the best way to capture the mood of your cat is by studying its eyes, because eyes are the most expressive part of the cat. However, cats have many other ways to communicate their emotions; they can also show their moods with other parts of their anatomy, such as the ears, whiskers, or tail. Just the angle at which a cat holds its tail will tell you something about its mood; waved slowly from side to side usually means that a cat is content, but if the tail is lashed sharply about or is twitching, the cat is angry. And if a cat lets his tail drag between his legs, it is probably not feeling well.

All cats exhibit universal body signals and postures that reveal their moods. When a cat is angry, it will hold its ears close to its head and keep its eyes almost closed. If the ears point up, however, you can be pretty sure that the cat is happy. The way in which a cat holds its whiskers also can reveal something about its mood; if they are laid back close to the face, it most likely means that the cat is irritated or excited in some way.

The way a cat walks or runs is also an indication of its mood. A slow, leisurely walk means that the cat is relaxed. But if the cat spies a strange dog or even another cat, its fur will stand on end, the back will arch, and the legs will stiffen.

The cats shown in this section were drawn or painted with the mood of the cat foremost in mind. In many cases, even the medium used to render a particular type of cat was chosen for its abilities to evoke a certain mood.

Blue Cat

Cake watercolor on cold press illustration board

There's no way to escape this cat's gaze. The relaxed expression and the deep dark eyes, however, keep the experience from feeling unpleasant. I painted this cat with Gamma retouch watercolors on a surface of d'Arches cold press watercolor board. The rich range of achromatic pigments of this medium creates soothing, muted tones. These soft washes add to the moodiness of the cat's expression. Because I wanted a minimal look to this painting, I used dark tones only where I thought they were necessary, a technique which keeps this portrait fresh. Notice how the symmetrical composition of light/dark values in this painting helps draw you into the dark eyes of the cat. The light values are basically distributed around the edges of the drawing, giving the picture a semi-vignette style of illustration. The darker values are concentrated in the center; and the darkest value—the black pupils—is the focal point of the painting.

Snarling Cat

Pencil on hot press illustration board

The teeth-baring mouth on this cat's face lets you know that the cat is angry and might attack. The crouched stance, slanted eyes, and ears held tight to the head also contribute to the cat's expression.

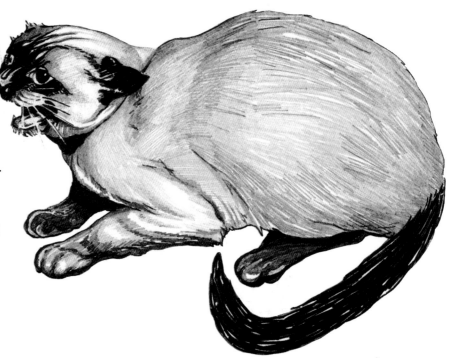

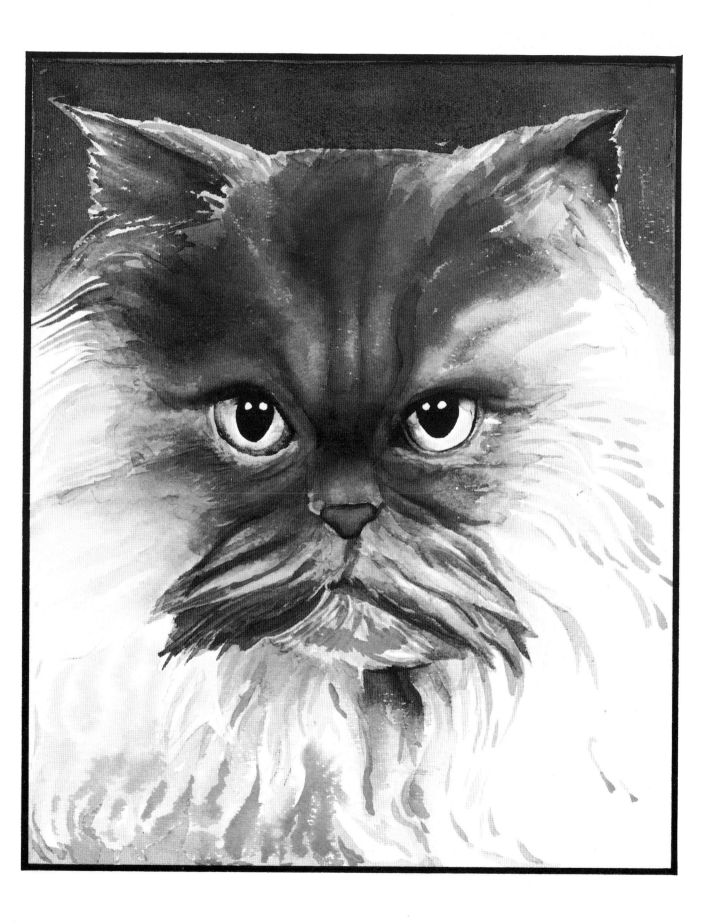

Expressions

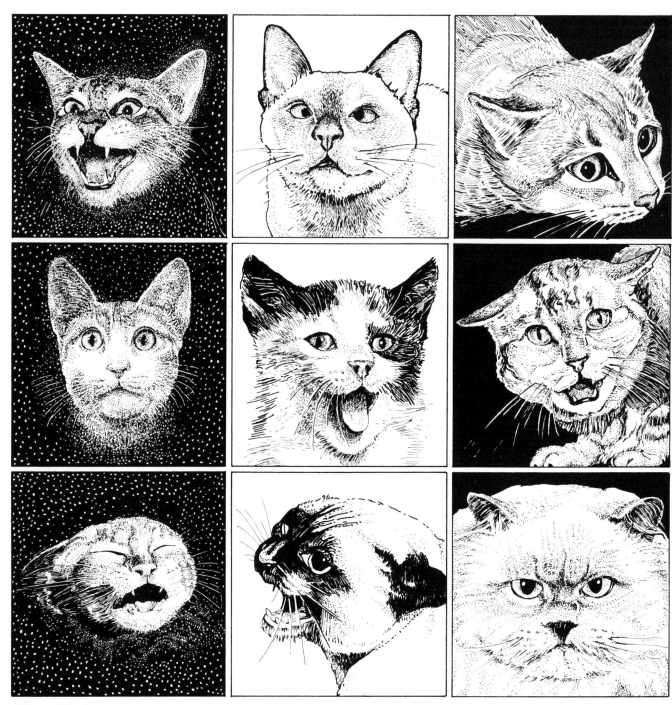

1	4	7
2	5	8
3	6	9

Nine Facial Expressions

Black ink on hot press illustration board

1. This cat's mad, smiling expression and its head rendered against the starry background give the drawing a supernatural look. Since this drawing is reversed, the white of the board comes forward as focal points. The predominant white used in the cat's face creates a contrast that separates it from the background and describes the facial form. The surrounding white dots reduce enough of the contrast to integrate background and subject.

2. The rigid frontal view and the pupils floating in the centers of the eyes make this cat appear to be staring straight through whatever is in his path. The symmetry of the drawing also emphasizes the single-minded-ness of the fixed gaze.

3. The elliptical shape of this wailing cat's face makes it look as if it's being propelled through space. I created this effect by flattening out the features of

the face, especially the ears, and merging the right side of the face with the background.

4. The crossed eyes of this Siamese dominate his expression. The silly, but cute look is brought out by emphasizing the darkened area of the nose, where the cat's eyes are focused, against the white coat. This area then becomes the drawing's focal point. It is ringed by adjacent areas of high-contrast that repeat the theme of light and dark.

5. This little kitten looks like he's yawning. The bi-colored coat was created by juxtaposing the light and dark areas, an effect achieved by letting white board peek through the dark areas and a few black lines in the white areas. Thus, the black pen lines define the light parts of the face, and the white lines define the black parts, such as the ears and the left side of the face.

6. The angry look of this cat is accentuated by the open mouth and turned head. I used the white negative space of the background to better reveal the open mouth and teeth that create the snarling expression. Notice that the lines that define the features of the cat—the head itself, the slanted eyes, the flattened ears—are compressed in an angry cat.

7. This cat's look of inquisitiveness is strengthened by the drawing itself. The overall composition of the drawing creates the projected feeling; the cat's head, pointing in one direction, stands out against the background.

8. This cat looks alarmed, as if he has been startled by oncoming headlights. Note the fierce mouth, the flattened-out ears, and the crouched posture. The predominant light values of the cat against the dark background reinforce the impression that it is night and the cat has been startled by bright light.

9. This cat projects a dominant, powerful personality, so I filled almost the entire drawing with his face. The big, round head with tiny ears, the furrowed brow, and the turned-down mouth all contribute to the "bah humbug" expression.

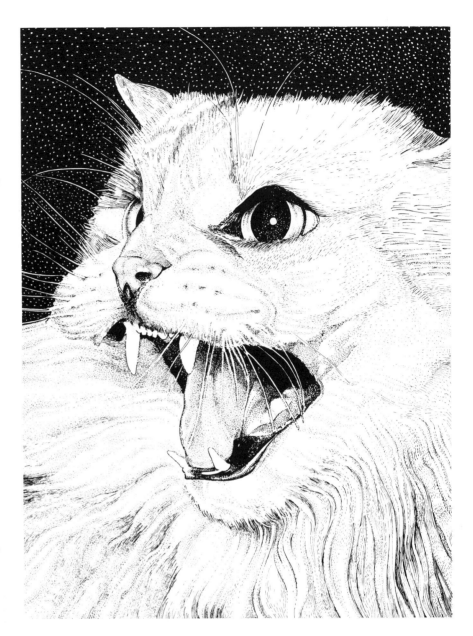

Cat Growling

Black ink on hot press illustration board

In this drawing of a cat growling, notice the changes that take place in the features of the face. The mouth opens, exposing the teeth and tongue. The lips, cheeks, and nose assume contours resembling a snarl; the eyes and brows slant to indicate anger or displeasure. The head is turned, which conveys a sense of movement and adds to the tension of the drawing. The dark, starry background and the cat's dilated pupils indicate a nocturnal environment. The semi-solid black background adds a graphic quality that allows the cat to come forward.

I rendered this illustration by combining a range of dots, dashes, and lines to create the different textures and movements of the cat's face. Note how all the different directions found in this drawing add to the movement and keep the picture lively. The pen strokes on the neck area are composed of long, wavy lines; collectively, they create a textured pattern and show the direction of the fur. The fur of the neck sets off the cat's face because it is longer and moves in a different direction. It also provides contrast to the face, which is basically rendered with a combination of shorter dashes and stippling. In the background, I use the reverse stipple technique, leaving the white of the board as the focal points.

Expressions

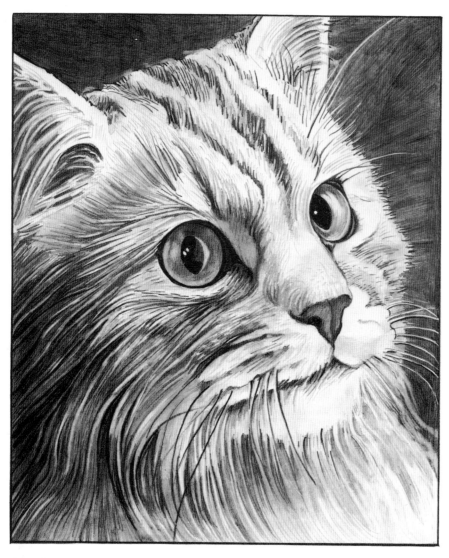

Cat Gazing

Black ink on hot press illustration board

This cat's steady, fixed gaze tells us that's he's preoccupied with something. Most of the drawing is rendered in a medium-to-high-value range. It is primarily executed with line, using a pencil with a very sharp point; and much of the tone is created by a series of lines. These lines are sharp and distinct. Collectively, they create tone, a pattern of texture, a sense of direction, and describe the markings. All of the elements—direction or movement, texture, markings, and tones—are basically comprised of distinct lines. Note that the furrows in the brow, and the hair on the inside of the ears are created from a series of lines and also some blended tone. However, in some areas, such as under the chin and on the chest, the tone is produced by blending the pencil rather than by creating it from a series of lines. These

areas act as a softer-looking complement to the more linear textures so evident in the rest of the cat's face. I also made use of the white of the board. The white chin and mouth areas help to describe the cat's markings; they also define the separation between the features.

Since the eyes portray the expressive quality of the drawing, I accentuated them with dark values, using a soft 6B pencil. The fixed, glassy quality of the eyes provides a textural complement to the busy quality of the hair. This transparent glassiness is achieved by blending the medium to get smooth tonal levels in the eye—from the white of the highlight, to various shades of gray, to the black pupils. The background was rendered quite solid because it allows the busy, textured cat to come forward.

Nine Facial Expressions

Black ink on hot press illustration board

1. Something has captured this cat's attention. The pupil rolled upward in the eye and the upwardly tilted head add to the feeling that the cat is staring at something with great interest.

2. This cat has the contented look that comes over an animal at the finish of a meal. The long, relaxed lines (especially around the cat's right eye) used to describe the hair of the face echo this impression of contentment. The licking tongue is another indication that the cat has finished his dinner and has begun to wash up.

3. Although a sense of humor is perhaps strictly a human emotion, this cat looks to me as if he's amused. To emphasize the rather light mood, I used a repetition of triangular shapes: the black negative space of the mouth; the triangular shape next to the left eye; and the shape of the head itself.

4. Furrowing his brow and baring his teeth, this cat is made all the more menacing because you are looking up at his slightly turned head. With the exception of a snarling, open mouth, an angry cat's face is compressed and pulled downward; here, the nose is flattened, the eyes slant down, and the ears are held close to the head.

5. The musculature of the cat is so flexible that in certain sleeping positions the head can appear to be sinking into the body. I've tried to capture this scrunched-up look by using broken, squiggly lines, which are very evident in the neck and shoulder areas.

6. A look of annoyance in this cat's expression is enhanced by the furrowed brows, the tightened turned-down mouth, and the pronounced outlines of the eyes. The minimal use of the short, staccato lines work well to convey the bristly attitude of the cat.

7. The profile of this kitten against a starry background creates a strange other-worldly mood. The kitten seems to be "glowing" in space, an effect achieved by merging the profusion of small white dots near the perimeter of

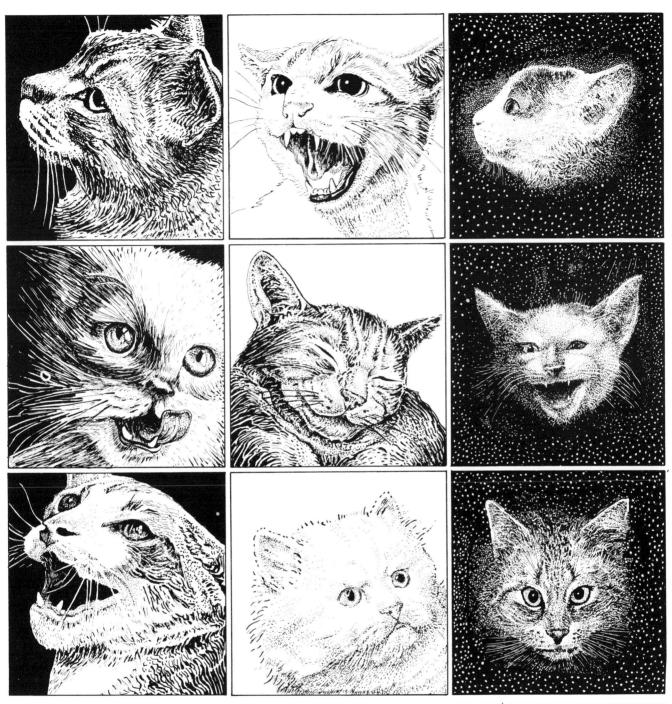

the kitten's head with the dots of the background.

8. Sometimes you may want to deviate from a strictly realistic image of a cat and create an imaginary, more fanciful creature. This half-human, half-feline floating head is an example of this approach, one that is often used in children's illustration. Note that the ears and shape of the face are cat-like, but that the nose and mouth are decidedly human. In fact, if the ears and whiskers were removed, the face would look like an elf's.

9. The steady stare of this cat looms out from a haze of white dots. The effect of staring out straight-on is hypnotic and commanding. Similar to the half-human creatures above, portraying an animal in this fashion is more appropriate to illustration than to an accurate rendering of a cat. The effect of a head emerging from a fantasy background is achieved by merging the area where the head ends and the background begins. Notice how the fine squiggly hairs evolve into small dots, which in turn evolve into the larger white dots of the background.

1	4	7
2	5	8
3	6	9

CATS IN MOTION

Cats are extremely graceful and agile animals; the way they move and hold their bodies has an immense visual appeal to the artist. In this section, I have included cats caught in a variety of movements. The various positions that a cat goes through while falling is a tribute to its flexible spine and extraordinary sense of balance. A number of complicated movements allow the cat's body to bend and rotate at the same time, and in most instances, to land safely on all four feet.

Because cats are natural predators, many of their movements are those needed for stalking prey, an activity for which the cat has a great deal of patience. The soft pads on their toes enable cats to hunt silently and stealthily. It is an interesting fact that, along with the giraffe and the camel, the cat walks or runs by moving the front and back legs on one side, and then repeats the same movement on the other side. Cats are also excellent jumpers, hopping onto trees and other high places with seemingly effortless ease.

As artists, it is a good idea to get acquainted with the many fascinating forms of the cat in motion. By observing and continually drawing the various ways in which cats move and position themselves, your work will take on an authenticity that can only be achieved by first-hand knowledge of your subject.

Prowling Cat
Cake watercolor on cold press illustration board

The simple three-part value scheme of this watercolor sketch shows an effective way to indicate the contour and underlying structure of the cat in mo-tion. Notice that in the chest area the bones of the rib cage have been suggested by a darker wash blending into a lighter wash.

Walking Cat
Black ink on hot press illustration board

In this black ink drawing, I wanted to develop a sense of movement, not only from the action of the cat, but throughout the entire picture. I even wanted the surrounding space to express movement. I drew the cat moving in the same direction one usually reads a page, from left to right. The angle of the cat, from the tip of the tail to the tip of the nose, slants downhill. This also accentuates the sense of movement. Much of the movement in this picture comes from a multitude of little white focal points that make up the background and foreground. I started with a white board; but, little by little, I covered areas with black ink until I achieved a reversed effect. With this technique, the white portions of the board peek through the blank ink to produce the white focal points. Since the cat is the main object, it is the whitest area in the picture.

I rendered the background with thousands of reversed white dots and dashes of different sizes, moving in different directions. These illuminated particles produce a sense of energy and movement, while at the same time they create an overall texture and an overall tone as background for the cat. Even the foreground on which the cat is standing is animated with reversed dots and dashes. These, how-ever, are fewer in number, allowing this area to appear darker and heavier, assuming the proper character of terra firma.

The cat is further animated by the appearance of rippling muscles, rendered by light stippling. The musculature and movement are described by the contours of the cat's body, which are created by tonal variations in the amount of dot density. These variations are dictated by the amount of light hitting the various contours of the cat. This effect can be seen quite clearly in the hip area, for instance, where the belly meets the leg. The darker shading at this juncture indicates the separation and relationship of leg to underbelly; it also accurately describes the cat's form. In the more light-filled areas, subtler transitions from light to dark are used.

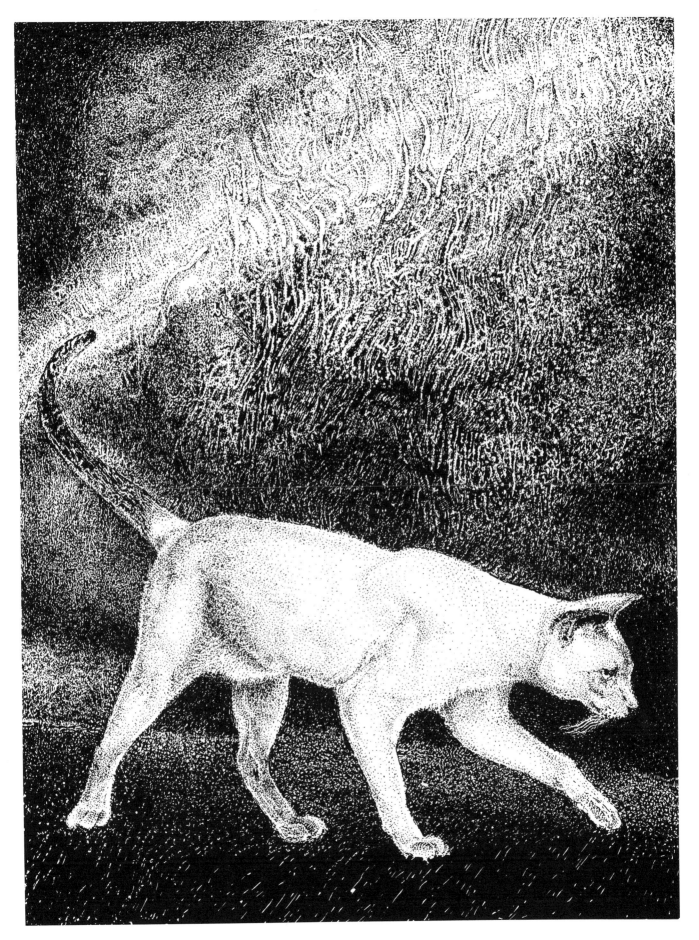

Cats in Motion

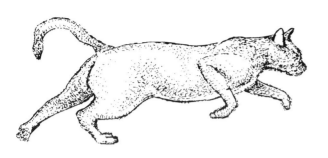
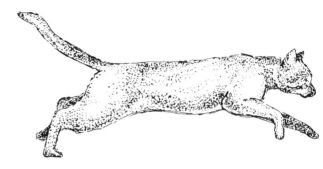

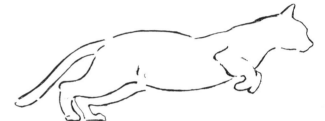

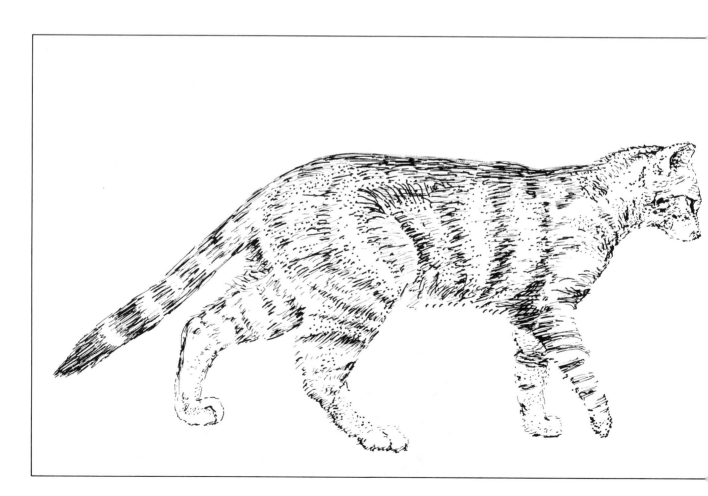

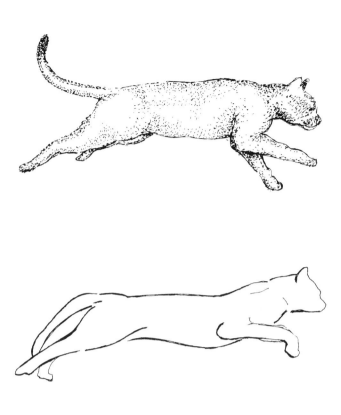

Cat Running

Black ink on hot press illustration board

In the top/left drawing, this cat is exhibiting the typical way a cat's legs move in four-time when it walks. The sequence is right foreleg; left hind leg; left foreleg; right hind leg. The middle and right-hand top illustrations show the cat in a run, taking full strides. I added a slight stipple tone to these three cats to minimally describe their form.

The bottom three drawings show a cat going through the stages of leaping forward, standing with the body and muscles coiled for action, and continuing with an agile release of energy, as the cat stretches out. Notice how the body shapes elongate at the end of this cycle.

In these three drawings I used just a simple outline. This way the total attention is focused upon the body shape and movement of the cat. In the middle drawing, you can see how I employed the use of the "implied line." The implied lines in the drawing are places where there is actually no line at all. It's created by drawing a line, breaking it with a space, and then continuing it again. The viewer's eye jumps the spaces and visually connects and continues the lines.

Notice the break between the tail and the cat's back. This is an implied line. This technique can add movement to the drawing for it allows the viewer's imagination to fill in the gaps, even if it's just for a moment.

Cat Taking a Step

Black ink on hot press illustration board

This black ink drawing of a cat taking a step shows the relative size and shape of the various body parts. Since I was drawing movement, I worked rather loose and sketchy. You'll notice that the area on the top/back of the cat, the markings and the tail, are quickly sketched with a series of small, loose, parallel lines. Keeping these lines loose and in an apparent visual state of flux further adds movement to the drawing. The markings also help to describe the contours of the cat's body. I also sprinkled in some stipple between the markings to add a little tone and form to the drawing. Even the outline of the cat is produced by dots and dashes.

Cats in Motion

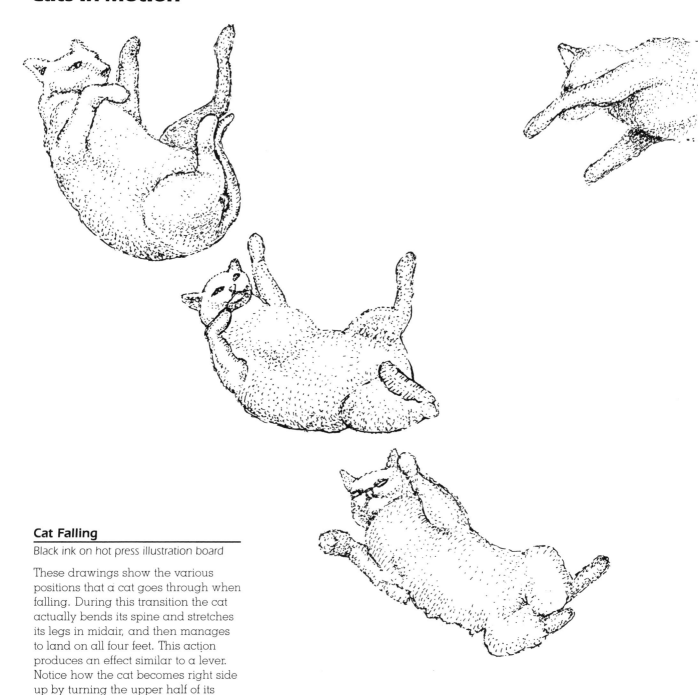

Cat Falling

Black ink on hot press illustration board

These drawings show the various positions that a cat goes through when falling. During this transition the cat actually bends its spine and stretches its legs in midair, and then manages to land on all four feet. This action produces an effect similar to a lever. Notice how the cat becomes right side up by turning the upper half of its body first; when the upper half is completely turned around, the hind-quarters follow through.

In the last stage of the fall, the cat's body is illustrated with the back arched, the legs extended, and the tail pointed upward. In order to illustrate the sequence of this phenomenon effectively, I kept the drawings simple. In each case I used an outline to capture the basic body shapes and gestures. Then I added a slight tone with fine stippling to minimally explain the cat's form.

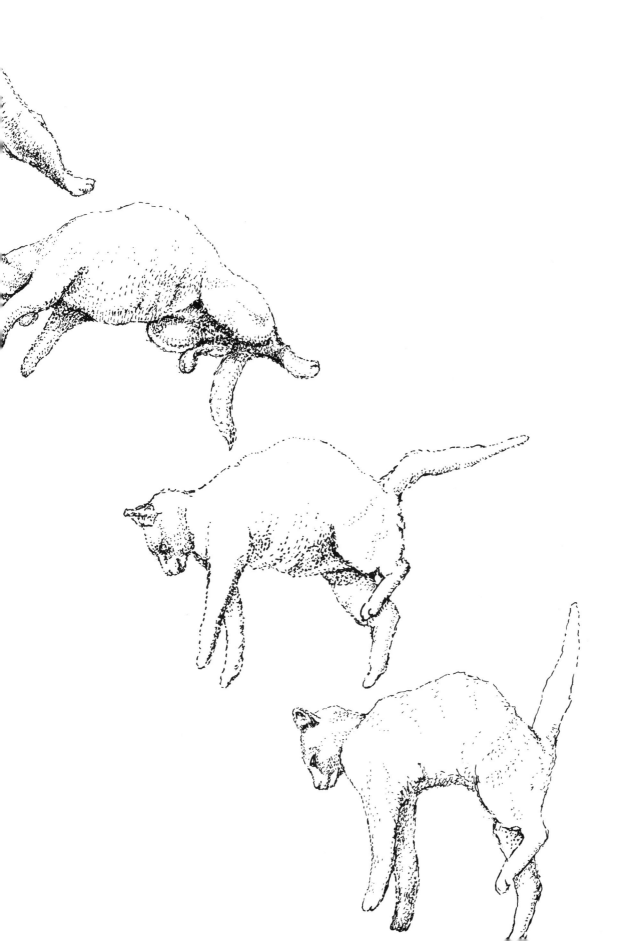

KITTENS

A kitten's form, movement, and personality are quite different from the full-grown cat's. Whereas the older cat is sleek, graceful, and rather cautious and quietly alert, the kitten's form is awkward, the movement often clumsy, and its curiosity unlimited. Because a kitten is at the age of discovery, its expression is often one of wonder.

Three Kittens

Black ink on hot press illustration board

The young Siamese shown *at top right* was drawn with a rather timid expression, often projected by inexperienced kittens. At this point, his features are a little pudgy and cute. When full grown, his portrait will be that of a sleek, muscular, graceful cat.

The tabby-and-white kitten's stance, turned head, and expression (*bottom right*) look as though he has stopped moving to become momentarily alert. Young cats are extremely curious and active. Spontaneous, jerky movements are a typical part of their expression.

The sketch of a long-haired kitten *at center right* describes the cute fluffy character of his coat. This breed is normally quite fluffy, but as kittens their features can appear less prominent, which makes them look like little fur balls.

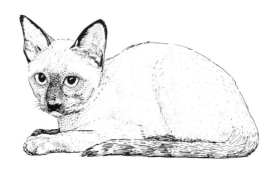

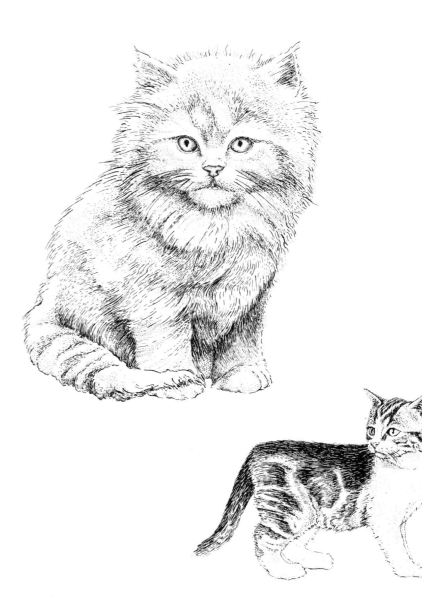

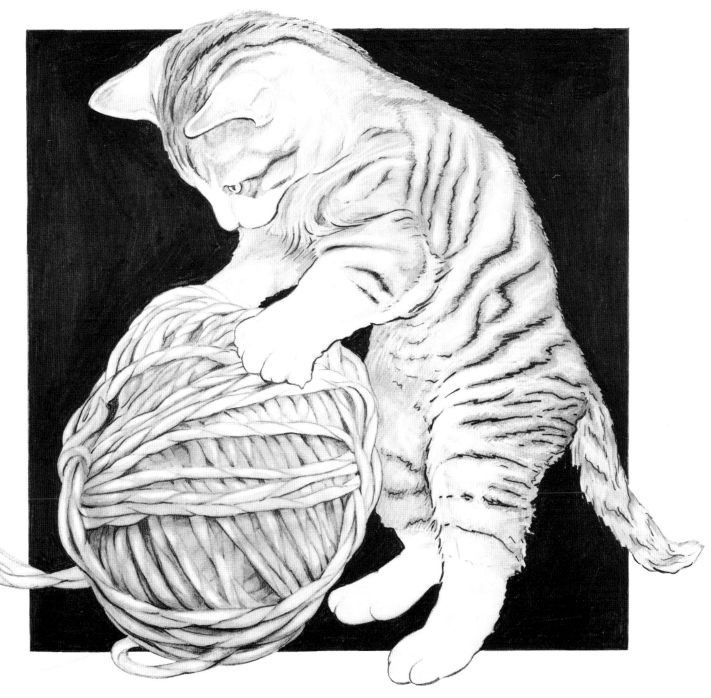

Kitten with Ball of Yarn

Pencil on hot press illustration board

No book on cats would be complete without this classic scene. The drawing was developed by coming in initially with a light-colored 6H pencil and sketching in the major outlines of both kitten and yarn. Then, with the same pencil, I laid in some neutral light tones behind the kitten's ears and on the side of the head. Similar subtle gray tones were also applied to the yarn. At this stage in the drawing, I began working basically from light to dark, going through my range of H and B pencils. Notice the darker shad-

ings on the side of the kitten's ear, laid in with a 5B pencil. The dark centers of the striped markings, seen on the kitten's head and back, were drawn in using a 4B. I then came back with a 3H pencil to widen the markings. The lighter value pencil softens the contrast between the dark striped markings and the white board.

I wanted the yarn to look like yarn, so I tried to capture the character of its overlapping forms. It was drawn and shaded mostly with H pencils. I used a sharply pointed 2B pencil to further

define the outer strands of yarn, which are more prominently described. The directions of the strands create patterns which describe the overall form of the yarn ball. Ultimately, I came back with a soft 6B on the stripes and created little black accents in the centers of all those stripes.

The solid black square was filled in with a soft 6B pencil. It acts as a background, adding contrast to accentuate the shapes and details of the kitten and yarn. It also pushes the kitten and yarn forward.

45

Kittens

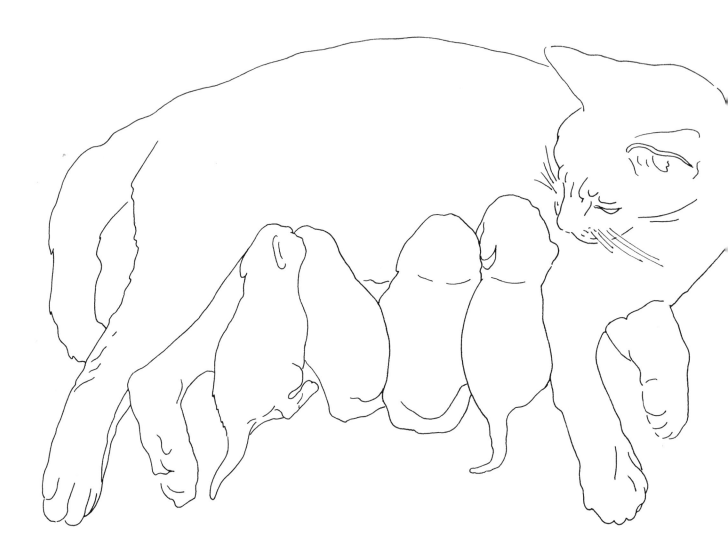

Mother Cat Nursing Kittens

Black ink on hot press illustration board

This drawing shows how you can
record and convey a great deal by
way of a simple contoured outline.
When I drew this picture, I produced a
continuous fluid line of constant thick-
ness.

When you look at the kittens, notice
how minimally they are described. Yet
you know they are kittens. This exam-
ple shows the powerful influence of
context. When you place a kitten in a
setting where a kitten is what you
expect to see, a minimal representa-
tion is all you need.

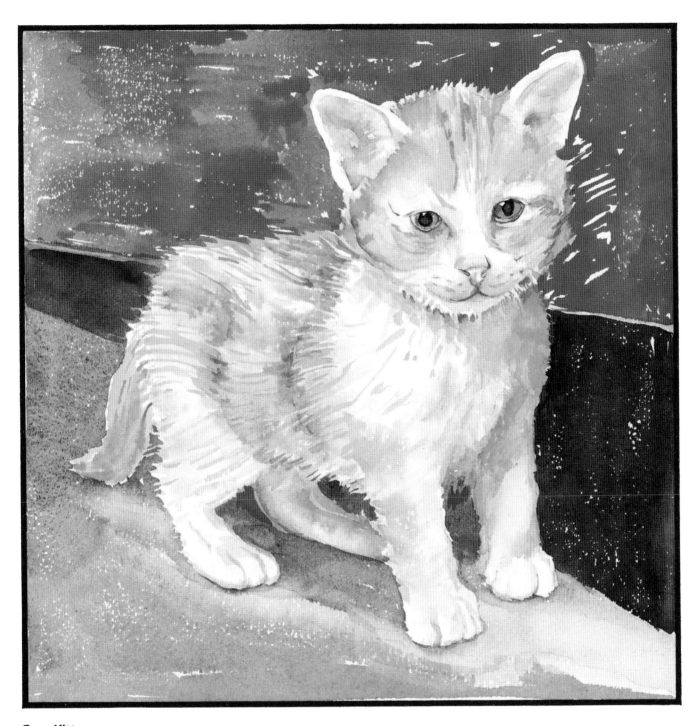

Gray Kitten

Cake watercolor on cold press illustration board

The stance and viewer's downward perspective contribute to the cute character of this kitten's appearance. Notice the diversity of light to dark value levels that co-exist in this illustration. Even though the approach is sketchy, the diverse values help the picture to look full and complete.

I painted this kitten with a set of Gamma retouch cake watercolors. These paints can be used in either a transparent or opaque manner, de-

pending on how much water is added. I executed this painting in a style similar to sketching. Notice the variety of spontaneous brushstrokes producing the texture of the coat. The soft textures of the cat's fur were created by applying quick brushstrokes of gray paint to a wet surface. The wet surface allows the edges of the brushstrokes to spread and soften. Notice the white of the board's surface peek-

ing through the gray pigment of the background. This effect is the result of applying thick pigment to a dry surface; it produces these hard-edged white accents.

In the middle-right section where the background is darkest, the little white accents are also the board showing through. These accents, however, result from the inherent texture of the board's surface.

USING PROPS AND BACKGROUNDS

Including additional subjects in your paintings and drawings give an added dimension to your work. When you select a particular subject or prop, such as a mouse or a ball, people will often have preconceived ideas about its relationship to the primary subject—in our case, a cat. Because these preconceptions do exist, people bring entire mental scenarios to the illustration before them. For example, if you combine a cat and a mouse in the same illustration, you don't necessarily need to include what will happen next. The dynamic has already been established for you.

Backgrounds are another design element that you can use to add an environment to your cat drawing. Unlike a prop or other additional subject matter, a background remains a passive element in an illustration; but it still has the ability to create a setting for your cat drawing. I frequently use background material when I want to place a cat in an imaginary or historical setting; that is, when I want to show the subject in a particular time and place. For example, just by introducing an assembly of Egyptian-looking stones and figures behind a cat (see page 50), the drawing takes on a mysterious, exotic aura.

Cat and Fish
Black ink on hot press illustration board

In this drawing, I wanted a cat to be the focal point of a wharf environment. Notice the number of elements that contribute to the feeling of depth in this picture. There are four distinct planes: (1) the foreground structure that is hiding part of the cat's tail; (2) the cat, fish, and horizontal rope above the cat; (3) the fisherman with his net full of fish; and (4) the surface of the sea in the background.

When developing depth in the environment of your illustration, think in terms of drawing objects or pieces of objects in different planes of depth. Allow for the difference of size as objects recede from the foreground and for objects in the foreground to partially cover objects behind them. When I blocked out a portion of the cat's tail with the foreground structure, I was careful not to cover too much. I also chose an area of the cat to cover that would not interrupt the image of the cat.

As busy as this picture is, the cat easily reads as the main focal point. The picture is rendered in a reverse technique, and the cat is the largest white area. The cat is made even more prominent by adding a cast shadow behind and beneath him. This contrasting dark tone brings the white cat forward. The fish in the foreground is prominent for the same reasons. It is also accentuated because the cat's stare draws our attention to it.

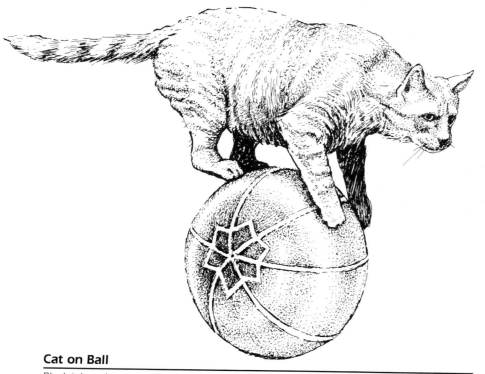

Cat on Ball
Black ink on hot press illustration board

By incorporating a ball into this drawing, I was able to convey the idea that cats are tremendously agile and possess a remarkable sense of balance. Notice that the stiff pose, the forced concentration on the cat's face, and the rigid tail all contribute to the apparent effort of balancing.

I rendered the distant legs in silhouette to simplify the visual clarity of the illustration. I started the drawing of the ball with a simple circle. The spherical volume was developed by adding the convex lines, which are part of the surface design, and by shading with stipple.

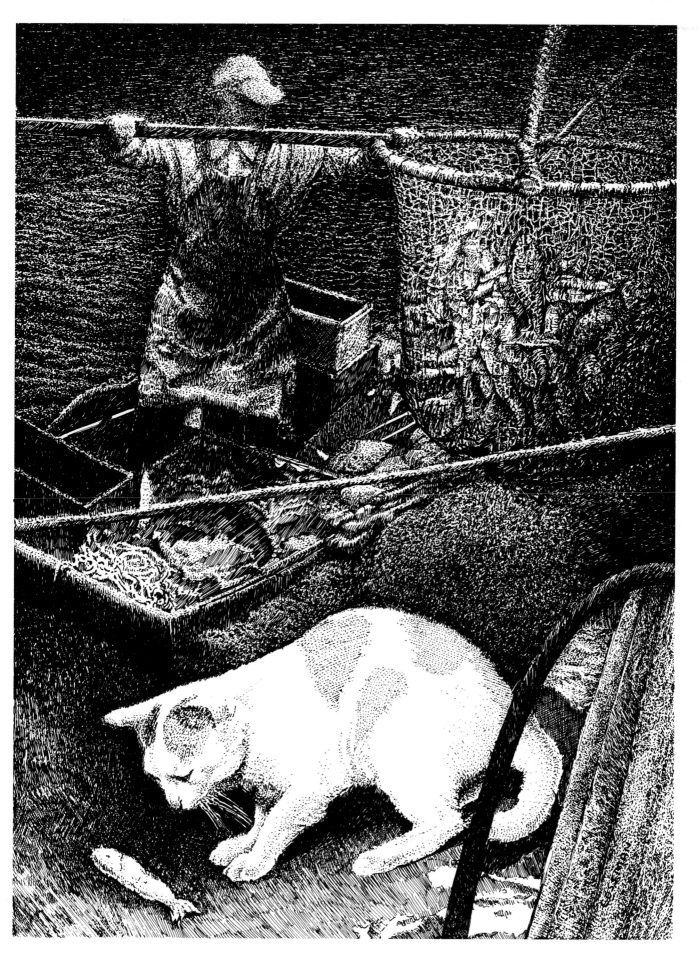

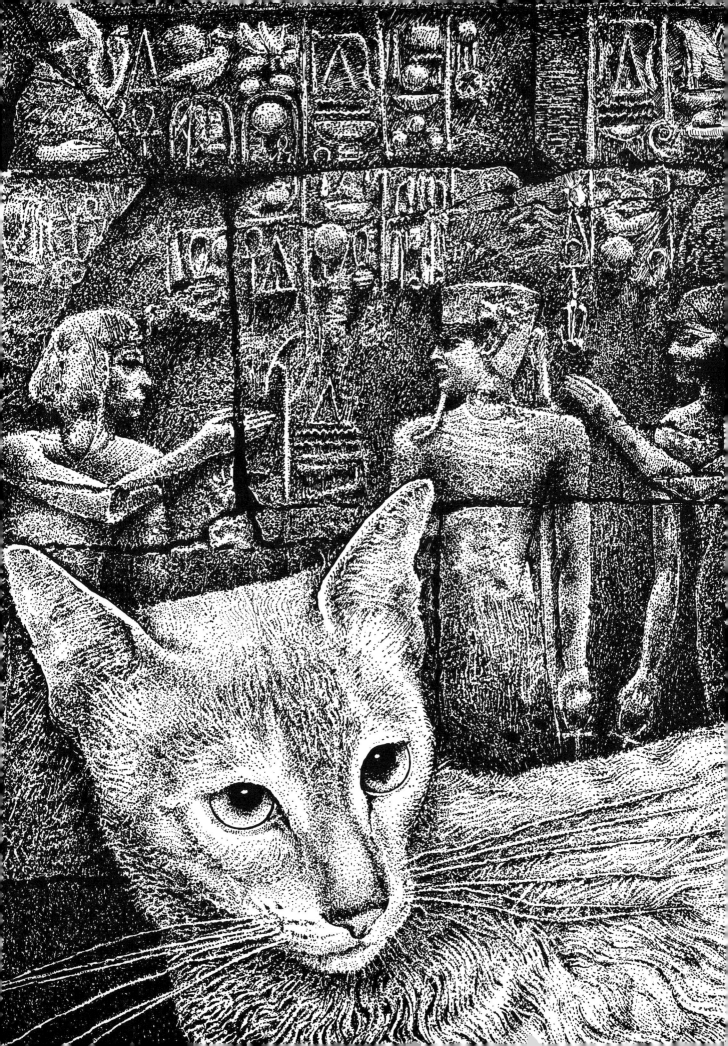

Cat and Egyptian Background

Black ink on hot press illustration board

In this drawing, I wanted to place a cat in an environment that appears natural, even though it's exotic and foreign. The hieroglyphic carvings in the background place the cat and the viewer in Egypt, so this prop tells a story and sets a mood. My approach in creating this illustration was to basically play one kind of texture against another.

I worked in a reverse technique, making the whites and high values the focal points. Although the wall is intricately detailed, it has an overall darker tone than the cat. Even the highlights on the wall are grayer than the light areas of the cat. This contrast allows the wall to visually separate from the cat and remain secondary in the overall illustration. These darker values were produced merely by stippling a fine tone across the background and subtly reducing the amount of white space showing through. This stippling is also used for rendering the tones describing the textures, details, and contours of the hieroglyphic stone wall.

In addition to being a lighter value, the cat comes forward because it's coat is rendered with a much coarser texture than the wall. The strands of the cat's fur have a contrast produced by accents of dark lines and white space, placed side by side. I used stippling to model the cat's form; however, if you look at the head, you'll notice that I stippled sparingly. This keeps the cat lighter than the background so it can visually come forward. Notice how I darkened the background in the lower left corner, which works to accentuate the contrast a little more.

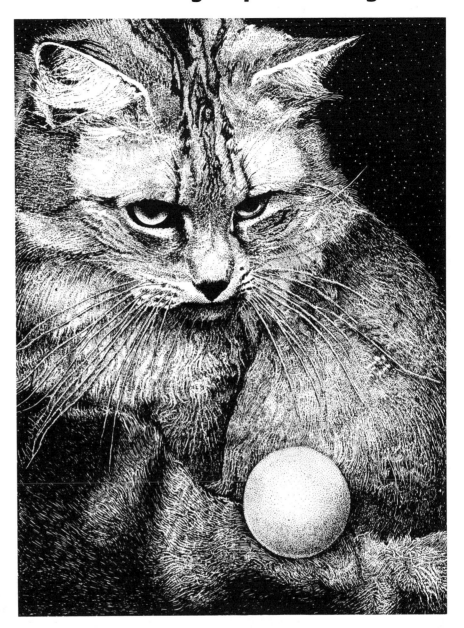

Cat with Ball

Black ink on hot press illustration board

By adding visual props to your picture, you can capitalize on the direction in which the cat's eyes are staring. In this picture, I rendered a floating ball that looks like it's been levitated by the cat's eyes. The ball, the cat, and the background enhance the depth of this picture by presenting a distinct foreground, middle-ground, and background. I accentuated this effect by rendering the background a dark, low value, the cat a middle-gray value, and the ball a high, light value. I increased this effect a step further by making the background relatively flat,

the cat textured, and the ball smooth and spherical.

Notice the various textures that represent the cat's fur. On the cat's forehead, solid black ink was used to draw the symmetrical markings. Light stippling was used to model the hair and contours just above the eyes. A combination of lines and stipple was used on the top of the head between the ears. This area is darker, more textured, and juxtaposes the primarily black focal areas and the primarily white focal areas.

Using Props and Backgrounds

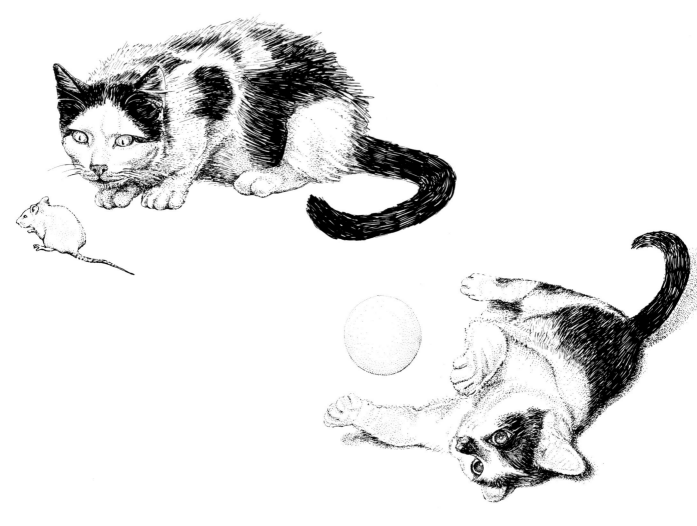

Cat with Mouse, Cat with Ball

Black ink on hot press illustration board

This illustration of a cat scrutinizing a mouse shows how you can build drama and tell a story simply by introducing an additional element, such as a mouse. When using a prop in this manner, it's usually important to create a direct relationship between the prop and the eyes of the cat. I illustrated the cat with a combination of stipple, sketchy black lines, solid black areas and white lines reversed out of the solid black areas. Notice how the sketchy lines and solid areas describe the textures of the coat and markings, while the stippling expresses the subtle tones and shading. Since the mouse is small and has relatively less texture than the cat, it is minimally rendered with a black outline and slight stippling.

The cat and ball basically follow the

same techniques as the cat and mouse. Here, the gesture and position of the cat contribute a lot to the picture. When drawing a cat with this much foreshortening, it's important to draw the shapes of the legs and other body parts accurately. This pose is unusually awkward, so extra attention must be paid to the anatomy and to the problem of foreshorting. Foreshortening is one of the most difficult aspects of drawing to excel at. The features of the cat must be somewhat distorted in order to show foreshortening, but they still must look as if they are in the proper perspective. Foreshortening requires odd angles and proportion changes. In this illustration of a cat playing on his back, the cat's foreleg and shoulder actually block out other parts of the cat's anatomy,

which, of course, makes the cat more difficult to draw than if you were looking at its profile. I've found that one of the best ways to acquire prowess as an illustrator of foreshortening is through observation. Take the time to observe your cat; see how the body shapes change when you're viewing your cat from unusual angles. Notice how the facial features of this cat are slightly altered. This distortion results from the head being pushed against the floor, and the effect of gravity on the flesh and fur of the cat's face. This effect becomes more apparent if you look at this drawing upside down.

The ball was minimally rendered with stipple, a technique which keeps it light in appearance. Lightness is appropriate here since the ball is floating in the picture.

Cats Dancing

Black ink on hot press illustration board

Sometimes cats will strike a pose that triggers the imagination. If you take the time to really observe these fascinating animals, you will find that they often assume poses that are reminiscent of activities that people engage in. The cats in this drawing aren't really dancing—they only *look* like they're dancing. I've taken the liberty here of combining the two cats in a musical relationship. The horn acts as a prop, and suggests the idea that the cats are responding to music. Two important considerations for the

drawing are to size the two cats so that the scale is correct; and to draw the cats in the same spatial plane.

Cats are often found in unusual and amusing positions, many of them suggesting human emotion or activity. To capture these positions, it's a good idea to take a series of snapshots of your cat. Use these snapshots as a way of freezing the motion. You can also pull together different shots to compose your own imaginative compositions.

Using Props and Backgrounds

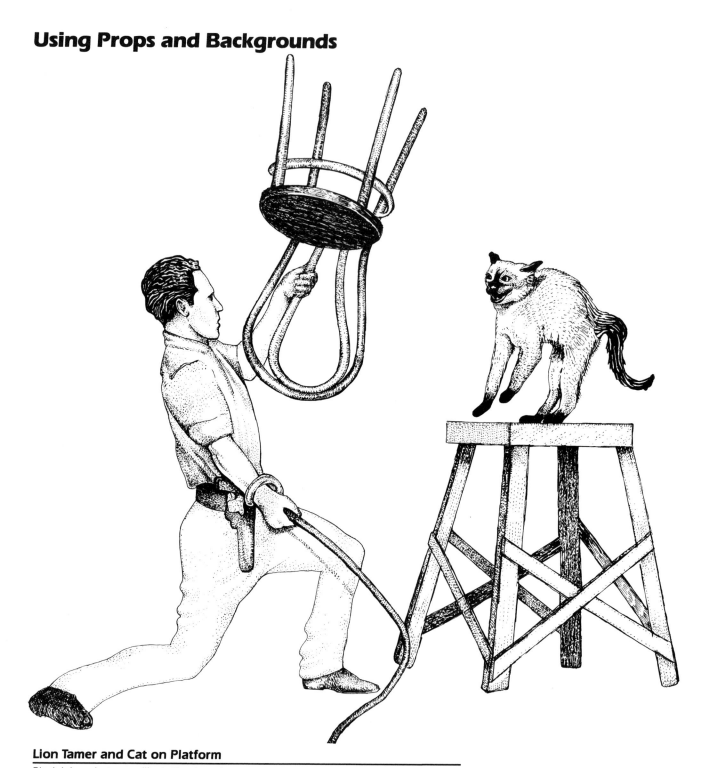

Lion Tamer and Cat on Platform

Black ink on hot press illustration board

In this drawing I was able to project a little humor by replacing the lion you would ordinarily expect to see with a cat. Actually cats do look and act like their big cousins. In this drawing, the compositional focal point will be whatever is sitting or standing on top of the platform—in this case, a Siamese cat.

I drew this cat with an arched back, rearing up on its hind legs, with a snarling face. It's the appropriate pose and gesture for this classic setting. The distant boards of the angular platform

are heavily shaded to enhance the depth and visual separation of the structure. The lion tamer, who is also a prop, is drawn in the classic pose with his own props of chair and whip. The tamer and the cat are eye to eye. Notice how the whip casts a shadow on the tamer's leg, and crosses in front of a portion of the platform. These little touches help tie the various elements of the drawing together, and add to the feeling of depth.

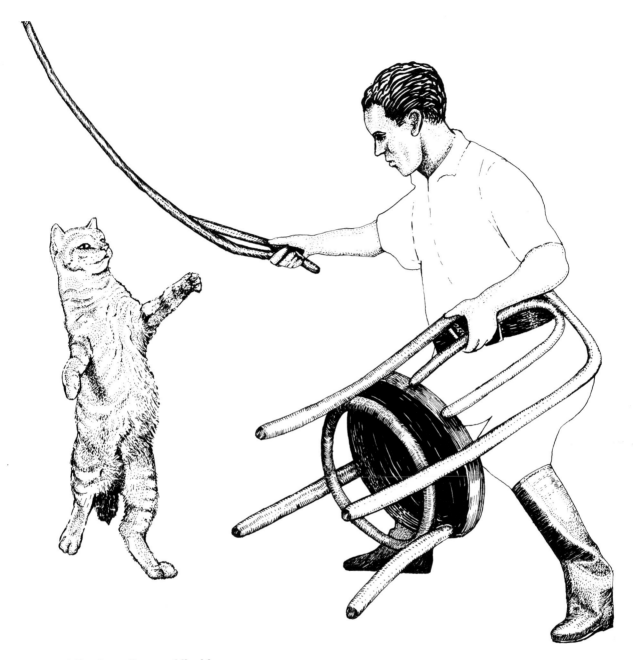

Lion Tamer and Cat Standing on Hind Legs

Black ink on hot press illustration board

There are times when you can get a cat to assume positions that can be incorporated into a picture in order to tell a story. In this continuation of the lion tamer theme, the cat has once again replaced the lion, allowing the tamer, the chair, and the whip to become effective props. The relative position and action of the two figures standing creates a visual tension that moves your attention from left to right and back again. The cat was rendered with both line and stipple. Its position is such that it interplays with lion tamer and chair. I adjusted the sizes of

lion tamer and cat so that the perspective works, and also so that the cat (which I have made larger than life-size) relates to the man better.

Because of the busy visual nature of the chair and tamer, I drew most of the tamer in simple outline. The chair makes an interesting prop; the circular seat, ringed support, and projected legs take the viewer's eye through a journey of diverse shapes and directions. Since the chair itself possesses a lot of depth, it contributes considerable perspective to the overall draw-

ing. I drew the bottom of the chair dark to act as an effective background for visually separating and pushing forward the light-valued legs and support ring of the chair. Notice the various contours and highlights rendered on the tamer's boot. These were produced by creating a range of tonal values with varying densities of line and stipple. The boot's wrinkles and the light source coming from the upper right establish the relative positions of the tones, reflections, and shadows.

SKETCHING CATS IN LINE AND TONE

Sketching in line and tone is the foundation on which advanced drawing and painting techniques are based. It's also an excellent activity for practicing and improving your hand/eye coordination, conceptual understanding, and powers of observation.

You can capture spontaneity, movement, and gesture with simple line drawings. This quick sketch technique should provide you with the shape or outline of the cat. Line drawings work as a good point of departure for further development with tone.

The demonstrations that follow in Part II all begin with a simple line drawing and are then developed with tonal techniques. When you build up your drawing with tone, your cat will gain a sense of form. Tone goes beyond line to explain light and shadow. It can be used effectively for drawing textures such as soft and fluffy cat hair. It can also be used to produce the spots, stripes, and patterns that describe the cat's markings.

When you're drawing a cat with a light-colored coat, try laying in a background tone for greater contrast. The use of tone will help you portray the personality and character of your cat. It will make your drawing more realistic and lifelike.

Line Drawings
Pencil on hot press illustration board

1. The simple sketch of this Siamese captures the gesture of a cat who has apparently been walking, and has stopped for a moment to look around. Notice the position of the feet in this common pose.

2. By the direction of his stare, and the downward slope of his body, this young tabby shorthair looks as though he's about to spring forward. Note how the use of line alone captures the markings of the tabby.

3. The sketch of this spotted tabby presents a familiar cat pose. Here, I've used the cat's markings to help explain the contours of his body.

4. You can describe a lot of gesture and movement by capturing the twists and turns of the body in a quick sketch. Note how just a few short dashes successfully indicate the cat's musculature.

5. Although this sketch is the simplest of outlines, and there are no lines describing the interior of the form, it still manages to tell the story of a cat walking at a fast pace.

Line Drawing/Tone Drawing
Pencil on hot press illustration board

The basic gesture, contour, and features of this smiling young cat *at far left* are captured through line alone. Any elaboration of technique would perhaps destroy its simple charm. However, if you want your drawing to suggest texture, form, and depth, found in the Himalayan *at near left*, then a more tonal approach is required.

1

2

3

4

5

Sketching Cats in Line and Tone

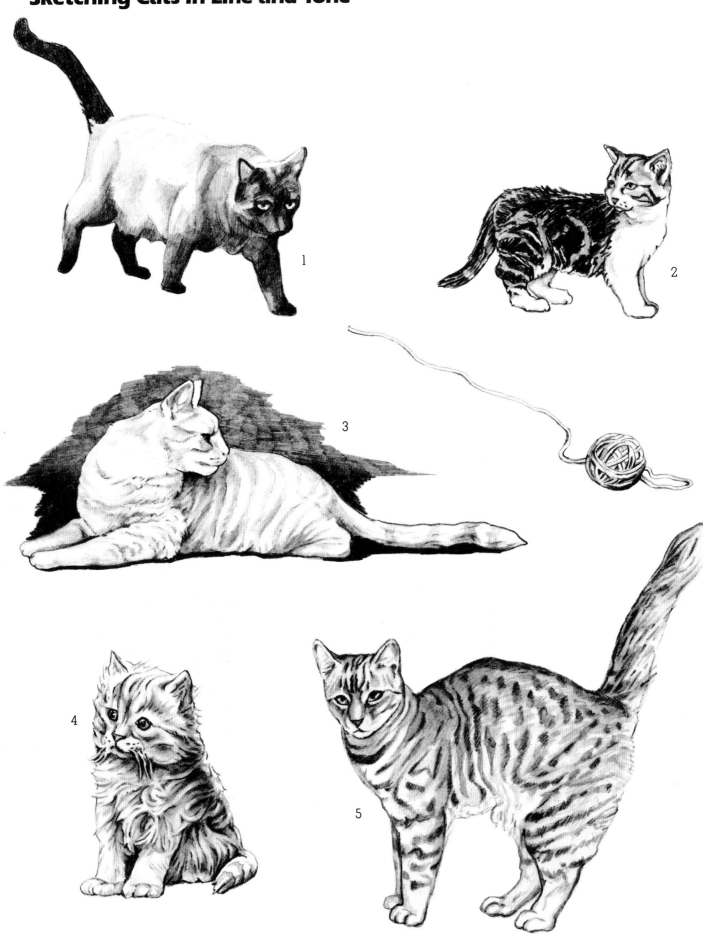

1

2

3

4

5

Tonal Drawings

Pencil on hot press illustration board

1. This drawing shows how a little pencil tone can add some dimension and form to the sketch. Since form is expressed through light and shade, the tone of the cat's surface is determined by the presence of an overhead light source, which indicates the shading that describes the various muscles. The tonal variety also explains the markings. Note that the line quality is still present in this drawing and contributes a feeling of fluid movement.

2. Pencil tone added to the sketch of this tabby-and-white kitten helps to briefly describe his markings and identify his breed. The lighter tones were sketched in with a harder H pencil; I came back to indicate the darker value markings with a soft B pencil.

3. A pencil outline captured the classic pose of this tabby, but the light-toned striped markings follow the contour of the body and thus describe the cat's form. Since this tabby has a light-colored coat, I included some background tone with softer, darker B pencils to help bring him forward.

4. In this sketch, I used a bit of light tone to describe and soften the hair of a cream long-haired kitten. The light value of an H pencil against the strands of hair indicated by the white board help to convey the idea that this is a light-colored kitten. Note the spots of darker tone used for the eyes and for the shading between the legs.

5. This spotted tabby is in a familiar pose, with his back slightly arched and his tail in the air. In this sketch I used some tone to quickly describe his spotted markings. Collectively, some of the markings create patterns that help to describe the contour of the cat's form.

Pencil Sketch

Pencil on hot press illustration board

This sketch shows the sequential evolution of an illustration in one drawing. From left to right, the hindquarters of the cat shows the initial linear sketch, describing basic shapes. Notice the directions and weights of the various lines. Each of these act as a point of reference for further development of the drawing. The basic exterior outline, which carries a major description of the cat's overall shape, is the darkest. It was drawn with an HB pencil lead. The lighter lines indicate the proper direction and placement for the tones, which will be drawn next. They were drawn with a 3H pencil. The middle area of the cat shows the early development of tonal coverage. Using a 3H pencil, I lightly sketched in tones. This step establishes contours and light/shade areas. These light tones are actually made up of sketchy lines, which are drawn to follow the contours of the cat's form.

The head of the cat shows the final stage of development. Here I came in with an H grade pencil to darken the tones and shading. I used softer B grade pencils to develop and darken the markings.

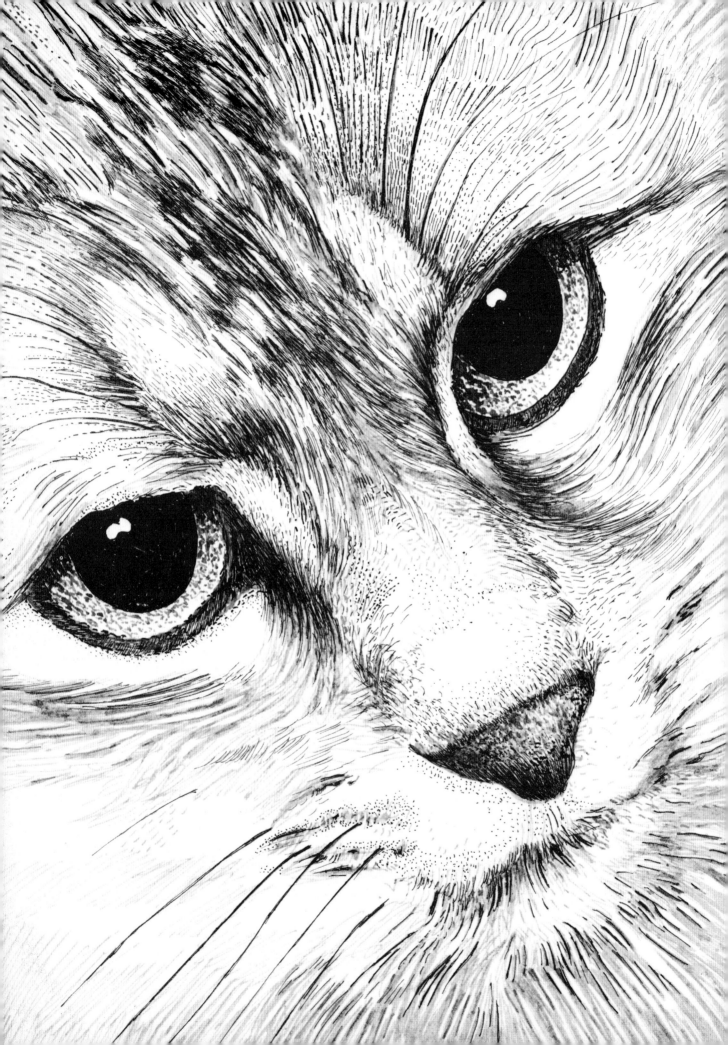

Part Two
Mastering the Media: Cats Step-by-Step

THE PENCIL MEDIUM

Pencil is a versatile medium that can be used to create quick sketches or comprehensive renderings. One of its many advantages for drawing cats is that you can get great variation in line quality: soft/hard, straight/wavy, thick/thin, sketchy/detailed. This range of lines is available to show either the sleek contours and outlines of cats or to render the textures of the cat's coat. The pencil can also produce tonal ranges that are well-suited for describing light and shade to explain the cat's form or musculature. Soft pencil tones work very well for expressing the soft, fluffy quality of the longhaired cat's hair. Because pencil is such a tonal medium, it is an excellent choice for rendering cats' eyes. When using pencil, you have a great deal of control over the subtleties and range of tone, which is ideal for expressing the glassy, smooth quality of the cat's eye.

One of the limitations of pencil for drawing cats is, of course, that it is a black-and-white medium; it doesn't give you the opportunity to work in color, and express the variety of color found in cats' eyes or coats.

Ordinary, graphite drawing pencils are the type I refer to throughout this book. They are available in a series from 1H to 6H, and 1B to 6B. The H series are the harder grade pencils. They render hard lines and light gray tones. The H grades become harder and harder as the number gets larger; 6H is the hardest, and renders the lightest tone. The B series are the softer grades. They render soft lines and dark tones. The B grades become softer and darker as the number gets larger; 6B is the softest lead and can render a black tone. A complete set of H and B pencils can be used as a palette, representing the total achromatic value range. (See scale at right.) It's a good idea to create a scale of your own from the pencils you're using as a source of visual reference.

When you render an illustration with pencils, it's important to maintain a sharp point for best results. There are a number of different sharpening devices available. The most convenient are the electric sharpeners. You can purchase these in both battery operated and plug-in models. The battery operated are quite mobile, and can easily be used in the field. The various manual sharpeners are also effective. Some artists still prefer to use a razor blade or X-Acto knife to sharpen their pencils.

In addition to sharpening the pencil, there are times when you'll only want to sharpen the lead. This is desirable for drawing

sharp details and thin lines. This procedure can also extend the life of your pencils. Small hand-held sharpeners are sold at most art supply stores. I use the artist's *sandpaper block* for this purpose. This product consists of a small pad of sandpaper sheets that are attached to a flat piece of wood. Sandpaper is an excellent tool for producing and maintaining a sharp point on your pencil leads.

When creating tones with pencil, keep the lead sharp and avoid scrubbing or digging the point into the paper's surface. If you want a darker tone, switch to a softer lead.

There are several varieties of paper surfaces available for pencil illustration: hard, soft, textured, smooth, white, tinted, etc. For the drawings in this book, I chose double-weight hot press illustration board. I prefer double-weight board because it feels substantial and can withstand a great deal of handling. Hot press means a smooth, hard surface. I find it works best for developing a sharp, clean tonal drawing.

Pencil is excellent for creating tones by blending and smearing. You can use tissue paper, your fingers, or a chamois cloth for this purpose. The *tortillion stump* is a tool which is used for smearing and blending pencil tones. It's made of a soft paper material that is rolled into a cone. The pointed end of the cone offers the advantage of controlled blending when working on the detail areas of your illustration.

In addition to eliminating portions of your drawing, an eraser can also be used for blending or softening your pencil rendering. The *kneaded eraser* works well for this because of its soft pliable consistency, somewhat similar to a piece of dough. Although this eraser comes in a small rectangular block, it can easily be squeezed into any shape for controlled erasing or blending. It's also a good tool for creating highlights, by lifting pencil tone up from rendered areas. When the exterior of the kneaded eraser gets dirty from lifting the dark pencil dust, you merely squeeze it together and pinch out a clean part to work with.

The *erasing shield* is another useful tool. It's a small metal template with various linear, round, and angular holes. This template allows the artist to control erasing. By properly positioning the shield over your drawing, you can use the eraser through one of the holes and erase only the part of the drawing you've chosen to eliminate.

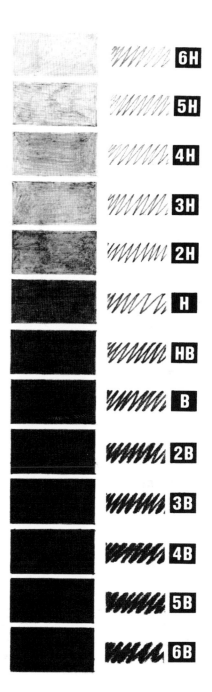

Pencil Grades

Pencil on hot press illustration board

Grades of pencil come in a range of values, from the hardest, lightest 6H to the softest, darkest 6B. Because the range of tonal values is so complete and extensive, artists can use the pencil medium much as they would a palette that offers a range of color values.

Developing Texture on a Cat's Face

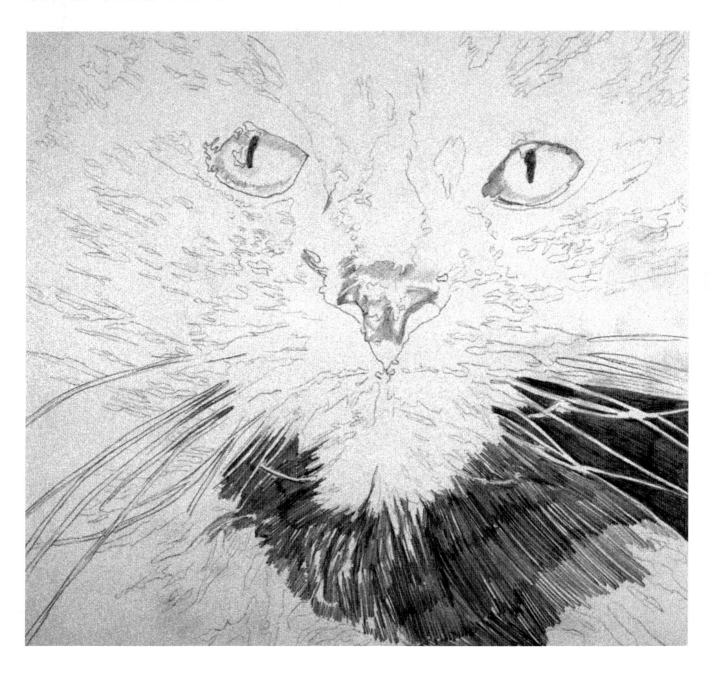

Step 1

I began this drawing of a Maine coon cat with a 5H pencil. The 5H has a relatively hard lead and renders a light gray line or tone. I lightly sketched the outline shapes of the cat's prominent features, including the eyes, nose, mouth, chin, and whiskers. The cat's markings and hair were also indicated with a minimal outline. This initial stage will act as a point of reference and the foundation for further tonal development. Note that the cat's facial expression is already established at this stage. I wanted to portray a very natural look, so that none of the features are distorted.

A 2H pencil was used to lay in the darker-value shadow under the chin. When shading in this area, I allowed a little of the white board to show through. These reversed lines represent a texture resembling strands of hair. I used an HB pencil to fill in the cat's pupils and the darker shaded areas around the edges of the eyes. I kept the pencil sharp so I could produce a crisp edge along the outline of the reversed white whiskers. The nose was lightly shaded with a 2H pencil, the pupils darkened with HB pencil.

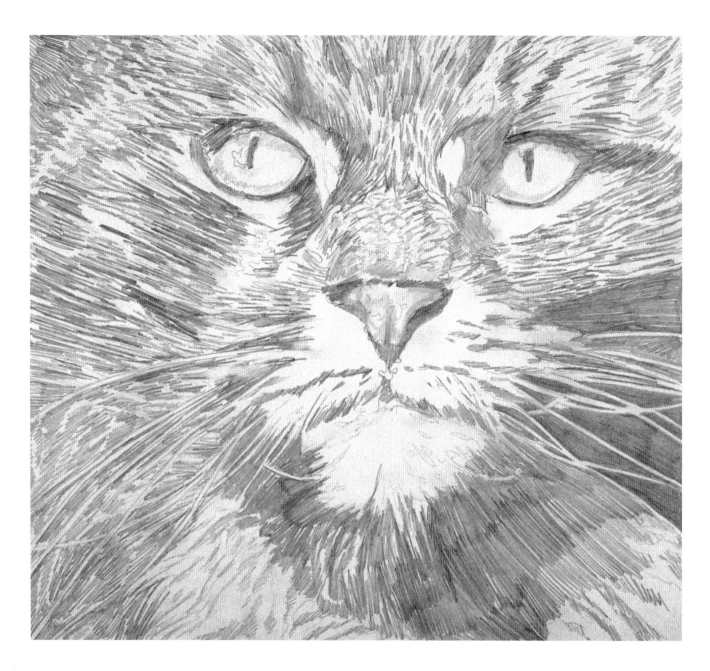

Step 2

In this second stage, I used a series of short sketchy strokes with an H pencil to draw in the cat's facial hair and markings. I kept the patterns of lines inconsistent and uneven to indicate the various textures and directions that represent the character of hair. The pencil strokes between the nose and eyes are little dashes, indicating the texture of short hair found in this area of a cat's face. On the cat's forehead, you can see how I used a range of textures and values, with patches of white board next to sketchy gray areas, next to darker areas of densely sketched lines. This area shows an example of the cat's markings. I used an H and an HB pencil to darken in the outlines of the cat's eyes and the nose. I also shaded in more on the right side, above and behind the whiskers. A 5H pencil was used to initiate the light shading on the eyeballs.

Developing Texture on a Cat's Face

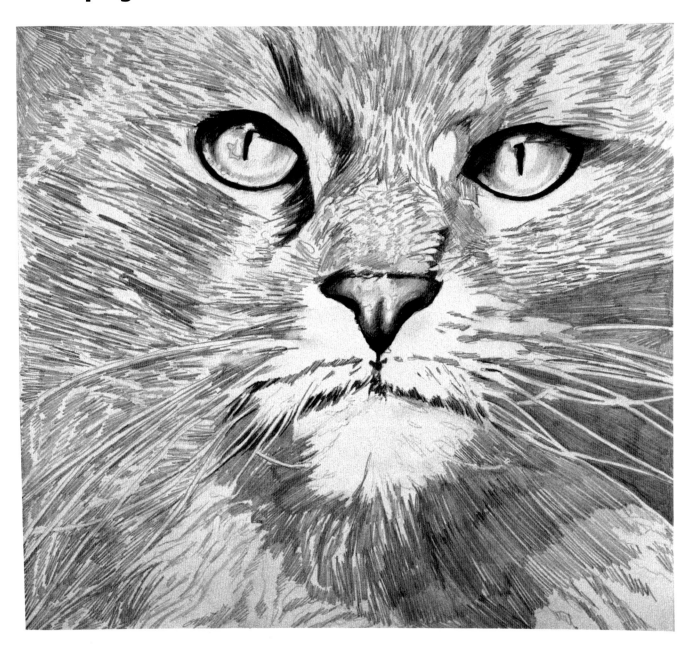

Step 3

So far, through steps 1 and 2, I've established an overall tone and texture, presenting a relatively monotone representation of the cat's features. During this stage, I've begun using a softer, darker 6B pencil to heighten contrast and introduce a wider value range to the illustration. Notice how the introduction of this dark value around the eyes, on the pupils, around the nose, and along the mouth helps the picture wake up and come to life. I used this dark value to create a wide tone across the tops of both eyeballs. This tone represents the shadow cast by the upper eyelids; and these dark areas contrast and accentuate the white highlights above the pupils. At this point, I came back with a 2H pencil to slightly darken the subtle shadows on the eyeballs.

A soft B pencil was used to begin darkening the marking above the cat's right eye. A sharp point on the pencil should be maintained at all times. When producing dark values, soft grades like the 6B wear down quickly. This means you should remember to stop along the way for frequent sharpening.

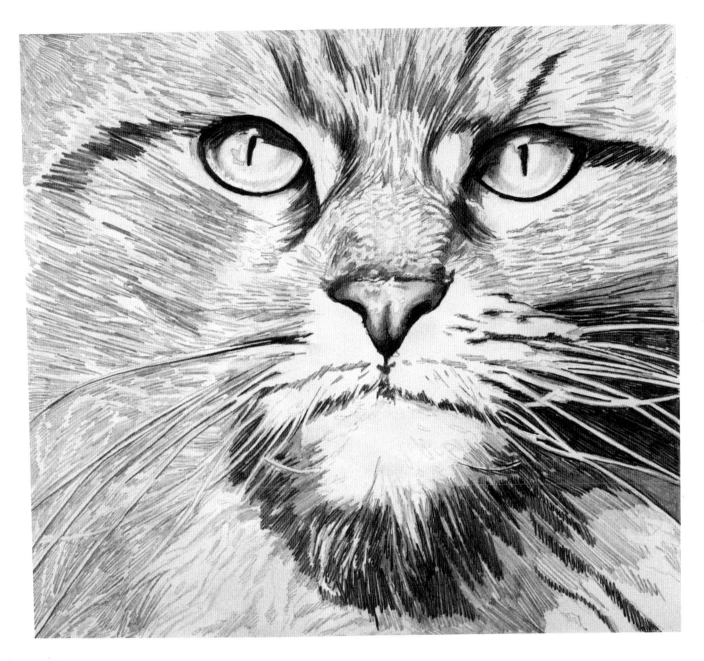

Step 4

In this stage I used a B pencil to continue defining and darkening the markings above and around the eyes. I also added tone to the areas to the right and under the chin. After darkening these areas with a B pencil, I returned with a softer 3B pencil to render portions of these areas even darker. This is particularly evident behind the whiskers and under the chin. In the area under the chin I allowed some of the white board and some of the lighter gray tones to peek through the dark 3B pencil shadows. This technique offers a greater range and texture to the drawing. I used an HB pencil to add a little modeling to the nose.

Developing Texture on a Cat's Face

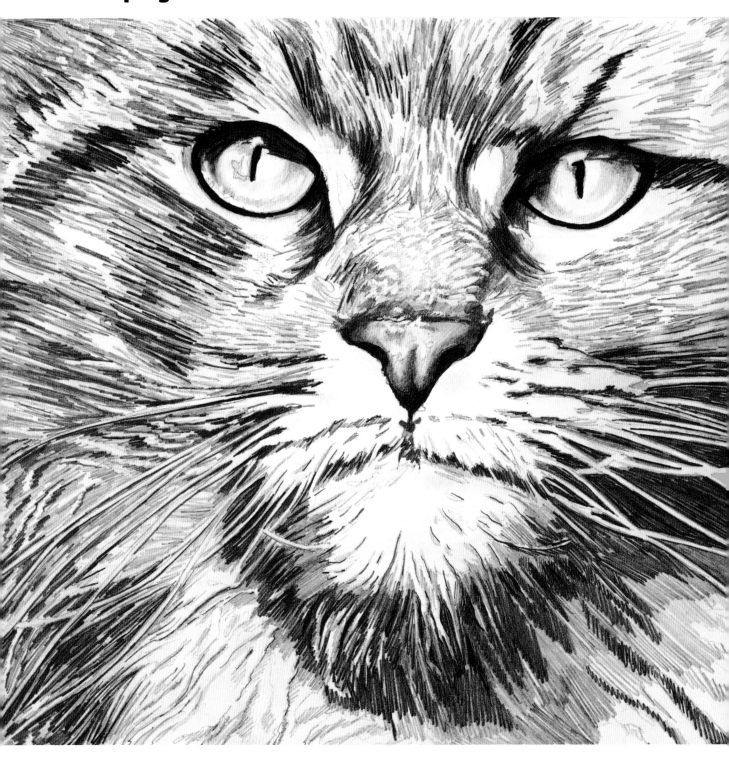

Step 5

In this final stage, I used a 2B pencil for adding dark accents to the right side of the cat's face. These dark accents add contrast and make this area look more like strands of hair. They also help to define the cat's markings. Notice how I used straight lines to indicate the hair on the cat's face, but I used wavy lines to represent the thicker, longer hair on the cat's neck. These wavy lines are further complemented by the straight, overlapping whiskers.

Rendering the Soft Textures of a Long-haired Cat

Step 1

I started this illustration of a Persian by lightly drawing the outline, shapes, and features with a 5H pencil. Loose, sketchy lines were used to capture the gesture of the cat's pose. Notice how the various directions of the cat's anatomy make the viewer's eye move about. The head is turned, the legs are facing front, the back and hips are at a three-quarter angle, and the tail curves into the background.

Drawing an agile pose such as this presents a distinct trait which is characteristic of cats. I also used the 5H pencil to render the light subtle tones that suggest the early development of form. I came back with a slightly darker 3H pencil to shade and accentuate various parts and features such as under the chin, between the leg and hip, and the eyes.

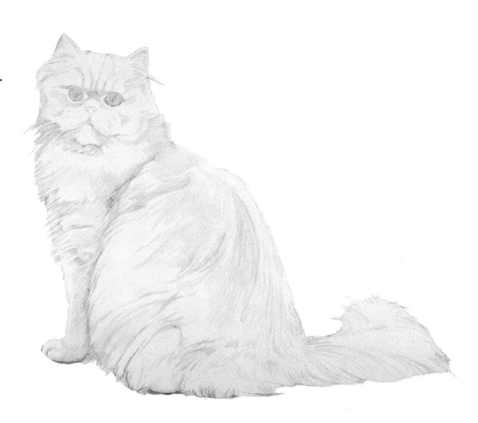

Step 2

In this second stage, I continued developing the form and texture of the cat's coat. A 3H pencil was used to produce a curved light and dark tone on the cat's back. I made the tone darker and wider at the top, where more shading is apparent; and gradually lighter and thinner at the bottom, where more white of the board shows through. This technique produces an appearance of strands of soft hair. The graduated shading produces a broad area of light and shading on the cat's side, which gives form to the body.

I also used the 3H pencil to add tone to the shoulder and front leg. A softer H pencil was used for slightly darker accents on the mouth, under the chin, under the foot, on the leg, and between some of the hair strands. Notice how the shaded area of the leg acts as a dark background to contrast and accentuate the hair of the cat's back.

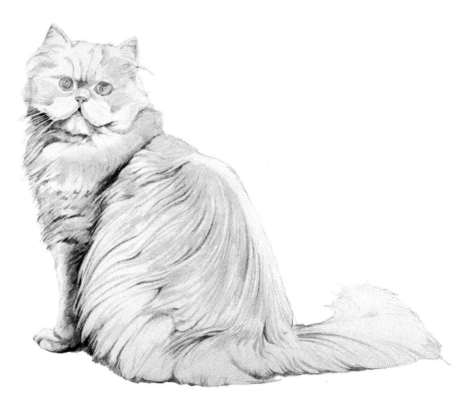

Rendering the Soft Textures of a Long-haired Cat

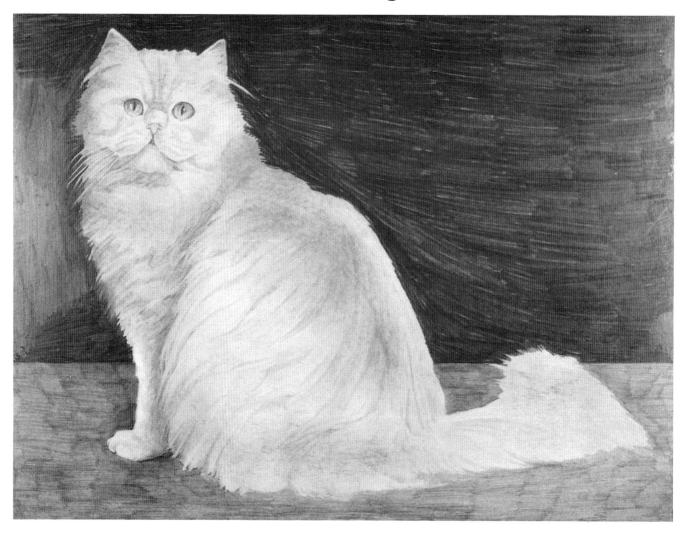

Step 3

In this stage I've used a B pencil to darken in the background. I applied the tone with sketchy horizontal strokes. After covering the background with this tone, I came back with a soft dark 6B pencil, and working over the previous tone, I made the background even darker. I applied this tone with sketchy horizontal strokes also. This technique produced a textured background in which you can see traces of lighter gray and white peeking through.

I shaded the foreground with small strokes from a 2H pencil. Collectively, the ground and background create a horizon line. They also accentuate the cat's shape and produce a reversed effect, which allows the light value cat to come forward.

I used a 4B pencil to produce the pupils, allowing specks of white board to remain as highlights. In preparation for the next stage, I used my finger to smear and blend a fine gray tone across the cat's face, shoulder, back, and tail.

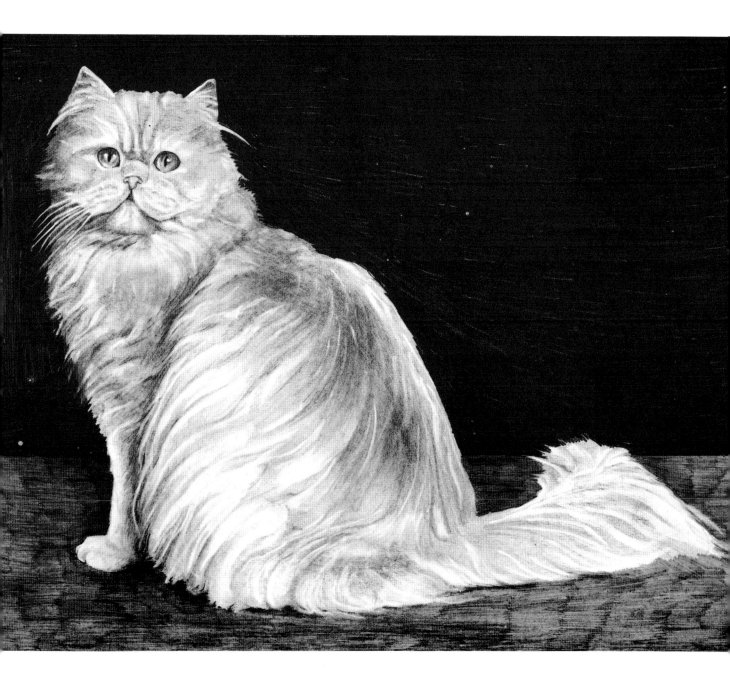

Step 4

In this last stage, I used a kneaded
eraser to create reversed highlights
out of the fine gray tone (previously
produced from smearing the pencil).

By pinching the kneaded eraser,
you can manipulate its shape into a
point or an edge, which is ideal for a
controlled lifting of tone. The eraser
can produce a highlight with soft
edges that is perfect for rendering
fluffy hair. Notice that the eraser not
only creates lighter lights on the cat's
back, but that it also creates a height-
ened contrast, which makes the darks
appear darker.

PEN AND BLACK INK

Black ink can produce a solid black value, lines with crisp, dark edges, and interesting textural effects. The solid black ink on white paper offers a maximum value range to work within. It can also produce dynamic graphic images when solid blacks and whites are used together, a quality that can add drama to a cat illustration. The ability to produce lines with crisp edges produces distinct features; the use of collective ink lines and dots gives great textures for rendering the cat's fur. If pens with different size tips are used, a great variety of effects is possible, ranging from the fine small dots used for rendering the smooth surface of a cat's eye to the bold strokes that indicate the cat's form.

When working with black ink, I like using a mechanical drawing pen. These pens are convenient and clean to use because they have refillable ink cartridges. Mechanical drawing pens come with various size tips, each of which produces a specific line weight. The ultra-thin or size 6×0 tip is ideal for illustrating fine detail. The thicker tips work well for filling in solid areas. I produce most of my drawings with the size 0 tip because I find it offers me the versatility for producing fine lines, as well as solid areas. The size of the tip you choose depends a great deal on the dimensions of your drawing. If you're working on a large piece, a mid-sized tip could appear relatively thin. If you're working on a small illustration, the same mid-sized tip could work relatively well for inking in solid areas.

When working with a mechanical pen, you should use the easy flow non-clogging inks that are made especially for these pens. This ink is available in a special bottle with a handy spout for easy filling.

Line Widths

Mechanical pen line widths come in 13 sizes, ranging from the very thinnest 6×0 to the thickest size 7. Sizes 0 and 1 are considered by many artists to be the most versatile.

Although you can use these pens on a diversity of paper surfaces, it is best to work on a relatively smooth surface. I prefer double-weight hot press illustration board. The ink flows well on its smooth surface, and it's sturdy enough to be handled a lot.

Black ink used with a pen produces line art imagery. The term "line art" in the world of printing refers to imagery that is strictly black and white. All gray tones produced in the line art technique are actually a combination of dots, lines, or dashes. These dots, lines, or dashes are combined into patterns that give the visual appearance of gray tones. The dot density, or amount of space between the dots, is one way to regulate the ultimate gray appearance of their combined pattern. The size of the dots is another variable. In the world of printing, this effect is produced mechanically and the dot patterns are called screens. Although the samples shown here were produced mechanically, they can act as an excellent reference for the artist. Notice how the light value at the top appears as tiny black dots on a white background, and how the dark value at bottom appears as tiny white dots on a black background. As an artist, you can emulate these effects and produce a variety of tones. If you look closely at reproduced images, you can see how the dot patterns work; it's a very good visual lesson in how descriptive and intricate your drawing can be just by placing different dot densities and sizes in varying distances and relationships to each other. Once you have studied these dot patterns, you can then start applying them manually to your drawings of cats.

Mechanical Line Art

This bar of mechanically created dots contains gradations of dot densities that illustrate the way in which dots can represent the various tones of gray. The seven squares of differing dot densities are a good example of the precision that can be achieved with mechanical dots. They are a good visual reference of the range of grays available by simply varying the dot distribution in a given area. Notice that in the lightest square the dots read as black on a white field; but that as the squares progressively fill up with more and more ink, the dark predominates and the dots read as white on a black field.

Pen and Black Ink

Abstract Ink Drawings

Black ink on hot press illustration board

The top ink panel illustration is an enlargement of the sky/background area of the drawing that appears on page 127. It is an example of how the line art technique of varying dot densities can be applied manually in a looser, more artistic fashion. Here, dots are used not only to create different tones of light and dark, but also to create shapes and textures.

In the bottom panel, which was taken from the chin and neck area of the cat shown on page 124, a linear technique was used to suggest the texture of a cat's fur—the individual strands of hair that make up the cat's coat. By using a variety of line in this drawing—straight/curved, dots/dashes/long strokes—a great deal of textural variation has been created. In both these panels, it is important to remember that all the effects were achieved by the application of black ink to a white surface. The character of your drawing can be changed just by the amount of dots and their relationship to each other.

Building Form
Through Tonal Variation

Step 1

When starting your ink illustration of
this Burmese cat, lay out the pose and
shape of the cat with a light pencil
sketch. A 2H to 5H pencil works well
for this because it renders a light gray
contour line. Remember to use light
pressure. You don't want the pencil
lead digging into the paper's surface,
and you want to retain the ability to
erase portions later on. Choose the
size pen you desire. I used a size 0
mechanical drawing pen throughout
this illustration. Create a light dotted
line around all the important shapes of
the cat's features. This will establish

the basics of the illustration and offer a
point of reference for further develop-
ment.

Once you have recorded the shapes
and gesture of the cat, begin identify-
ing the various planes that represent
the contours of the cat's form, such as
the outline of the hindquarters and the
various shapes of the legs and feet.
Use a stippling technique by produc-
ing multiple dot patterns. At this stage,
keep the dot patterns simple, flat, and
light in value. Always work from gen-
eral to specific by stippling in the
larger planes first.

Building Form through Tonal Variation

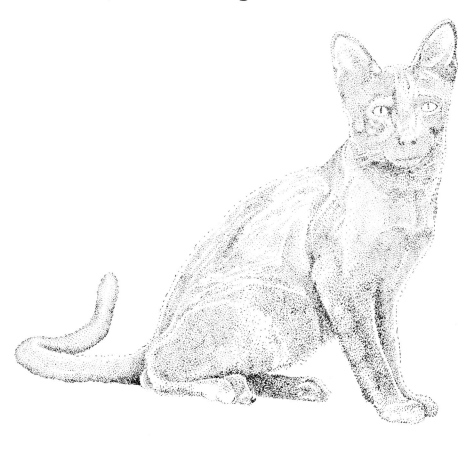

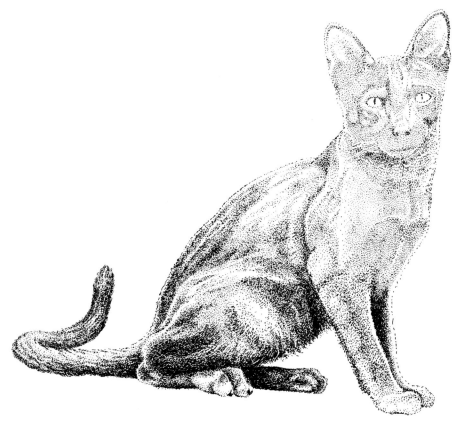

Step 2

Continue developing the stipple dot patterns until you have created a light tone across the surface of the entire cat. The purpose of this stage is to establish the basic contours and form of the cat. You can allow for the effects of light by regulating the relationship of the plain white board to the dotted areas. For example, notice the vertical highlight running up the right side of the front leg. This white area of the board's surface stands out because it's contrasted by stippled tone on both sides. Its prominence is important because it not only helps describe form, it also creates a necessary separation between the two front legs.

The other relationships of tone and white board are more subtle. Most of these areas will provide an undercoat for further development. Note how the subtle tones fading to the white of the board explain the musculature and contour of the cat's body. Some of these tones will be darkened and developed more fully later on; some will act as subtle transitional tones between the white board and the darker development yet to come; and some areas will appear in the final stage just as they are now. These areas will not be rendered further and later on will act as important visual bridges between the more developed darker tones and the lightest tones.

Step 3

Once we establish an overview of the basic tones and contours, we can better see how and where to proceed with the final stage of development. We now begin selecting areas for the application of darker, denser dot patterns. We also add solid black accents here and there as finishing touches. This stage introduces textures to the drawing. Notice how the addition of texture describes the hairy surface of the cat's tail. Adding darker areas creates a wider value range. This range intensifies the highlights and increases the development of form. The addition of darker tones on the rear leg and hip have produced a more solid, three-dimensional form. Dark tones and solids also complete the description of details and features. The dark tones are used to explain the character of the back foot, and the use of small solid accents indicate the toenails.

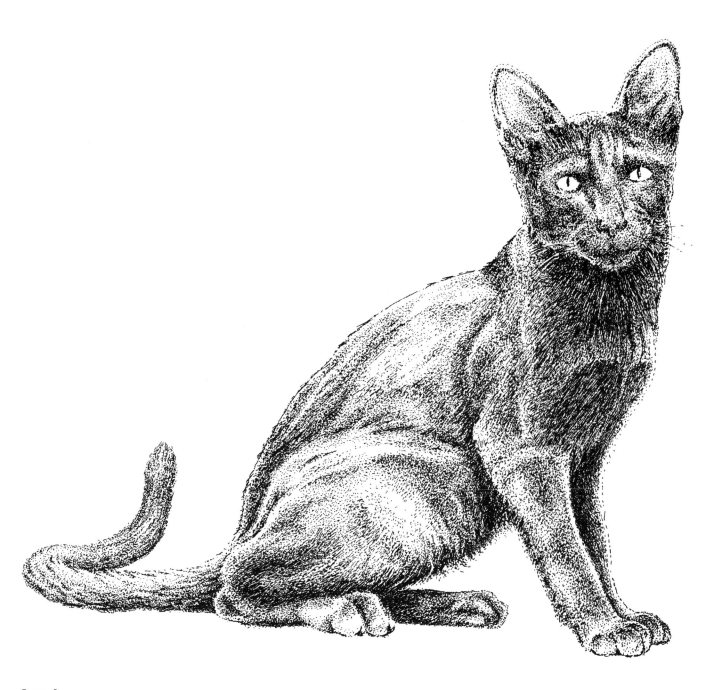

Step 4

The finished illustration shows us how all the various stages of tonal development culminate. If you study this picture, you can isolate and observe the earlier stages of development in various parts of the drawing. Notice how the increased development of the final stage produced different textures. On the front of the hip, I accentuated a few strands of longer hair. I accomplished this by allowing some of the lightly stippled underdrawing to show through and adding short dashes over the dots. The highlights, which are enhanced by a variety of tones, not only describes the cat's form, but also come across as the reflective sheen of the cat's coat. The final dark accents also serve the important purpose of separating and defining the cat's features. Notice the dark accents separating the chin and the neck, the front legs, the back feet, and the hip from the body.

Building Form through Tonal Variation

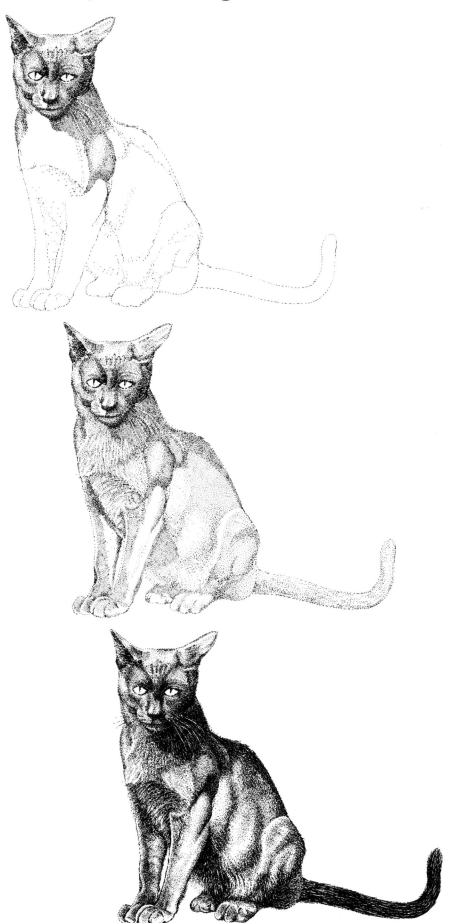

Step 1

Although the process of developing this Havana cat is quite similar to the Burmese, I've included it here to show you a slightly different approach to capturing the form of the shorthaired cat. Here, the tonal areas are seen very distinctly and evolve almost in a puzzle like fashion to a final, tonally integrated image.

After laying out the shapes, gesture, and reference points with stipple, begin identifying and creating the contours and form with light tones. Use lightly stippled dot patterns to indicate these areas.

Step 2

Continue developing the stipple dot patterns until you have created a light tone across the entire cat. Notice how I have produced a variety of tones and textures by varying the application of dots in the different areas. For example, the stipple dots in the chest area assume a direction and pattern that appear as strands of hair running downward, until they meet a change of body contour. At which point, the dot patterns change to a concave, horizontal direction. In the neck area, the patterns assume light and dark areas because of the relative density of the dots applied; these variations explain the anatomy and contour of the cat's neck. The front legs are only partially rendered with dots, which shows their form as revealed by light and shadow. The open dot pattern of the cat's belly indicates soft hair and loose folds of flesh. If you look at the surface of the tail, you will note that it has a series of lines composed of dots, which give the impression of long groups of hair following the direction of the tail.

Step 3

In this final stage, use dark tones composed of denser dot patterns and solid blacks to further describe the cat's form and features, and to make more subtle transitions from one area to another. This builds and darkens the contrast and description of the cat's coat. In this drawing, the use of a direct light source has helped in rendering the form and contours.

Creating Texture with Stipple, Line, and Pattern

Step 1

This illustration of a longhaired Angora is initiated by producing a simple pencil sketch. As in the previous demonstrations, try to capture the basic shapes and gesture, using the faint pencil lines as a guide for inking in a light, stippled outline. Stipple in reference points to indicate the placement of tones for later development; then begin stippling in dot patterns to describe the basic tones and contours.

Unlike the short-haired Burmese and Havana, this cat has long hair. Successfully representing its appearance depends a lot on the presentation of its coat, rather than on the underlying musculature. In this initial stage of the development, notice how I've begun rendering the cat's hair. The hair on its face is short. Here, I used a minimal stippling, allowing a lot of white board to show through. On the neck and chest, I've used a stipple technique to produce a pattern of wavy lines. These lines create a pattern of reverse white strands which appear as thick tufts around the cat's neck.

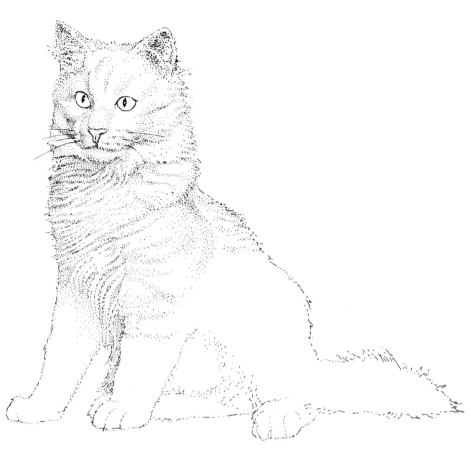

Step 2

Because the cat in this drawing is white, extra care must be taken in the use and development of dark tones. When illustrating a white cat, unless there's a direct light source causing dark shadows—where areas can be differentiated with light and shading—most development must consist of lines, light stippling, and well-placed dark accents.

In this drawing, I concentrated on the rendering of short hair versus long hair. I used wavy, stippled lines to produce a shaggy outline on the back of the legs, the head, neck, back, and tail. The bits and pieces of straight and untextured lines on the front of the legs, toes, nose, eyes, etc., work as important elements for complementing and balancing the soft textures in the drawing. I allowed the long shaggy hair of the ears, neck, chest, tail, and hip to disappear and overlap into the short-haired areas. The bushy tail was developed by stippling in a series of curved lines that radiate from a central point.

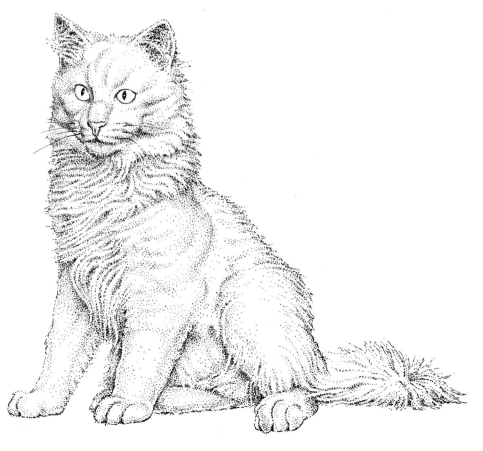

PEN AND COLORED INK

Colored ink can produce lines with crisp edges. It can also offer varieties of stipple, dashes, lines, and solids. These combinations are excellent for rendering the diverse textures of the cat's coat. By changing pen tips you can produce a range of dot and line sizes allowing you to portray coarse hair or glassy eyes. This medium provides a multitude of colors which can be visually mixed through the placement of various combinations.

As opposed to watercolor and pencil, colored ink has limitations when it comes to producing transparent or subtle tones. It is also limited to relatively small pictures; because of the size of the dots and lines, it takes considerable time to develop an area.

When drawing with colored inks, you can use mechanical drawing pens; however, these pens are relatively expensive. If you're using a variety of colors, you would need a pen for each color and it could be quite costly. The alternative is a pen holder with the interchangeable crowquill pen tips. With this approach, you can either wipe the tip clean with a tissue in between the change to different colored inks, or use a different tip for each color. With crowquill pens, you have to keep dipping the tip in the bottle as opposed to the convenience of a refillable cartridge; but the cost is less than ten percent than that of the mechanical pen.

When I work in colored inks, I use only a few mechanical pens for the colors that are predominant in my illustration; I use crowquills for all the other colors. Color inks are available in both transparent and opaque colors. The transparent inks come in many more colors than the opaque inks, but transparent inks are subject to fading.

Although mixing can be achieved by combining different color inks in a bottle, I prefer the technique of visually mixing colors through proper placement in the drawing. For example, dashes of yellow ink placed next to dots of red ink create a visual mixture of orange.

For best results, apply ink to a smooth surface. I prefer hot press illustration board because it is durable and the ink flows well on its surface. As I develop the illustration, by slowly covering the board with ink, I save portions of the white surface to represent the light values in my drawing.

Working with colored ink is similar to working with black ink. With colored ink, however, in addition to considering the value ranges, color relationships and intensity also become factors. When working with color, simultaneous contrast (how a color's appearance is affected by other surrounding colors) plays a major role. If there are any colors you are sure you want to use, apply them in the early stages of your drawing for they will dictate the relativity of your color scheme. It is a good idea to initiate your drawing with a light neutral color, such as gray or a pale sienna. This approach allows the artist to lay in lines and tones that can easily be worked over with other colors.

The technique for working with color inks is similar to working with markers. Pen tips produce a much finer, sharper line than markers; therefore color inks offer a more intricate and controlled result. The best way to become acquainted with color inks it to play with them and not think about a final product or drawing.

Transparent Drawing Inks

Scarlet

Carmine

Vermilion

Orange

Yellow

Light Green

Deep Green

Cobalt Blue

Ultramarine

Prussian Blue

Red Violet

Blue Violet

Sienna

Burnt Sienna

Sepia

Gray

Black India

White

Opaque Drawing Inks

Black

Red

Yellow

Green

Blue

Violet

Brown

Opaque and Transparent Colored Inks

Colored inks are available in both opaque and transparent colors. The opaque inks come in a limited palette; they are pigment-based rather than dye-based, which is what makes them opaque. Of the colored ink drawings presented in this book, all were done with transparent inks, with the exception of the abstract sketch on the following page.

Pen and Colored Ink

Abstract Sketch
Opaque colored ink on hot press illustration board

Here's an example of an abstract sketch produced with opaque colored inks that I made while getting acquainted with this medium. I tried producing a variety of lines, textures, color combinations, reversed effects, shapes, dot densities, and movement. It was fun and uninhibited because I wasn't concerned with drawing anything realistically; I just wanted to experiment and get acquainted with the medium. You will note that while this particular drawing was not meant to convey a realistic image, its abstract shapes and textures could also be used for creating realistic textures, such as the patterns that make up a cat's fur or an interesting background area.

Achieving Color Balance

Step 1

I began this portrait of an Abyssinian by creating a light pencil sketch, indicating the basic shape and features of the cat's face. I used a 4H pencil to produce a light, thin line. For the next step, I used a size 0 mechanical drawing pen with sienna ink to produce the preliminary texture and coloring of the cat's hair. I created a textured pattern by spacing little solid squiggles of solidly colored ink. I drew these marks in groups, moving in various directions to help explain the markings and contours of the cat's face. I used gray ink to initiate the markings around the cat's eyes; a combination of scarlet and gray stippling on the nose; and some black ink for the outline of the pupils.

Step 2

In this next stage of development, I've brought the cat forward by laying in a cool stippled background of cobalt blue. The general warm coloring of the Abyssinian is typical of this breed. Therefore, my choice of blue for the background was a desire to produce a cool surrounding which would recede and complement the warm colors of the cat. The added background also defines the cat's shape by creating a color difference and contrast along the outline border of the cat.

I varied the color density and value of the background by adding a preponderance of stippled dots on the upper right side and lower left of the picture. This variation makes the background more interesting, and the lighter area in the upper left leaves room for the inclusion of an additional color.

I darkened the color of the cat's fur by applying pen strokes of burnt sienna over the previously applied raw sienna markings. I used gray ink to begin the further development of coloring and contrasting the hair. I also used gray ink to define the outline of the eyes.

Yellow and green have been added to the eyes to brighten their coloring another step. I used a few strokes of scarlet and gray to establish the coloring of the ears. I like to develop the picture gradually by indicating portions of areas and seeing how they look.

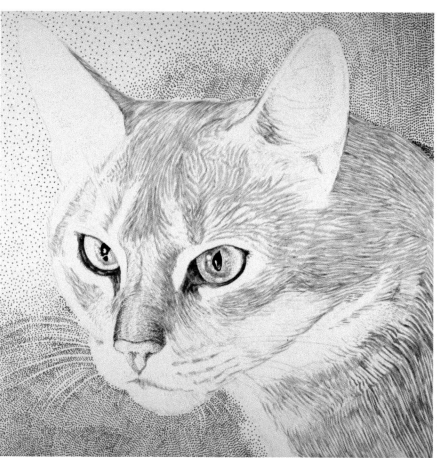

Achieving Color Balance

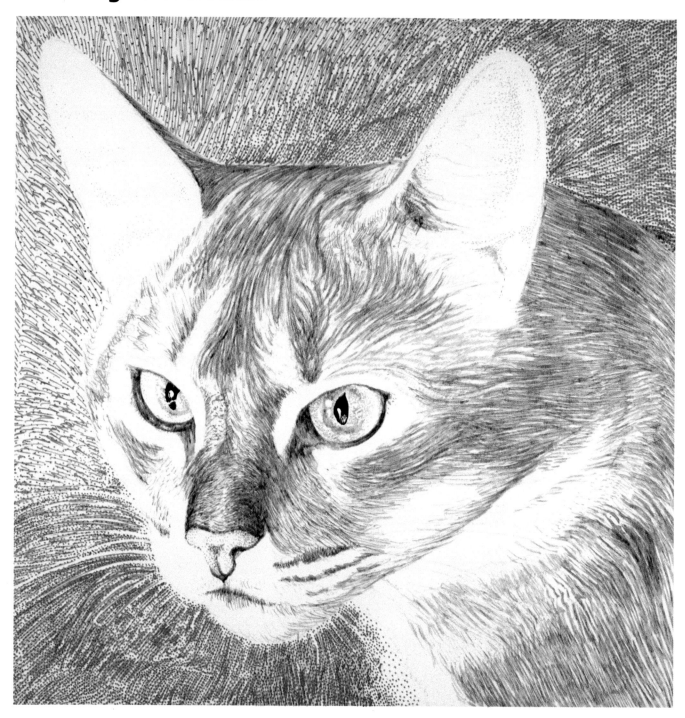

Step 3

In this stage, I've covered the background with a series of little lines, radiating in a direction away from the cat, using cobalt blue ink. Now the background is darker, creating even more contrast by color and value. The texture of the background has changed also; it's now a combination of lines and dots. You can see at the bottom, under the cat's chin, how I've begun adding a little light green ink. Once again, I'm testing to see how the inclusion of this color might look for the entire background. I've also used this stage to develop and darken the hair of the cat. I've applied gray ink over and next to the sienna markings. The gray ink adds solidity and accentuates the shape and direction of the markings.

Actually, I think the drawing has taken on an unattractive look during this stage. I have established some of the dark levels with the gray ink, but now the illustration desperately needs some strong chromatics to bring it back into balance.

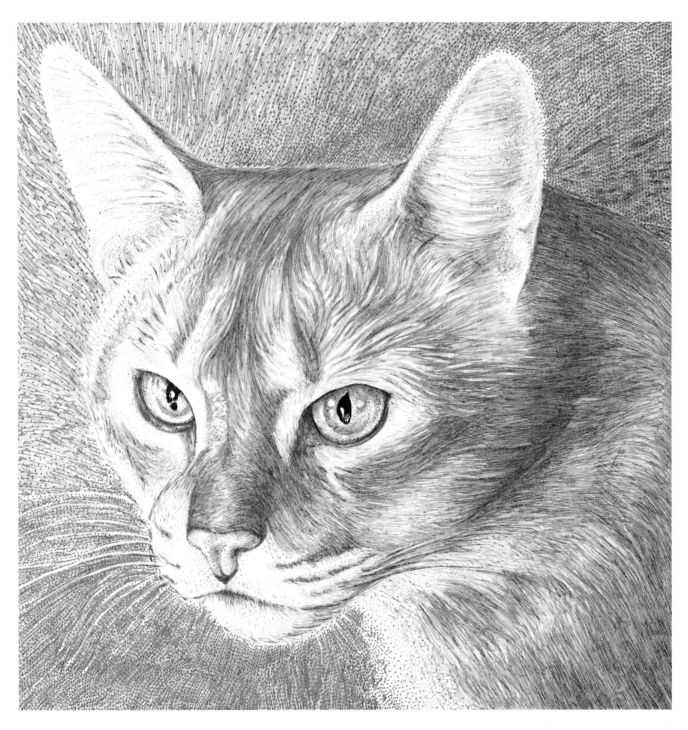

Step 4

In this final stage of development, I've added light green ink to all of the background. Green is slightly warmer than blue. I added green to the blue background to make it a little warmer and less distant chromatically from the cat. The addition of a second color also gives the background and the overall picture a richer look.

Purple accents were introduced at this stage for the same reason that I added the green: the purple and green of the background, together

with the orange color of the cat, produce a triad of balanced colors—which again gives the overall drawing a fuller chromatic effect. I've also included accents of sienna in order to carry a touch of the cat's coloring into its surroundings. Notice how the darkened background accentuates the cat's white reversed whiskers. All of the whites are the board's surface showing through.

Generous amounts of burnt sienna ink have filled in and balanced out the

dark grays that were applied in step 3. I've also added more green and yellow to the eyes, scarlet to the nose, and gray to the ears. As a finishing touch, I darkened the mouth and the outline of the eyes.

Notice how the development of the hair in some areas, such as the area above the cat's left eye, includes several different colors and values. This effect is accomplished by developing the area layer by layer. The technique is similar to painting layered washes.

Developing Contrast with Color and Value

Step 1

With this illustration, I wanted to show that dramatic moment when a cat peeks around a corner and discovers a bulldog with a spiked collar. The drawing was initiated by composing the picture so that it reads from left to right. I wanted the bulldog to look larger than the cat. I chose bricks for the wall because they provide an interesting color and texture. The cement that's between the bricks offer a series of horizontal lines. These lines help the overall design by comple-

menting the predominantly vertical breakage of space caused by the dog, cat, and corner of the wall. I cropped the dog, cat, and wall so that you see only what's necessary for their interplay to visually communicate.

I started the illustration by sketching the important shapes and reference points with pencil. After I got the drawing sketched out as you see it here, I went back with a kneaded eraser and lightened all the lines before proceeding with ink.

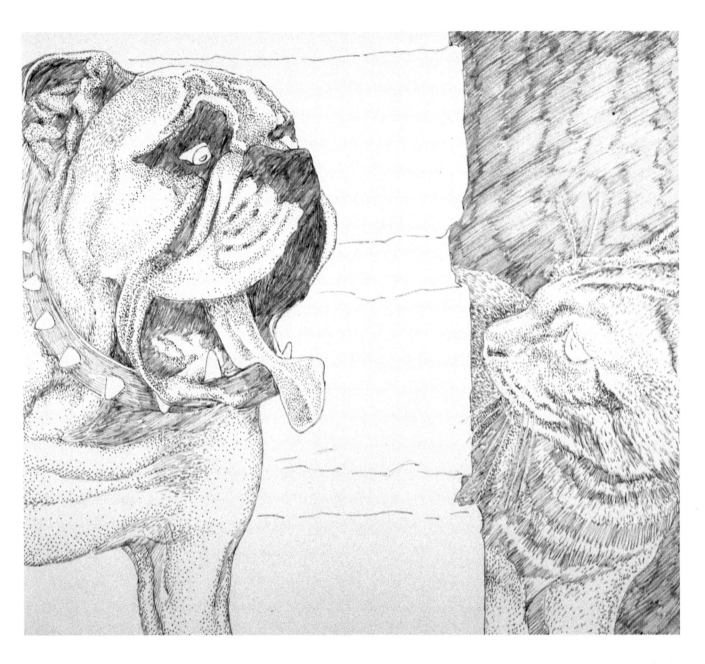

Step 2

After laying out the basic outline with pencil, I began developing the early stages of tone. In this stage of the drawing, I used a size 0 mechanical drawing pen with transparent gray ink. I chose gray because it's neutral in color and light enough to work over in the later stages. The neutrality of the gray makes it ideal for using as a base color throughout the picture. Any additional color I may add will not contrast with gray. I used a combination of stippling and lines to create the various tones and textures. The values

were kept relatively light, so I would have the latitude to add more color and rendering at a later time.

I used the gray ink to establish the preliminary levels of darks and lights on the dog. I achieved this by varying the densities of ink coverage. Notice the light value on the dog's cheek, mid-range on the dog's forehead, and dark on the dog's nose. This procedure will produce a very helpful series of reference points during the later stages of development.

Developing Contrast with Color and Value

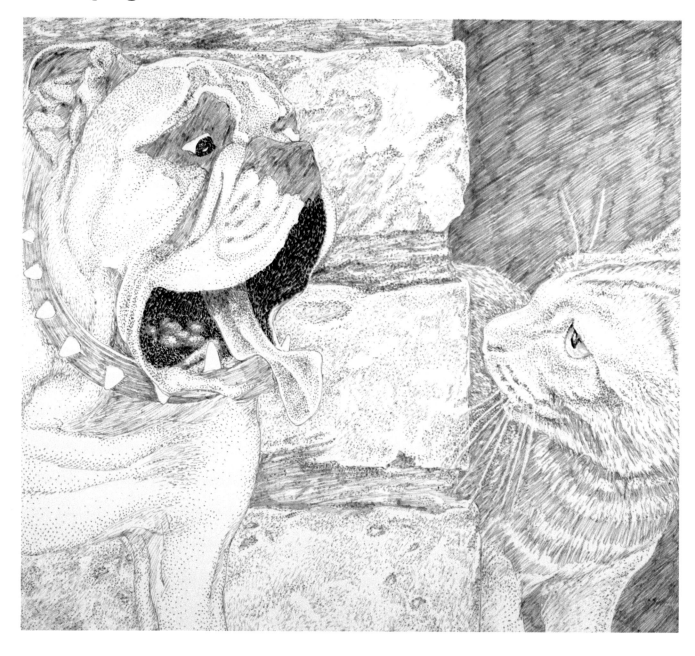

Step 3

In this stage of the development, I continue using mechanical drawing pens to add color to the illustration: sienna for the cat's coat, a mixture of yellow and light green for the eye; and sepia for the dog's nose and around the eye. As the development continues, the placement of additional ink becomes critical. When ink is added, the placement should contribute to the development of form and texture as well as the coloring. Re-

member that each time you add ink to the illustration, you're losing the white of the board, and the overall picture keeps getting darker.

In this stage, you can see how I started establishing a warm/cool balance as the picture moves from achromatic to chromatic. As I add cobalt blue and sienna to the gray background, the dog and cat start appearing lighter in value by comparison. At this point, the focal points

in the illustration shift from the dark value areas to the light value areas. Notice how I've begun developing the textures of the brick wall. Through careful placement of the stippled dots, the colors (gray and sienna) and the texture are created simultaneously. Although this drawing has already undergone considerable development, it still is missing strong color and contrast.

Step 4

At this final stage of development, since I began introducing several additional colors (such as scarlet red for the dog's tongue, and blue violet, red violet, black, and raw sienna inside the mouth), I included the use of crowquill pen tips. When using a diversity of colors, crowquills are less costly than mechanical drawing pens. Notice the increased color and contrast of this stage, compared to the preceding stage.

I have darkened the sky considerably here by adding a cool cobalt blue ink. I also added accents of warm yellow and orange ink to develop the color, texture, and markings of the cat. I did this sparingly, so the cat wouldn't get much darker. As a result, the cat comes forward because it's lighter and warmer than the background. Usually I try to develop the contrast as much as possible with colors only. I like to use black sparingly, and mostly in the final stage of development.

The dog is the lightest value in the illustration. I used black ink to accentuate the dark features of his mouth, nose, and eyes. Placement, light value, and highly contrasted features allow the dog to pop forward as the closest object in the foreground.

MARKERS

Markers are extremely convenient to work with because they are a self-contained color medium that does not require brushes, water, or any other support materials. The stipple, lines, dashes, and solids that markers produce work well for developing the various textures of a cat's coat. Markers offer the opportunity to produce vivid colors for portraying the eyes, markings, and colorings of different breeds. Compared to ink, markers create a rather soft dot and line; but are limited in relation to pencil and watercolor when it comes to subtle tones.

Fortunately, this medium is available in a wide range of colors and sizes. You can get markers with tips ranging in size from wide to extra-fine. I like to use markers in a style that utilizes a variety of techniques, including stipple, line, and solid color areas. When producing thin lines found in whiskers and hair or the fine stippling used to describe smooth surfaces, such as the eyes, fine-tip markers work best. Solid areas or thick lines found in background areas or the cat's coat are best achieved with a wide-tip or bullet-tip marker. When I'm in need of a wider tip, I almost always use the bullet-tip marker, which in size is halfway between the fine-tip and the wide-tip. Although the bullet-tip has a relatively large tip, the tip is rounded and not squared off as are the wide-tipped markers. The rounded tip of the bullet-tip marker produces a round dot, which makes it very useful when applying markers in a pointillist fashion.

Although the size of the tip basically determines the size of the mark produced, the results are also partially affected by the length of time the marker makes contact with the paper's surface. If a large marker touches an absorbent paper for any length of time, the paper sucks the ink from the marker and the dot will spread and keep getting larger.

Because I mainly use fine-tip markers for rendering the many details required in drawing cats, it is important to make sure the tip is kept sharp. I often have to replace used markers because the tips become blunt from extended use. Replacing the caps is an important habit to develop; otherwise, the markers will dry up.

Since each marker basically produces a raw color, integrated color schemes in your illustration must be developed through a pointillist approach. When specific colors are placed next to one another, visual mixes are produced. For example, a mixture of yellow dots and blue dots will produce a green visual effect. Instead of mixing the colors on a palette, the colors are mixed in the eye of the viewer. With the same technique, if a color like red is too warm or intense in the overall illustration, you can visually neutralize it by placing dots of its opposite color—green—next to the red.

Once you get the hang of it, the placement of color dots, dashes, and lines can produce striking results. Since the component parts are raw color, even intricate blends result in intense, vibrant color effects. This approach to illustration provides discipline and excellent training in the uses and relationships of color.

Although you can use markers on virtually any paper surface, I prefer the absorbency and texture of d'Arches cold press watercolor board. Absorbent surfaces produce softer lines and dots; harder, smooth surfaces produce crisper lines and dots.

Box of Markers

Markers on cold press illustration board

Markers come in a diversity of colors,
brands, and sizes. This illustration,
which was executed with markers,
shows the actual box full of markers I
used to produce all the marker draw-
ings in this book.

Markers

Marker Tips

Markers on cold press illustration board

Your dots and lines can vary in thickness as a result of the tip size and marker brand that you choose. Tips are available from different manufacturers in extra-fine, medium, bullet-tip, and wide sizes.

Pushing Color Intensity

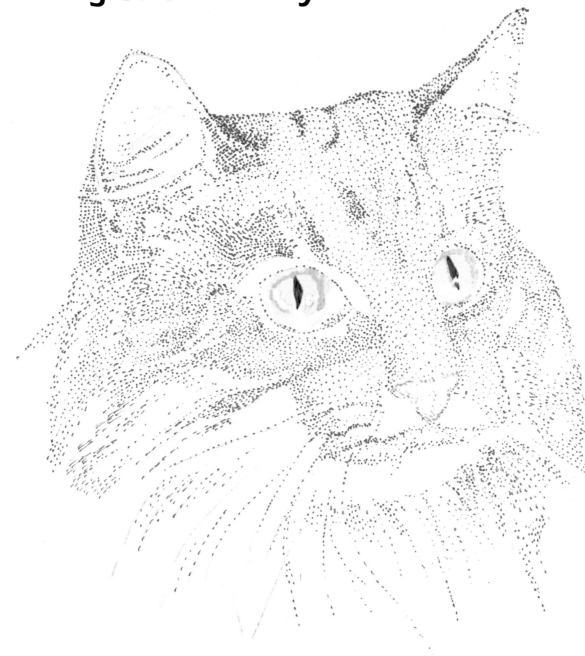

Step 1

I initiated this illustration of a Maine Coon cat by laying down a light pencil sketch with a 5H pencil. I used a fine-tipped brown marker to stipple in the basic shapes and markings of the cat's face. I kept the stippled dots well-spaced. In the areas where the markings were more prominent, I allowed the dots to assume patterns of greater density. The shapes and patterns applied in this stage will provide the foundation for reference during the following stages of development.

For the initial coloring of the eyes, I used yellow and willow-colored bullet-tipped markers. As you can see, the bullet-tipped marker renders a softer tone than the fine-tipped marker. The pupils were filled in with a black fine-tipped marker. Notice how I saved small areas of the board's white surface to provide highlights on the eye's surface. The nose was stippled with a fine-tipped pink marker.

Pushing Color Intensity

Step 2

In this stage, I've begun establishing the color scheme of the cat's face by laying in small samples of different colors. The predominant color I've added throughout the face is yellow ochre. It was applied with dots and dashes. On the bridge of the nose and center of the forehead, you'll find some yellow-orange. On the cheeks and left brow, there is some mauve. In front of the right eye and left center of the forehead are some peach-colored dots. The nose coloring has been strengthened with both a pink and a gray fine-tipped marker.

I added a coat of brighter yellow to the eyeballs; then I used a light green fine-tipped marker to stipple in some color accents. Notice how this addition has increased the form and roundness of the eyes. Also notice how the increased contrast has made the white highlights more prominent.

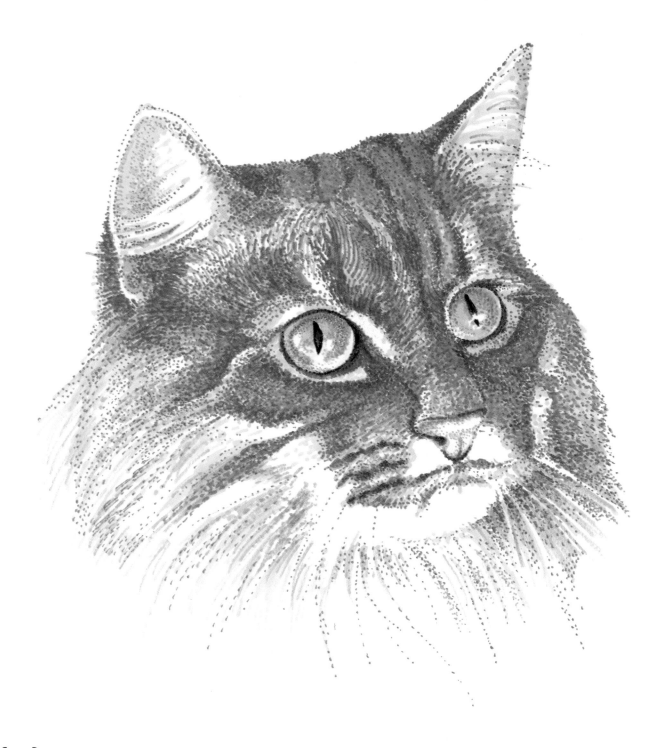

Step 3

This last stage shows how, as an artist, you can take liberties when it comes to exaggerating the color scheme of your illustration. Although these colors are basically those of the Maine Coon cat, I've added a considerable amount of brightness and intensity. On the warmer markings, I've used solid applications of pure orange. On the cat's forehead, you'll find yellow, yellow-orange, orange, ochre, light blue, white, mauve, and red. As the development evolves, from the first stip-

pling of dots, to the stronger dashes, and finally to stronger areas of solid color, the proper placement of particular colors begins to reveal itself. The trick is to think about both color and value. For example, when the cat's facial colors became too warm or intense, or when I wanted to make a subtler transition from dark to light values, I added dashes of light blue to visually cool or neutralize the color. Note the blue and blue-green colors around the eyes and where the neck

hair begins.

When parts of the markings required more contrast, I could either add dashes of a brighter color or a darker color. The common color that visually binds the picture together is ochre. In the development of a picture like this, one of the most important things is to use up the white surface of the board gradually and carefully. White is the one element you can't add with markers.

Pushing Color Intensity

Detail

This close-up of the Maine Coon cat's right eye clearly demonstrates the marker medium's capability of building up areas of solid, raw color. In the iris area, color was built up from solid applications of bright yellow overlaid with red and green stippling. For dramatic contrast and to carry over the red color found in the eyeball, I used an intense red to outline the under part of the eyelid. The intensity of this color further accentuates the prominence of the cat's eyes. Note that the solid color areas are always juxtaposed with areas that are predominantly white. Without this white contrast, the effect of bright, solid color would be weakened.

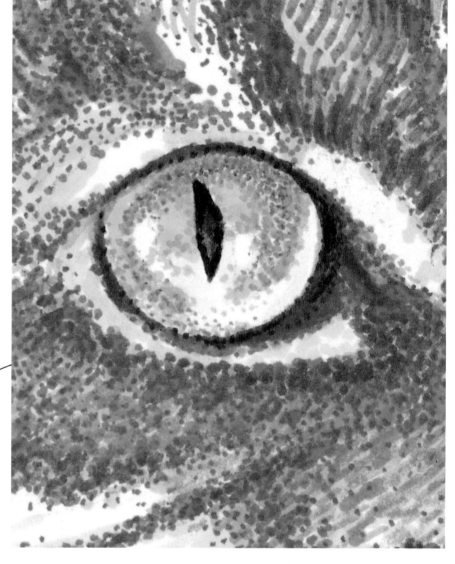

Combining White Space and Pointillist Technique

Step 1

Kittens share the common trait of being curious, yet apprehensive. This attitude often appears in their body language, such as when their posture seems to inquire and hold back at the same time. In this illustration, the kitten is venturing forward with its head and one paw, while holding back with its body. The angle of the kitten is nearly at three-quarters. The viewpoint is taken from slightly above, an angle that requires some foreshortening. It's a good pose, however, because it shows all four legs, the tail, both eyes, and both ears.

I initiated this drawing with a simple sketch, using a 5H pencil. I followed the light pencil sketch with a light blue fine-tipped marker. This size marker works well for stippling in the cat's outline and markings; the shade of blue works well for initiating a drawing because it is light in value and relatively neutral in color. These factors allow light blue to appear with or be worked over by other colors in subsequent stages. In some areas, I begin to lay in short lines and dashes to indicate the direction of the cat's hair.

Step 2

In this next stage, I've returned to the drawing with a buff-colored bullet-tipped marker. Although this color is also somewhat neutral, it adds a warm complementary balance to the tones of cool blue that were previously applied in step 1. The bullet-tipped marker renders a slightly larger and softer dot. I applied this color with a stipple technique, still following the contours and directions of the kitten's body and hair.

So far, only two colors have been used in this drawing. Since these two colors have been applied in broad areas of tone, they alone will constitute the predominant color scheme of this picture. When the warm buff dots are placed next to the cool blue dots and the board's surface peeks through as little white specks, the result is a visual pointillist color mixture animated by the effervescence of the illuminating white specks.

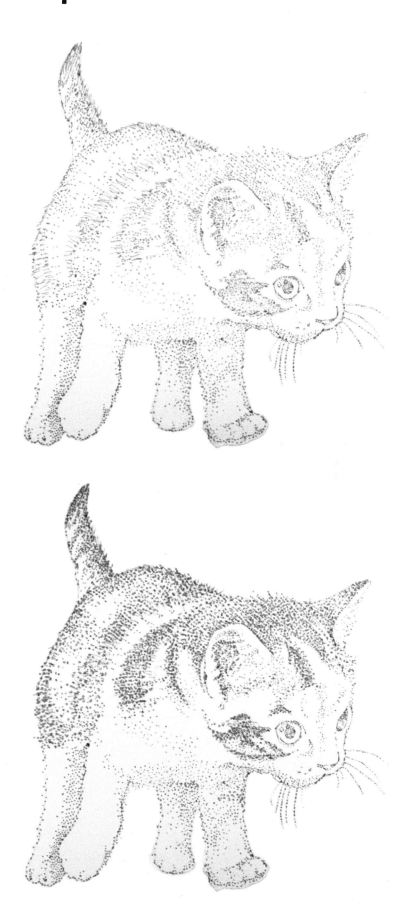

Combining White Space and Pointillist Technique

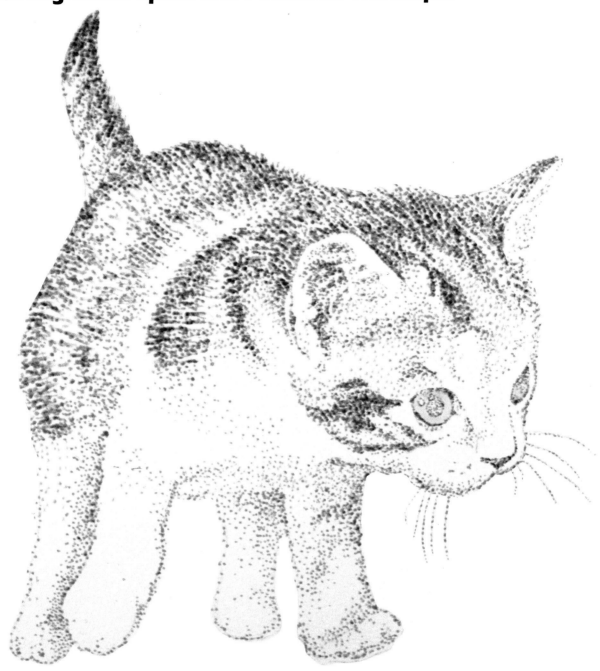

Step 3

In this third stage of development, I've come back to the coat of the kitten with a gray marker. I applied gray dashes between the stippled lines of the kitten's hair. This technique makes the hair look more like strands. Since the gray is applied throughout the coat, the strand look develops as a pattern. I've used this technique on the darker areas of the kitten where the markings have been rendered. I indicated soft stippled edges on the markings to produce a graduated transition into the white areas. This approach gives the implied appearance of strands in the white areas between the markings.

I've colored in the eyeballs with a yellow marker. Notice how I left small areas of the white board showing through. These areas will remain as highlights on the eyes throughout the development of the illustration. I've also stippled in some pink on the kitten's nose.

Step 4

In this final stage, I've returned to the kitten's coat with some heavy dashes of light blue, ochre, and yellow. This is particularly noticeable on top of the cat's head. Together, these colors lend a sense of form and substance to the kitten's appearance. I've used these short, thick dashes of color in various places to accentuate the important features, such as the ears and facial markings. Note that because I wanted to keep this drawing fairly simple and fresh, I left some parts, such as the legs, relatively underdeveloped.

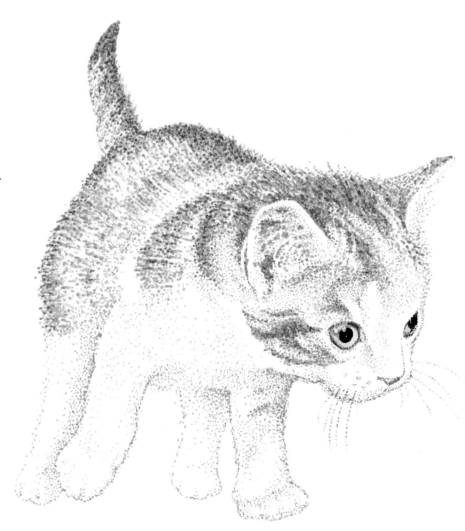

Detail

A light green fine-tipped marker was used for additional coloring on the kitten's eye. By placing this green around the white highlight of the eye, I've increased the gleaming effect. A black fine-tipped marker was used to fill in the pupils and outline the shape of the eyes. Note the use of purple marker inside the ear. This shade is a good choice for shading in an area where the local color is characteristically pinkish. In shadow, it would tend to look purplish.

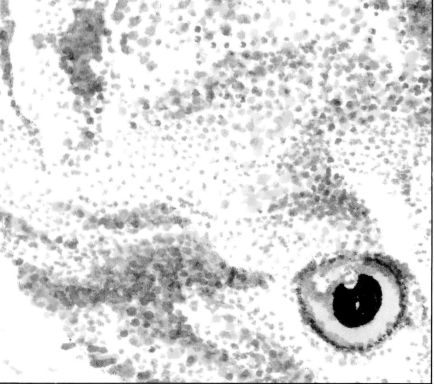

WATERCOLOR

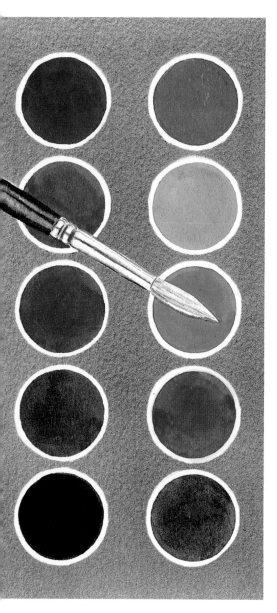

Watercolor Palette—Cool Colors

Left column from top to bottom: Prussian blue, cobalt blue, ultramarine, violet, black. Right column from top to bottom: blue-green, yellow-green, light green, green, gray.

Watercolor is an excellent medium for painting cats. It offers a wide range of potential color combinations. It's a quick, spontaneous medium ideal for producing the soft, subtle textures of a cat's coat and the glassy tones of a cat's eyes. However, it doesn't offer the stark contrast, sharp edges, and graphic quality of ink. Nor does it offer the gutsy color of markers.

Because watercolor needs to be worked so quickly, and time can mean the difference between a luminous, floating wash and a hard stain around a pool of color, the medium itself is extra important. Although watercolor paints are available in both tubes and cakes, I almost always use cake watercolors. In my experience, cake watercolor is conducive to speed: the cakes in their tins are already set up; they are always in the same position, so I know where they are almost without looking; and they are easy to transport for on-location work. At critical stages in watercolor painting, the rapidity with which I can move—dipping into color and then rinsing in water at a rapid-fire rate of speed—makes the cake watercolors indispensable to me.

My cake watercolor palette varies depending upon the coloring and markings of the cat. For example, when I paint white or light-colored cats, I like to use blues, violets, and grays to create shadows and various tonal areas. These colors are fairly neutral and won't give a misrepresentation of hair coloring. In general, most cats are best represented by neutral and warm colors. For these, I often use yellow ochre, raw umber, burnt sienna, and burnt umber. Since cats' eyes are typically yellow or green, I use the green and yellow cake colors. In the case of the Siamese, I use cobalt blue for the eyes, often with a warm touch of violet color.

Although expensive, the best brushes for working with watercolors are sable. Sable brushes are soft, but resilient. You can get brushes that are flat or round but when I paint cats, I prefer round brushes. I find that Nos. 2, 5, and 7 brushes offer a good range for most paintings. No. 2 is a small brush that is good for painting details. No. 5 is a mid-sized brush, good for general development. No. 7 is large enough for laying in washes. If you don't want to make quite so large an investment, sabeline brushes work quite well, and nylon brushes are also acceptable.

There are a few important things to consider when purchasing round sable brushes. First, the brush should hold a good point. To test for a good point, dip the brush in water and shake it dry. If the hairs reassume a pointed tip, the brush is good. Next, check the length of the hairs—the longer hair brushes work best. Finally, wet the brush, gently bend the hairs back with your finger; the

brush is good if the hairs spring back to their original shape.

The choice of paper used in watercolor painting is also quite important. Watercolor paper is made with a heavy rag content. It is relatively absorbent and responds beautifully to the watercolor medium. When working with a good watercolor paper, the surface will offer the time and leeway to float washes, blend colors, and soften edges before the pigment dries. The surface of watercolor paper is available in three basic textures: hot press, which is the smoothest; cold press, which has a medium texture; and rough, which is heavily textured. You can get watercolor paper in single sheets, pads, boards, and blocks. Watercolor paper produced by different manufacturers exhibit subtle variations in their response to the medium. I suggest that you experiment with different brands, textures, and formats until you find the combination which works best for your individual style.

Although many artists use a paper surface, most of the time I prefer d'Arches cold press watercolor board. (I use it for the two watercolor demonstrations that follow.) I find that its surface is smooth enough to create a light pencil sketch on, but also rough enough to produce an interesting painted texture on. I particularly like the way d'Arches responds to watercolor: the surface is forgiving and allows me more time to work; and the ultimate look of the painting is more transparent. I like working on a board because it holds up well, it's easy to handle, and it doesn't wrinkle or buckle when it gets wet.

When starting your painting, in addition to your brushes, paints, and paper, you should have a container of water; a good mixing surface, such as the lid of the watercolor tin or a porcelain-coated pan; and a rag or paper towel. Place the brushes you intend to use in the container of water, so that the water level comes above the place where the brush hairs join the ferrule. (The ferrule is the metal part of the brush that holds the hairs.) Allow the brushes to soak a minute or two. This will prepare the brush hairs to absorb the pigment and allow the brush to absorb water into the ferrule. This soaking protects the life of the brush, makes it easier to clean, and prevents pigment from entering and drying inside the ferrule. Use the largest brush to wet the surfaces of each watercolor cake, dipping the brush into the water and letting a few drops fall on each cake of color. Then, before painting, allow a few minutes for the water to soften the pigment. When you finish painting, wash your brushes gently with mild soap and lukewarm water (or the proper commercial brush cleaner). When not in use, always keep your brushes wrapped or boxed in a safe place.

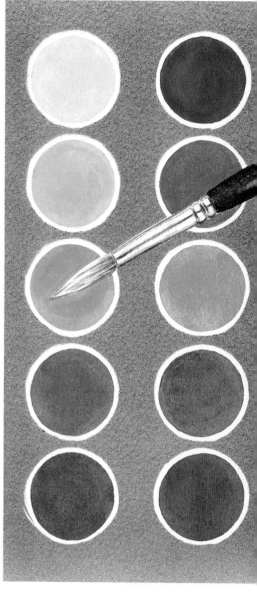

Watercolor Palette—Warm Colors
Left column from top to bottom: yellow, yellow-orange, orange, scarlet, carmine. Right column from top to bottom: Indian red, burnt sienna, yellow-ochre, raw umber, burnt umber.

Establishing Form and Texture with Tonal Masses

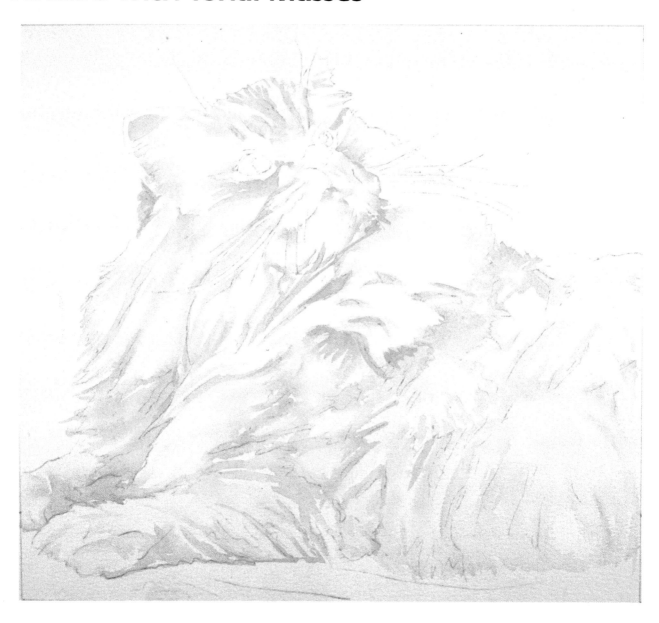

Step 1

Since the most prominent feature of this Red Persian is its long fluffy hair, I concentrated on presenting this feature. I began by laying in a light sketch with a 5H pencil. The sketch is kept quite simple because watercolor is a tonal medium; all the sketch really needs to do here is indicate where the outline, basic features of the cat, and the reference points for where the hair masses should be located.

Once the sketch was completed, I mixed up a batch of yellow ochre paint with a touch of raw umber and gray—a combination that approximates the "red" color of a cat's coat. I

added some water to produce a large, slightly diluted puddle on my palette, then dipped a No. 7 sable brush in clear water and applied this thin water wash to the centers of areas that I intend to represent the massing of hair clumps. Working quickly, I then loaded the brush with color from the mixed puddle and applied paint to the edges of these wet areas. When you do this, the paint feathers out and softens into the wet area, producing a gradated appearance while still remaining white in the center.

At this point, you must quickly rinse the brush and load it with clear water

again. Apply this water to the pigmented edges that you've just applied, so that they blend and travel into the perimeter of adjacent wet areas. This technique will help you avoid having hard edges form when the paint dries. By working fast and repeating this technique, you'll be able to create feathered, gradated separations between the various clumps of hair. Remember that the shape you produce with the clear water will dictate the ultimate shape of the hair and will appear as the highlighted areas in the center of the clump.

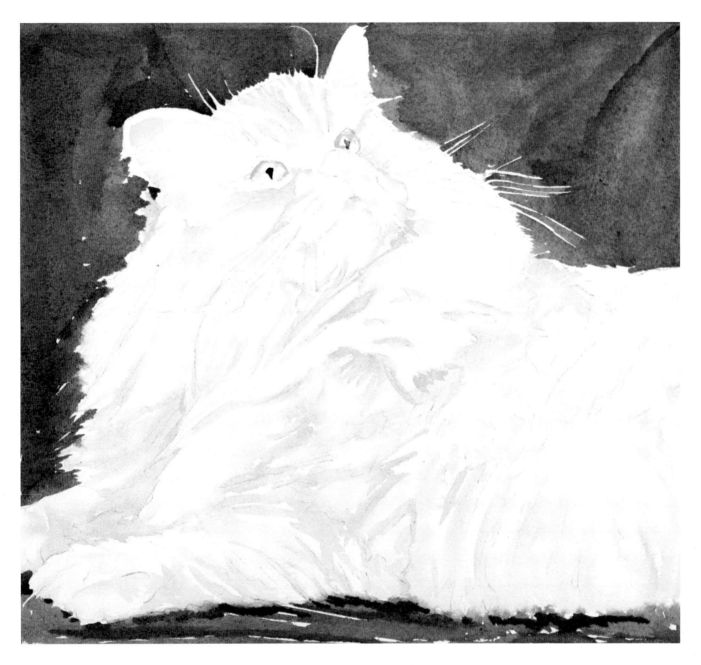

Step 2

For the next stage, I mixed a combination of red, cobalt blue, gray, and burnt sienna. I made a large puddle of the resulting maroon color with my No. 7 sable brush and added a little water. I rinsed my brush, loaded it with clear water, and shook the brush so it was wet but not drenched. I applied a few loose strokes to dampen areas of the background, and a little bit of the foreground. Next, I loaded my brush with maroon pigment from the mixed puddle and quickly painted

in the background and foreground. When the paint hit the pre-moistened areas of the board's surface, it created a slight variation in the tone. I thought this would look more interesting than a solid or even-toned background.

I chose the maroon color because it seemed compatible with the ochre coloring used for the cat's coat. The dark value of the maroon produces a contrast that defines the shape of the cat and allows it to come forward. Notice how the cat's whiskers are

created by the white board peeking through the background color. I also allowed little white accents to show through in front of the cat and in the foreground. I came back with some dark maroon in the foreground to indicate the shadow separating the cat from the ground. To indicate the color of the eyes, I used a mixture of yellow/orange and clear water. Leaving some white on the eyeballs for highlights, the pupils were painted gray.

Establishing Form and Texture with Tonal Masses

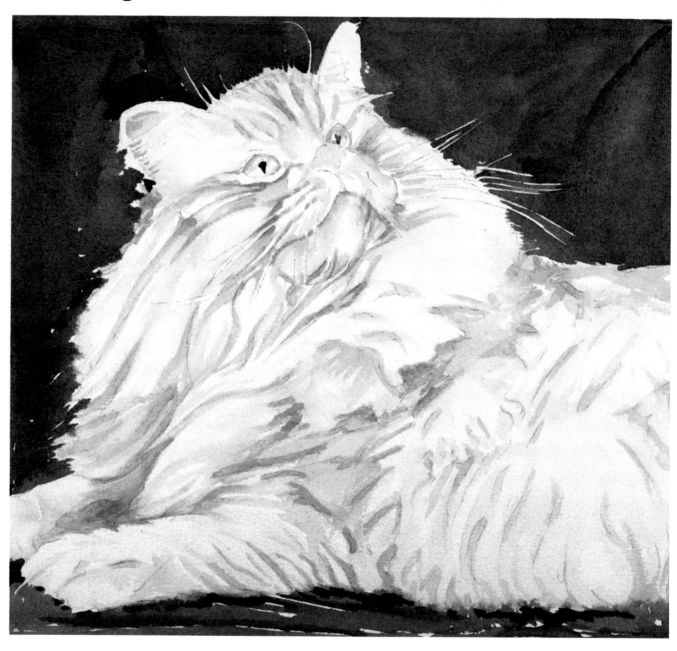

Step 3

In this stage, I continued developing the cat's coat. First I mixed color that was previously used for the hair with some more ochre and a little raw umber. This produced a darker value, suitable for shading and accenting the coat. I applied this darker color to key areas, such as the space between the legs and the edge of the cat's mane. I also used this color to darken a few tones separating clumps of hair, the cat's mouth, and markings on its forehead. In some places, such as the shoulder and the space between the forelegs, I laid in a slightly darker tone; then I came back with clear water to blend or soften the edges. A No. 5 and a No. 7 sable brush were used to paint in these darker accents. With most applications, I allowed the shape of the brushstroke to remain as the shape of the accent or shadow.

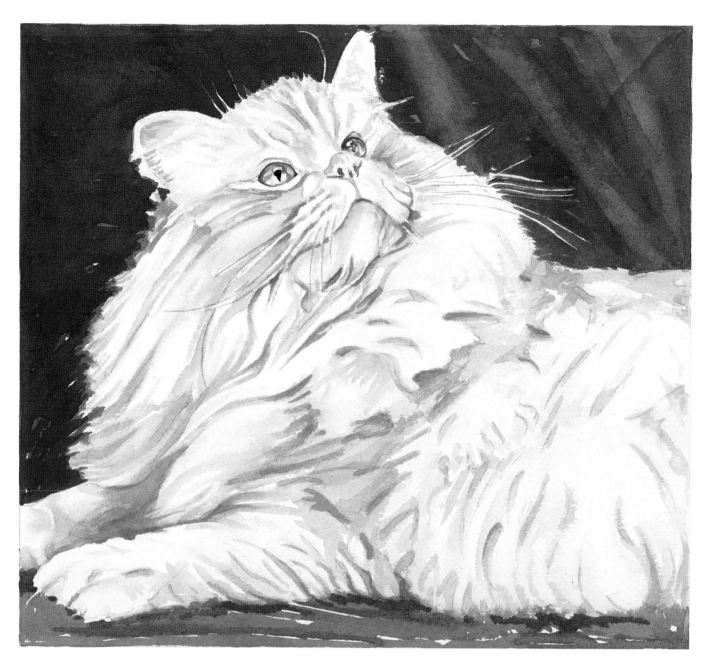

Step 4

In this final stage, I've come back to the coat once again with a slightly darker tone, which was produced by adding a little more raw umber to the mixture. You can see where I darkened some lines and accents, such as the line of the mouth and the hairs of the chin. I also defined the cat and brought it forward more by darkening the background again. I laid down three broad strokes of water on the right, then brushed in a mixture of dark maroon. This technique shows how you can paint over a previously applied color and build chromatic values in a lower intensity.

Yellow-orange and burnt sienna were mixed for additional coloring in the eyes. This creates a contrast that accentuates the highlights on the eyeballs. A smaller No. 3 brush was used for rendering these smaller details. I came back with a little plain water to soften and blend the coloring applied to the eye; this keeps the eyeball looking glassy and transparent.

Modeling a White Cat
Against a White Background

Step 1

I began this painting of this delicate, white Rex with a light sketch, using a 5H pencil. To initiate the shadow coloring of the coat, I mixed water with cobalt blue and a touch of gray. Light blue makes a good shadow color for modeling white subject matter. The slight addition of gray cuts back the chroma and makes it a touch more neutral.

I then loaded a No. 5 sable brush with clear water and minimally wet the areas where I intended to apply paint. This pre-moistening creates a soft feathered effect when the paint is applied, a result that's clearly seen in the cat's tail.

Mixing water with violet and a touch of cobalt blue, I laid in a light wash on the ears. A touch of red, mixed with a lot of water, was used on the nose. For the eyes, which convey a sweet-natured but intense expression, I used a yellow/orange, leaving some white board showing through for the highlights.

Step 2

At this stage of the painting, I began to develop the shadows and contrast. I mixed gray, a touch of cobalt blue, and water until I had a middle-to-dark-value color. This time the gray was predominant; the cobalt blue was added to keep the new color in character with the prevailing color scheme. In most cases, I wet the surface with clear water before applying the paint. This keeps the coat looking soft, even in the darker shadow areas.

Since the illustration is of a white cat set against a white background, I needed to outline parts of the cat to define and separate it from its surroundings. I thinned the gray paint for this and allowed the outline to start and stop, and to vary in thickness. This broken, uneven outline allows the cat to interplay with the surroundings. At the same time, it provides a separating element. The cat's whiteness presented other problems: there were areas where white features had to be defined against a white body. To do this, I used the gray mixture to separate parts like the mouth/face, chin/neck, and legs/body. In these instances, I worked on a dry surface to produce a more prominent line. Sometimes, such as the area between the forelegs, I would return to the line with clear water for a little softening.

Modeling a White Cat Against a White Background

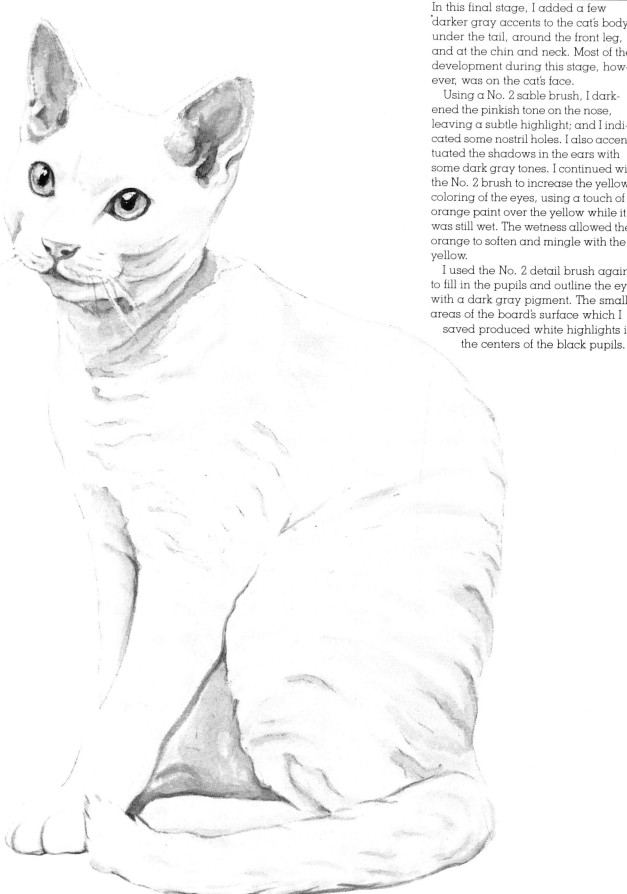

Step 3

In this final stage, I added a few darker gray accents to the cat's body: under the tail, around the front leg, and at the chin and neck. Most of the development during this stage, however, was on the cat's face.

Using a No. 2 sable brush, I darkened the pinkish tone on the nose, leaving a subtle highlight; and I indicated some nostril holes. I also accentuated the shadows in the ears with some dark gray tones. I continued with the No. 2 brush to increase the yellow coloring of the eyes, using a touch of orange paint over the yellow while it was still wet. The wetness allowed the orange to soften and mingle with the yellow.

I used the No. 2 detail brush again to fill in the pupils and outline the eyes with a dark gray pigment. The small areas of the board's surface which I saved produced white highlights in the centers of the black pupils.

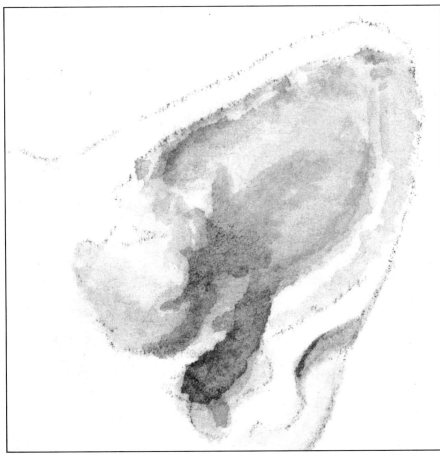

Details

In the close-up detail of the Rex's ear, an initial diluted wash of violet and cobalt blue was used to indicate the pinkish tones characteristic of the cat's inner ear. (This coloring is particularly true to white or light-colored cats.) Because the inside of a cat's ear is blocked from light, I find that washing a weak mixture of gray or grayish-blue over the pinkish tone and letting the colors blend together is a good way of describing the shading there.

In the bottom detail, in order to indicate that the cat's neck is in shadow, I used a slightly stronger mixture of cobalt blue and gray than the one used for the cat's coat. This darker color also creates a needed separation between the cat's head and its body. To further define the contours of the neck, a few fine brushstrokes of blue-gray color create the folds of the cat's neck.

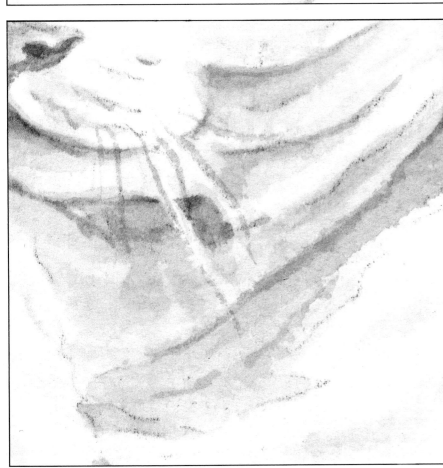

ACHROMATIC WATERCOLOR

This medium is good for painting cats. Like color watercolor, it can produce the soft, subtle textures for rendering cat fur and the transparent tones for creating cats' eyes. Although black ink, of course, does not offer color, there is something about the achromatic palette which captures and portrays the moody quality of cats very well.

Except for the absence of color, the materials and procedures for working with achromatic watercolors are identical to chromatic watercolors. The black-and-white watercolor pigments I've chosen are Gamma retouch cake pigments. Although these paints are intended for photo retouch work, I've found they are an excellent medium for the creation of black-and-white fine art illustrations.

You can also produce achromatic watercolor paintings by using a standard black watercolor cake. With this approach, various gray tones can be achieved by adjusting the relative combinations of water and pigment. This technique is capable of varying the degree of transparency and offers a diverse range of tonal values.

I find that the Gamma pigments offer a depth, range, and fullness that is not available from a solitary black watercolor cake. They can be transparent, opaque, or mixed to produce a combination of both effects.

The Gamma palette provides a substantial range of values, from off-white through the gray tones to solid black. Although these pigments are achromatic, some of the gray tones offered are either cool or warm in appearance. The use of this feature alone can provide numerous visual effects and add further dimension to an illustration. The Gamma palette also provides a substantial variety of achromatic tones. These tones are continually visually available to the artist because of the convenient layout of the palette, a feature which makes it much easier to match values that have been previously applied in the development of a painting.

Because I have found that the gray values as they appear in the cake form are different from how they appear in a painted form, I suggest that you produce a reference chart on the same paper as your painting with a sampling of each pigment. I often do this on the border of my illustration, and trim it off after completion of the picture.

Achromatic Watercolors

Cake watercolor on cold press illustration board

The Gamma retouch palette consists of black, glossy black, Gamma shader warm, Gamma shader cool, white print cleaner, three warm values of gray, and three cool values of gray.

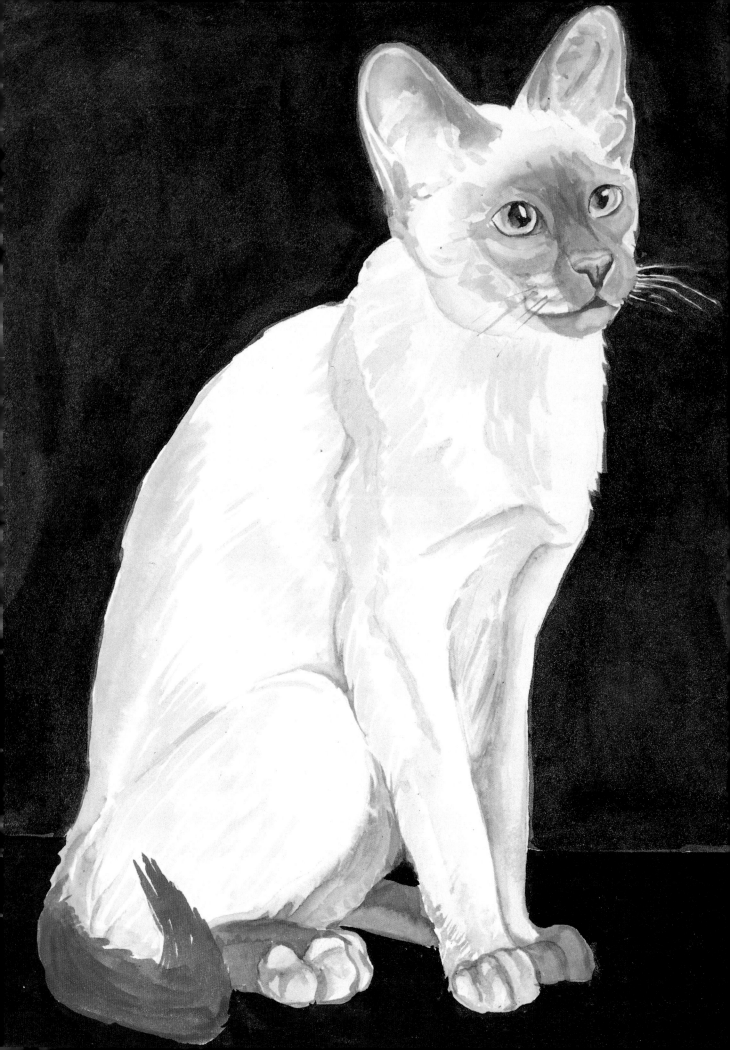

Rendering an Achromatic Tonal Study

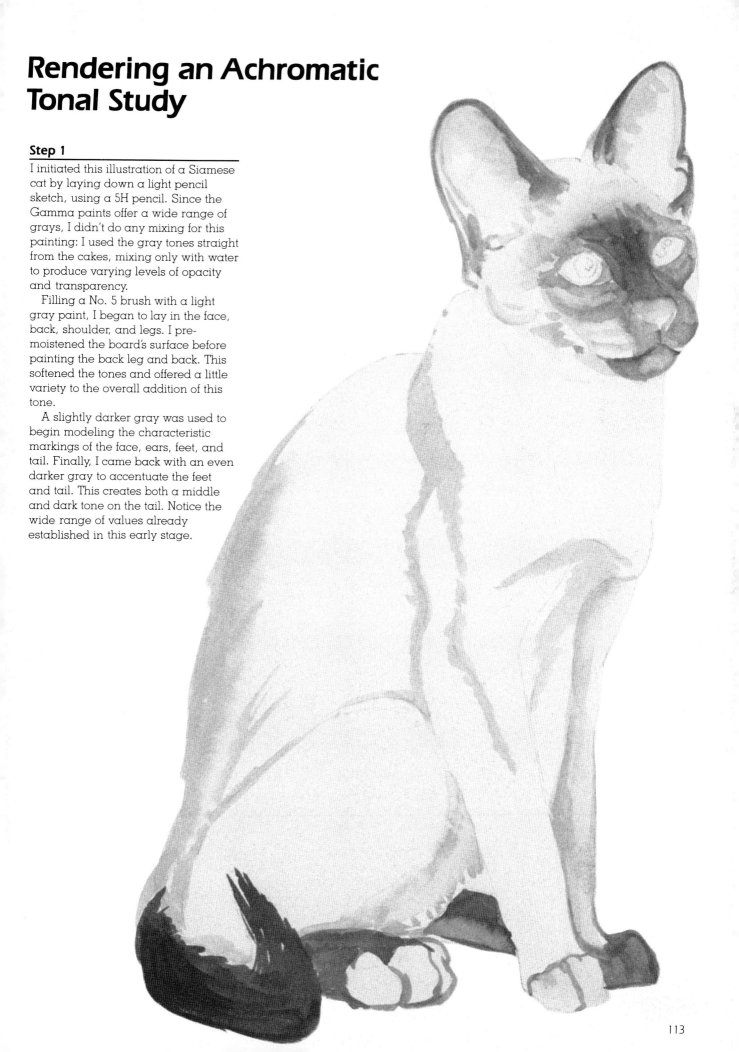

Step 1

I initiated this illustration of a Siamese cat by laying down a light pencil sketch, using a 5H pencil. Since the Gamma paints offer a wide range of grays, I didn't do any mixing for this painting: I used the gray tones straight from the cakes, mixing only with water to produce varying levels of opacity and transparency.

Filling a No. 5 brush with a light gray paint, I began to lay in the face, back, shoulder, and legs. I pre-moistened the board's surface before painting the back leg and back. This softened the tones and offered a little variety to the overall addition of this tone.

A slightly darker gray was used to begin modeling the characteristic markings of the face, ears, feet, and tail. Finally, I came back with an even darker gray to accentuate the feet and tail. This creates both a middle and dark tone on the tail. Notice the wide range of values already established in this early stage.

Rendering an Achromatic Tonal Study

Step 2

In the second stage, I've come back with a No. 5 brush and the light gray paint to render a little more of the cat's coat. I allowed quick, loose brushstrokes to indicate the character of the cat's hair. I used a middle-to-dark value gray to further develop the modeling of the cat's face. This development helped to separate and define the facial features of the nose, cheeks, chin, and forehead. At the same time, it further defined the Siamese markings. I added a tone of cool, middle-to-light value gray to the cat's feet. This paint was applied to a partially wet surface to produce the graduated tone, forming the cat's toes. I came back with a more opaque consistency of the same gray to further define the features of the feet. A No. 2 detail brush and black pigment were used to paint the dark accents of the nose, mouth, and pupils.

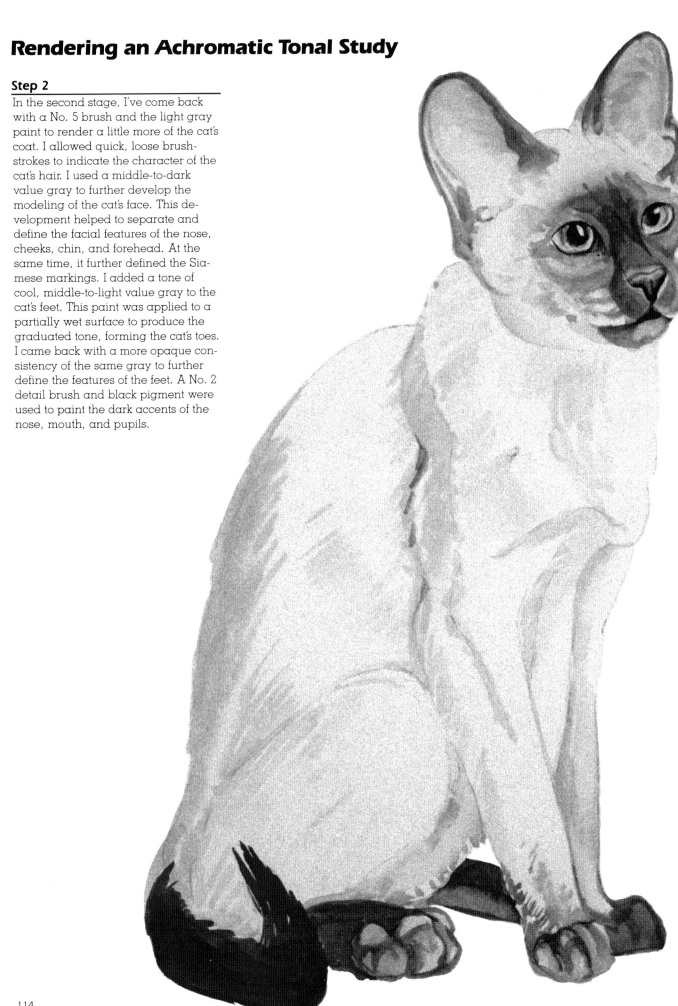

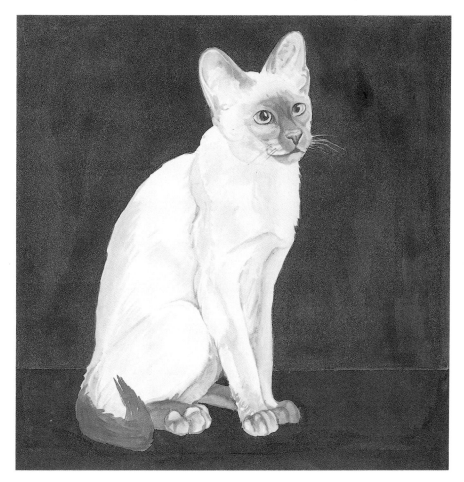

Step 3

In the final stage of this illustration, I used a No. 7 brush filled with a rather opaque mixture of dark, cool gray to paint in the background. Although the tone is rather solid, I allowed the brushstrokes to leave a subtle texture. The surface of the board peeks through to indicate the white whiskers. When I got to this area, I switched to a smaller No. 2 brush to paint the background around the whiskers, using the same dark, cool gray pigment. In the foreground, I used a solid coverage of black pigment. This dark area produces a horizon line. It also allowed a contrast and separation to exist between the cat and foreground, and the foreground and background. The dark value of the foreground and background creates a reversed effect which brings the cat forward.

Detail

The face area is composed of several values of gray, all of them applied directly from the cake. The initial wash used to establish the tone of the face is the lightest, coolest gray available in the Gamma palette. Then, to begin to develop the characteristic darker markings of the Siamese's face, I came back with a slightly darker cool gray and filled in the mask area. For the very darkest parts of the mask, such as the area between the eyes and to define the nose and mouth, I used a warmer, middle-to-dark-toned gray. The blending of all three grays give this painting a richness that is unexpected with such a limited palette. For final accents, I used the Gamma black for the pupils of the eyes and made sure to leave a great deal of white space to define the lightest markings of the face.

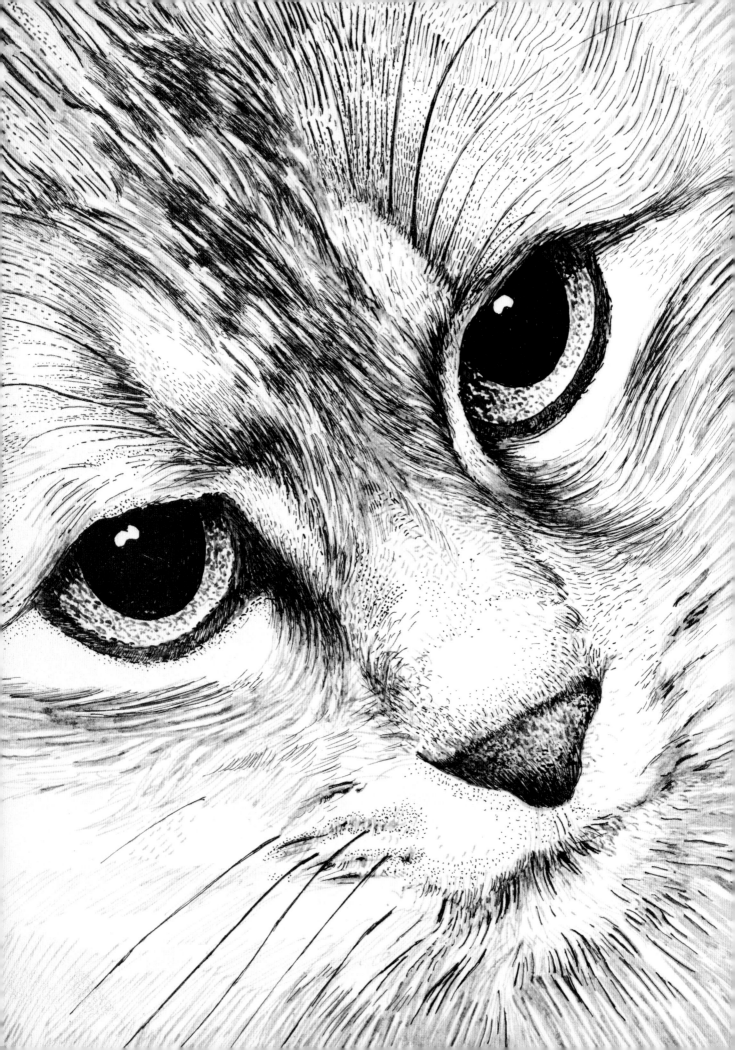

Part Three
Analyzing Finished Work: Learning From What You Do

WORKS IN PENCIL

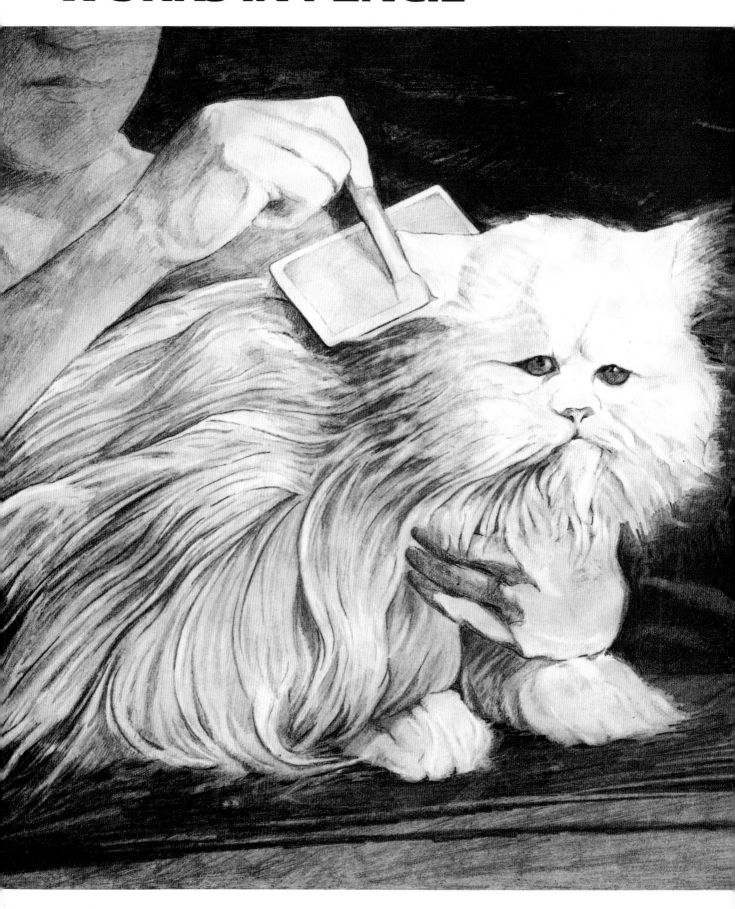

Cat Being Brushed

Pencil on hot press illustration board

As demonstrated in Parts 1 and 2, the pencil medium is ideal for rendering the long-haired cat's soft flowing coat. The cream Persian illustrated here has the slightly put out look of the cat who only tolerates hair grooming. The distraught expression is captured by eyes that slant downward, and a mouth set to one side; the tightly clasped hand around the cat's chest also tells us that the cat would flee if given half a chance.

The right cropping is an important compositional device here because it tells us the story behind the picture. The subject matter is cropped so that most of the cat is revealed, but so that just enough of the person is present to explain the story.

To build contrast and drama, I made the background black with a soft 6B pencil. I later came back with a kneaded eraser and lifted a few areas off the background. These lighter value patches keep the background from being too stark and alien in relationship to the main subject. The dark sketchy shadow in the foreground was drawn with a 4B pencil. The surrounding middle-gray tone produces an interesting complement of tonal values.

Details: In the detail at top right, the right side of the cat's face is softened to reduce the hard contrast against the dark background. I accomplished this by using H series pencils in this area and by slightly lifting with a kneaded eraser. The end result is a look of soft semi-transparent hair. Notice that the background area adjacent to the cat's face is rendered in middle-value grays, which helps to make the tonal transition from the white face to the dark background.

In the detail at bottom left, I took advantage of the cast shadow created by the cat blocking out the light from the right. This dark shadow area gives me the opportunity to use a darker value for the foreground, and allows a few long strands of the cat's hair to overlap the dark background of the table. To help bring out the lights in the cat's hair, I used a kneaded eraser. This technique indicates the nature of the long strands and also establishes the contrast between cat and table.

Reminder:

Cropping is an important device for conveying the intent of your drawing.

Pencil is excellent for achieving the look of long, light-colored hair.

A cats character is expressed through both facial features and body attitude.

Transitional middle-range values help to bridge subject matter and background.

Works in Pencil

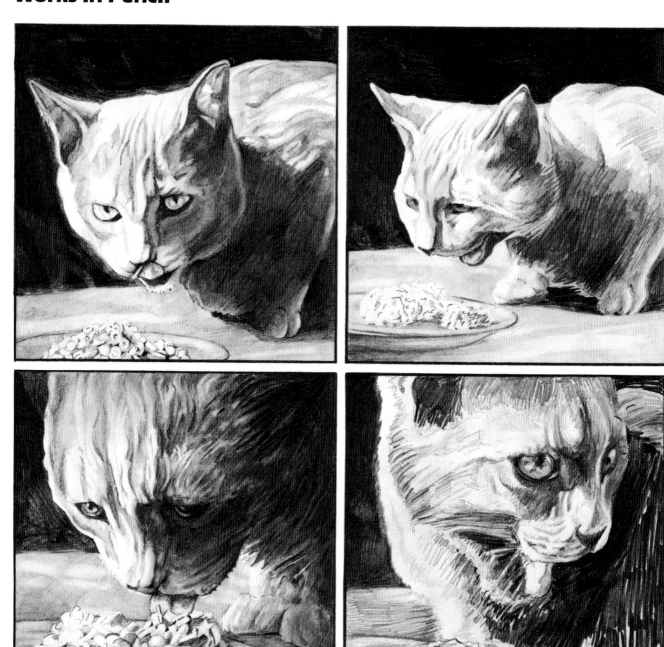

Cat Eating

Pencil on hot press illustration board

This series of pencil drawings shows various sequential interpretations of a young cat eating. Through careful observation, I noticed that this cat would look around, gobble its meal, stop to bite down on a particularly hard piece of food, gobble, and then look around again—all with a rather guarded, anxious expression on its face.

I increased the drama and simplicity of these drawings by cropping to create closeups of cat food and the cat's face. Close cropping also brings the viewer's attention right to the action; in each case, it allows this attention to flow from one square to the next. To further simplify the composition, I also tried to limit the overall value scheme to three values: a dark background, a middle-value gray, and the lightest value of the white board. To achieve this, I dropped in all four backgrounds with a soft 6B pencil,

letting the dark tone recede and create a needed contrast for the rest of the picture. The cats are rendered almost exclusively with middle-value grays and modeled by an overhead light source. They are rendered to achieve a tonal effect rather than indicating individual strands of hair. These tonal areas were developed with a very loose stroking of the pencil. This scribbly technique is most evident in the two bottom squares.

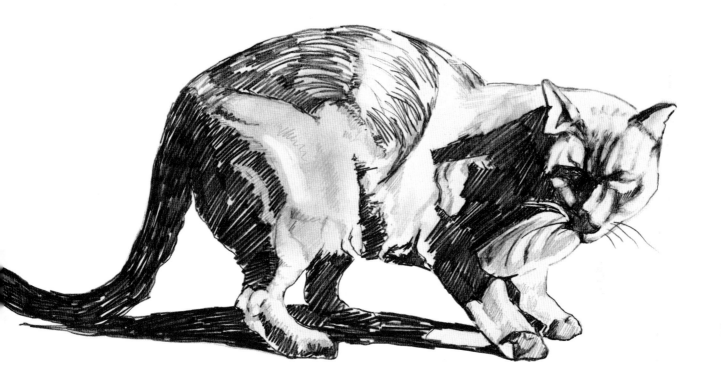

Profile of Cat Standing

Pencil on hot press illustration board

Similar to *Cat Eating*, my intention in this drawing was to create a sketch that was deliberate, but loose. At first I indicated this illustration with a light, fairly accurate outline, using a hard 4H pencil to establish the basic shape and gesture. Then I took the liberties within the drawing to get looser with the tone and markings of the cat. In *Cat Eating*, I introduced the loose scribble in conjunction with the more finely rendered areas of the cat. Here, I came in with a soft 6B pencil and boldly scribbled in the entire cat, without paying particular attention to filling in the white of the board. In addition to these scribbly, dark lines, some finer 3H pencil tones were laid in here and there to help create a textural balance. This smoother tone is found on the cat's rear leg and on its face. The alert posture combined with a spontaneous style of sketching make this cat look as if it's been caught in a frozen state of motion.

Reminder:

Careful observation of cats and their habits can provide excellent source material for your drawings.

A simple value scheme can add dramatic impact to your pencil drawings.

A good way to achieve textural contrast with pencil is by combining spontaneous, loose, scribbly lines with more finely rendered tonal areas.

Using a strong overhead light source in your drawing is a good technique for modeling the contour and form of the cat.

Works in Pencil

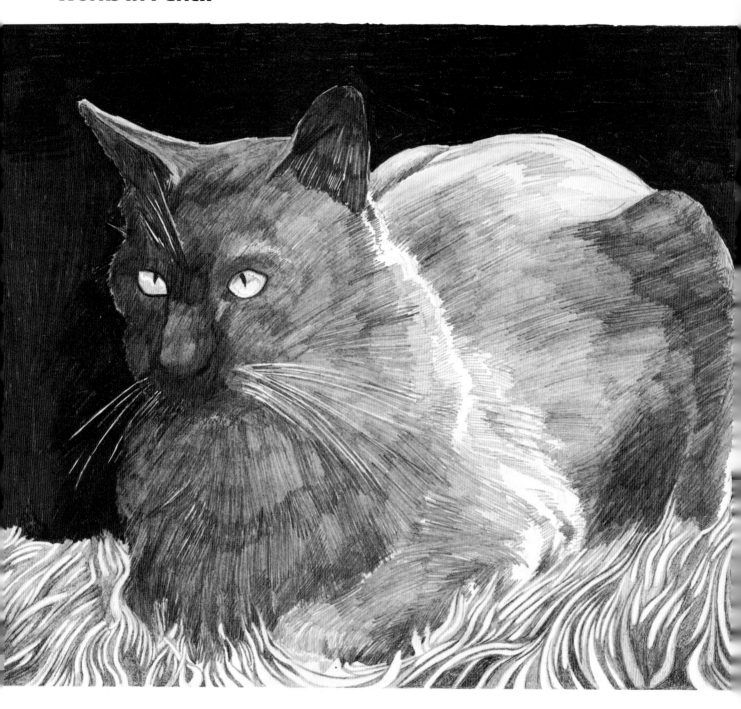

Cat Sitting in Grass

Pencil on hot press illustration board

This serene, watchful looking cat is sitting in the grass on a summer night, probably looking for unsuspecting prey. A strong light source is overhead and to the right. The black background, filled in with a soft 6B pencil, creates an environment for the cat. The cat itself represents a number of different tonal values: the very dark right side of the cat's face was shaded with a 2B pencil. Although it's very dark, the adjacent 6B background is even darker and thus offers enough of a difference to create a contrast. As I worked around from the cat's head to its body, I gradually lightened the series of parallel sketchy lines that make up the cat's form. I did this using an H pencil on the left side of the cat's face, letting the tone fade to a 3H level just before it meets the white highlight area of the cat's neck. Notice how the white of the neck shows the form of the cat and acts as a separation between the cat's front and the hindquarters.

The grass is illustrated in a stylized fashion. The rather flat tonal texture of the blades of grass offers a third design element to balance the more linear cat and the solid background.

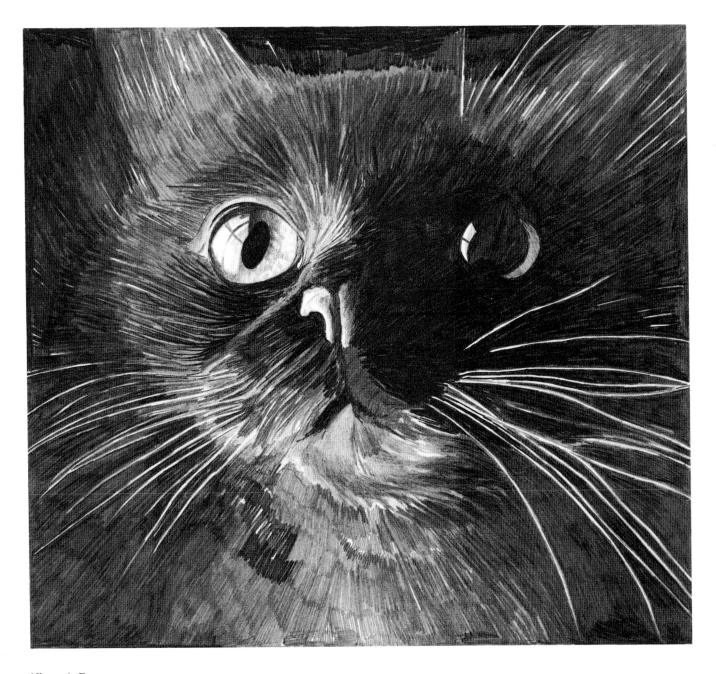

Kitten's Face

Pencil on hot press illustration board

Kittens have an irresistible curiosity. This kitten's earnest, inquisitive gaze was so compelling that I decided to increase the drama of the picture by cropping very closely on his face. The image was created out of the reversed technique, making the light values and whites the focal points of the drawing. This approach has also produced a lost and found effect, in which parts of the kitten seem to materialize out of the darkness.

The very darkest sections of this drawing, such as the pupils of the cat's eyes, were drawn with a 6B pencil. The other dark tones were created with a 2B, and the middle tones were done with an H.

The white highlights on the eyes, nose, and whiskers are produced by allowing the surface of the board to show through. When I darkened the areas surrounding the whiskers, I had to take time to be careful. I also had to keep the soft dark lead of my pencil sharp, so I could maintain a distinct separation between the edge of each white whisker and the surrounding background. I also had to switch pencils periodically to produce the different tones of the background and the cat's coat.

In this illustration, the predominantly dark background allows the minimal white highlights to carry the image. By contrast, the minimal white accents become quite authoritative in this context. Notice that in the white windowpane highlight of the eye, I also used a little bit of tone to help indicate the curved convexity of the eyeball.

WORKS IN PEN AND BLACK INK

Close-up on Persian's Face

Black ink on hot press illustration board

It is interesting to note that one of the most visually interesting things about cats is that they have such smooth, glassy eyes surrounded by waves of lushly textured hair. As an artist, you can take advantage of this phenomenon by playing one characteristic against the other. When you do this, the textured area appears relatively more textured and the smooth area even smoother. In this drawing of a brooding Persian's face, I used the eye and surrounding fur areas to complement each other. The fine, smooth look of the eyeball is best executed with very fine stippling, where dots are laid in so finely that there is no detectable variation in pattern. Whereas, if a very coarse texture is desired, such as when rendering fur, it is best to contrast dark, thicker marks and lines against stark areas of white.

The textures of the cat's hair are produced by sketching in different groups of short parallel lines with a size 0 mechanical pen. Repeating this technique over and over produces patterns that lend a consistency to the texture of the cat's coat. Periodically, I altered the directions of these lines and patterns so the hair would follow the different contours of the cat's features. Occasionally, stray hairs are drawn in that point in a different direction than those of the basic pattern. This adds a more natural look and breaks the monotony of the continual patterns. For an example of this, notice the area of the forehead located between the cat's eyes. Sometimes I slightly vary the amount of white space representing the hairs. This also adds interest and variety.

After I laid out the lines and patterns, I came back and blackened in some of the spaces between the hairs. It's only necessary to do this with a small percentage of the hair to enhance the texture and contrast of the coat. I also added black ink to shaded areas, such as the eye sockets and under the chin. This helps to separate and define the features.

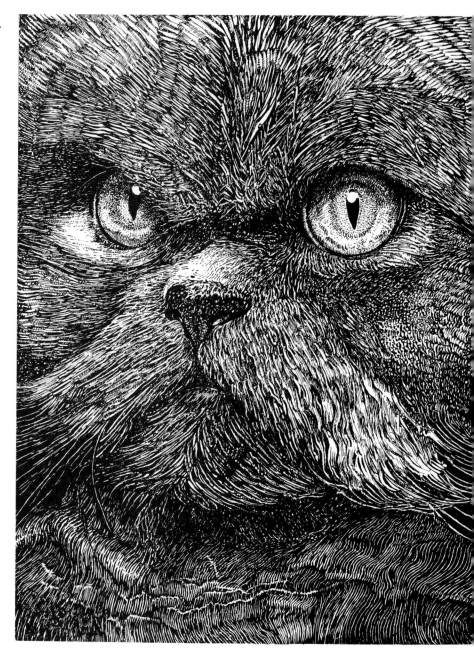

Three-Quarter Portrait

Black ink on hot press illustration board

My intention in this drawing was to produce a nocturnal setting with a starry sky. I wanted the cat to be bathed in light from a direct light source. I also wanted to produce a portrait with a primordial character. Using a size 0 mechanical pen, the technique I chose was a reversed style in which the focal points are the white board peeking through the black ink. One of the most important considerations when producing a picture like this is the development of tonal relationships and textures. Notice the difference in tonal values between the background which has an overall dark value, the cat's body which has a medium value, and the highlights of the eyes which are a light value. There are also values present that fall at various levels between the three basic ones. I saved white board to render the whiskers; it was necessary to draw around them to achieve their stark effect.

Details: I produced these different values by varying the spacial relationships between the black ink and the white board. 1. In the background, I used a reversed stippling with a preponderance of black ink. A No. 2 pen tip works well for filling in large areas such as this. 2. On the cat's face, I used groupings of short black lines running in different directions to produce textures and contours; this approach produced a coarse texture that looks like short, sparse hair and separates the cat from the background. 3. In the chest area, I combined the techniques used on the background and the face so the cat would appear semi-transparent, as though it were materializing out of the environment.

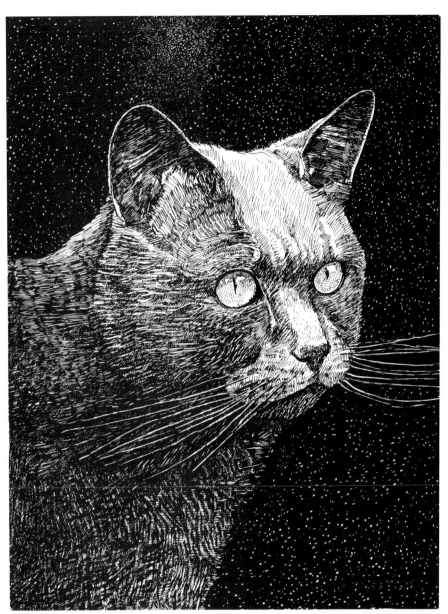

1

2

3

Works in Pen and Black Ink

Cat Bathed in Moonglow
Black ink on hot press illustration board

Since the cat has been present throughout history, in all different cultural and historical eras, I wanted to draw a cat in a legendary setting, where a mystical attraction exists between the cat and its surroundings. I also wanted the cat to interplay with his environment. When I drew this cat in this transfixed posture, I shaded him in such a way that, for a moment, he appears transparent and seems to intermingle with the sky behind him. I also wanted to create an ambiguous situation, where the floating sphere can change from a moonlike object high in the sky to a more earthbound ball that just happens to be illuminating the cat's face.

I created this drawing by combining a variety of techniques. The night sky, which is the element that recedes the most, was created out of the reverse effect. The ball was produced with fine stippling. The light emanating from the ball was also laid in with stipple, but its cloudy effect was created by using the reverse stipple technique so that tiny dots of the white board peek through the heavy application of black ink.

The cat is also composed of multiple handlings. The facial area is the result of stippling. The neck and shoulder are basically rendered in solid black ink, with little areas of white indicating the outline of the cat's form; and within that outline, there are white dots articulating the cat's form and random strands of hair. The bottom area of the cat is rendered in the reverse style, and then goes to areas of solid black, such as the tail, which provides form and contrast against the cat's hindquarters. All these techniques, used in their various ways, co-exist and work well together in the same drawing.

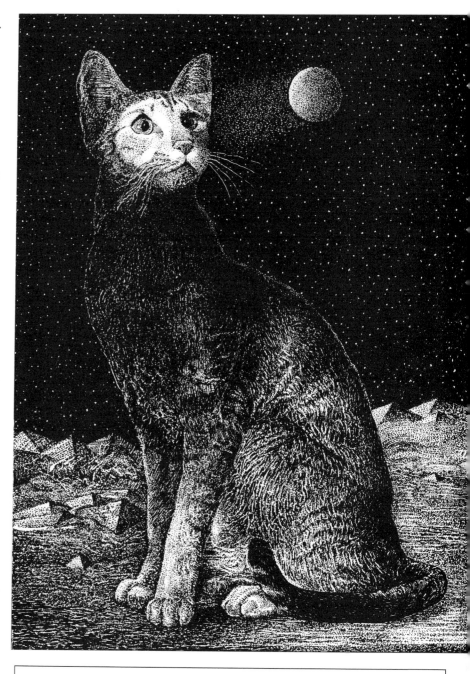

Reminder:

The stark, graphic quality of black ink on white paper works well to capture a supernatural environment.

By manipulating light and dark with black ink, subject and background can be made to intermingle.

In order to produce the illusion of light, illuminary objects must be placed in a dark environment.

The aura of mystery that surrounds cats makes them excellent subjects for fantasy settings.

Hot press illustration board provides an ideal surface for the application of ink because it gives you a sharp line and maximum control.

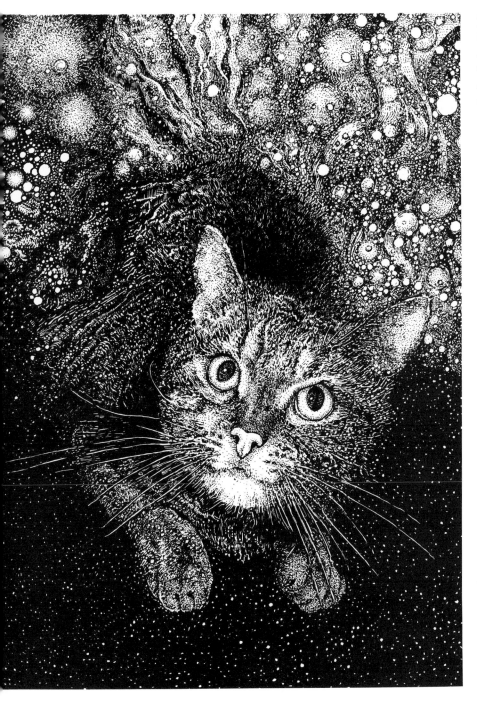

Cat with Stars

Black ink on hot press illustration board

Cats are extremely versatile models. They can be drawn to look cute, distinctive, mystical, or magical. They can also be drawn in different historical periods, and different countries. In this picture, I wanted the cat to be part of a strange, astronomical environment. I accomplished this by having the cat appear and disappear into an environment out of which he is made. The cat is floating and you can see space and stars through parts of him that are transparent.

If you want to produce the illusion of light, such as the stars in this drawing, it is necessary to place the illuminary objects in an environment that is dark. Working in black and white offers the range of dark and light necessary for developing the brightness of illuminary and illuminated objects. When drawing an illuminary object, remember that the brightest part is its center. As the light moves away from its center (or source), it gradually dissipates into the darkness. With ink this is accomplished by gradually covering the white board with more and more black ink as you move farther and farther from the center of the light source. The area close to the light will appear as black dots against a white background. The area farther from the light source will appear as white dots against a black background.

Two Cats In Space

Black ink on hot press illustration board

This drawing definitely falls into the category of illustration: its primary purpose is to tell a story; in this case, a surrealistic tale of two cats who descend from outer space and land on the roof of an observatory. The starry nocturnal backdrop was produced by filling in black ink around very small circles of the board's white surface. This technique offers a low-value receding background, which provides an excellent contrast for the development of objects in ranges of higher value. I rendered the descending particle cloud in a mid-value range by drawing hundreds of little circles, and darkening the spaces between them. This cloud serves a few purposes in the drawing. It establishes the path of descent. Since it exists between the cats and the sky, it creates a sense of space and depth. It also offers an additional texture and a mystical glow to the illustration.

Because the cloud is a mid-value, it works as a good partial background for the light-value cats. The cats are rendered with fine stippling. Their body language and relative angles are in character with their unorthodox location and circumstance. By drawing the top cat larger, it comes forward. The cat in the foreground, the cat in the middleground, the cloud in several dimensions, the observatory in the near background, and the sky in the distant background all contribute to a sense of depth and space in this picture.

Two Cats Looking Up

Black ink on hot press illustration board

This illustration continues the theme two cats descending from outer space. At this point of the story, the two cats are sitting on the roof of an observatory and looking at a descending particle cloud. This picture was composed so that the cats' subtle reflection can be seen on the roof in the immediate foreground. The cats and the particle cloud are in the foreground/middleground, the dome of the planetarium is in the middleground, and the starry night sky makes up the background.

The cats are rendered with a coarse texture. This helps them to stand out in contrast to the surroundings, which are more finely textured. Since the light source is overhead, the cats are illuminated by whatever has caught their attention.

Notice how a portion of the dome and sky shows through the particle cloud. This further increases the transparent, nebulous character of the cloud. The cloud was rendered with various sized stippling and dots so it would appear to be made up of solid particles, floating in space.

WORKS IN PEN AND COLORED INK

Cat with Butterfly
Colored ink on hot press illustration board

In this illustration, I feel as though I fell a little short of my original intention. I wanted to give the feeling that this red tabby longhair was looking through a glass window at a butterfly outside. I tried to achieve this impression by implementing a few different ideas. First of all, I tried to think of the glass windowpane as an object with transparent, reflective, and shaded characteristics. Then, I had to decide how and where this would distort the image of the cat. I made the parts of the cat closest to the window more clearly defined. I decided that features such as the eyes were too important to distort, so I rendered the shadows and reflections elsewhere on the pane.

I maintained a general middle-to-high-value color scheme for the cat and windowpane in order to produce a low contrast, semi-transparent, frosted appearance. I rendered the butterfly in a high-contrast, graphic manner, using solid black ink for the markings on its wings. I rendered the butterfly in this fashion to place the butterfly outside the window, to bring it forward, and to create a separation between butterfly and window.

This illustration was rather complicated. I think it could have been more successful if I used reference material, such as photographs, to work from when it came to illustrating the character of the window. Looking back, I believe I was correct in concept, but I fell short in the actual execution because I guessed about the crucial placement and appearance of the reflections and shadows. I think this drawing could have worked better if I had developed a more developed description of the building's exterior, instead of just a simple linear description. Also, a reflected image of the butterfly in the window could have also helped carry the concept a step further. Unfortunately, ink is a committal medium and does not lend itself to changes once it's placed on the paper.

Contemplation
Colored ink on hot press illustration board

When planning this picture of a Birman cat contemplating two caged parakeets, my intention was to place the viewer inside the bird cage, looking out past the birds and the bars to the cat. One bird was to face the viewer; the other reveals its patterned back. Using both these views adds more interest to the picture, allowing me to describe the different markings and colorings of the parakeets.

Because the drawing is broken up into four distinct spatial planes—the background area, the cat, the bars, and the most forward plane of birds and perch—I was able to begin by sketching in all these elements quickly and simply as I came forward through the picture plane. When placing the angle of the perch, I made sure to tilt its angle slightly so that it breaks pattern with the strong horizontal of the bars. I then used minimal stippling of sienna and sepia to render the perch. The white bars of the cage are ruled in with a pencil and ruler; they are simply the surface of the board showing through. I carefully positioned the cat so that the birds and cage would partially cover, but not distort, the features of its face.

The cat was sketched primarily with sepia, burnt sienna, and gray inks, using both crowquill and mechanical drawing pens. I used gray stippling on the white areas of the coat to fashion soft strands of hair. The dark markings are produced with linear pen strokes of sepia and sienna inks. Cobalt blue stippling was used for coloring the eyes, and the pupils are black ink with highlights produced by the white of the board. The background plane is predominantly composed of violet stippling. Notice that I've darkened a portion of the background with blue ink, picking up various other colors from different elements in the picture. This darkened area builds contrast around the birds, and brings them forward.

The vertical position of the two birds is an important compositional element

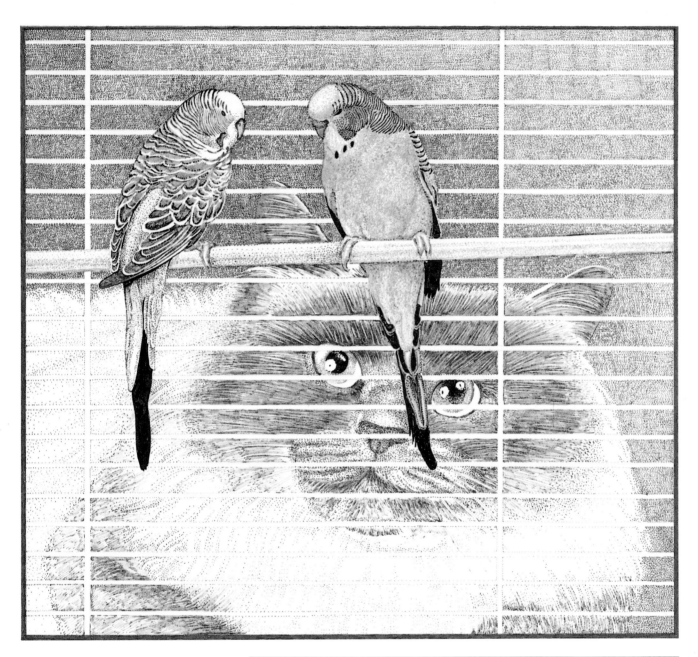

here because they contrast with the basically horizontal picture. The placement of the bird on the right makes it the focal point of the cat's attention. Its brilliant green color is composed of light green and yellow inks stippled together; black accents dramatize the tail, under the wings, and create the pattern of the bird's head markings. The bird on the left, although not so brightly colored, has equal appeal: the patterned wings are the most complex area in the drawing; and the blue-violet/red-violet color and white-tipped wings and head relate it tonally to the rest of the picture.

Reminder:

Colored ink is a committal medium; make sure your initial sketch is accurate and that the drawing is laid in with a pale neutral before beginning with strong color.

Inclusion of additional objects will place your cat in a specific setting.

Playing high contrast against low contrast is an effective technique for placing subjects in the correct spatial plane.

Eyes make an excellent focal point.

When using colored ink, proper placement of separate colors creates an exciting visual mix.

Works in Pen and Colored Ink

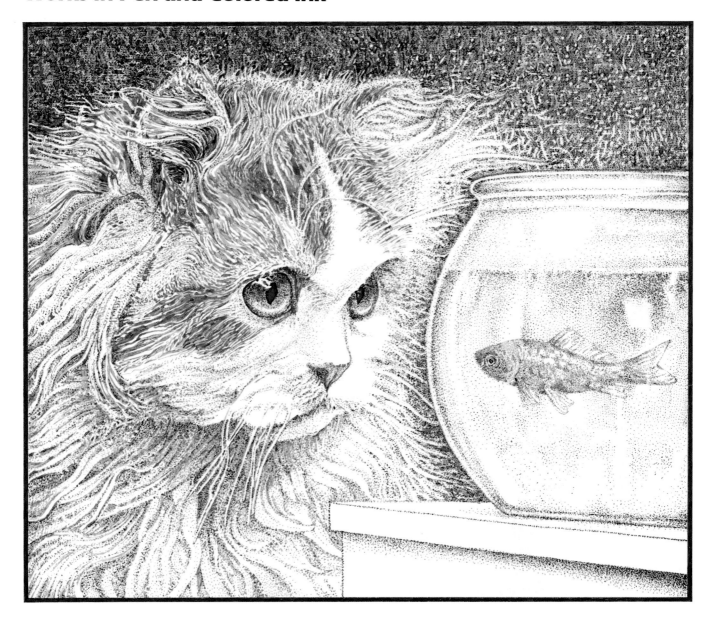

Reminder:

Color balance is best achieved by selected colors that in combination represent the entire range of hues found on the color wheel.

Carrying color over from subject to background and from one distinct area to another creates a chromatically integrated environment in your drawing.

A more or less equal distribution of warm and cool colors is an important element in color harmony.

Cat and Fish Bowl

Colored ink on hot press illustration board

When I illustrated the cat and fish-bowl, I wanted to create a focal point based upon the direction of the cat's stare, and the object of his interest. I chose a bi-color longhair as my model. I rendered the cat's soft orange-and-white hair with a lot of texture and movement. This created a good contrast to the stillness of the underwater world, surrounded by the smooth glass surface of the fish bowl.

The color balance in this picture is based upon several chromatic relationships. The goldfish is isolated and complemented by the blue bowl, but is linked to the cat by color. I chose green for the background because it complements the orange cat and fish. Also, the green comes closest to creating an overall color triad, as it relates to the blue bowl and the orange cat and fish. Since the green contains blue, and it is darker than a middle value, it visually recedes and allows the lighter value cat and fish bowl to come forward. The green background is also picked up in the cat's eyes. The cat's eyes and the fish bowl relate because they are the only glassy surfaces in an overall environment of texture.

I carried several of the yellows and oranges of the cat and fish into the background. This makes everything appear to be in a naturally integrated environment. I used the white of the board as my light values, saving some of these light-value areas for the highlights on the fish bowl and the cat's eye, as well as the table which needed to come forward as part of the foreground.

Notice how the different sizes of shapes and textures work to separate objects and areas of this illustration. The markings and strands of hair on the cat represent the largest shapes in the drawing. The coarse texture in the background creates another definite area. The eyes, the bowl, and the table are produced with fine stippling. These parts of the drawing represent smooth surfaces.

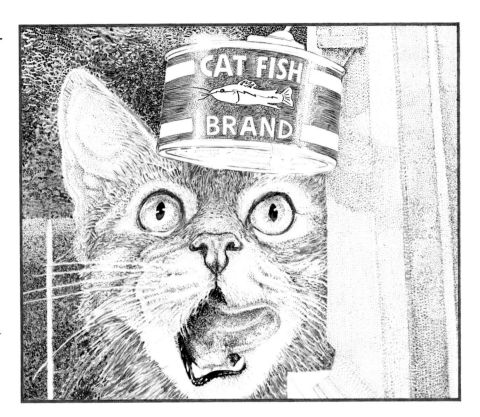

Cat and Can Opener

Colored ink on hot press illustration board

My intent in drawing this picture was to present the pet cat's typical response when dinner is announced by a can opener. To help the image read quickly, I chose to utilize close cropping in the composition. I wanted to show just enough of the cat, the can opener, the kitchen tile, and the counter-top to tell the story.

The relationship between the eyes, the can, and the cat licking its chops is an integral part of the scenario. There are basically three spatial planes in the picture. The background is comprised of blues and greens, which tend to recede. The middle plane is occupied by the cat. The can opener, can, and counter are located in the foreground. These foreground objects partially crop the cat and background, which gives a feeling of depth. The can is colored red, which brings it forward.

Each object and area in this picture include both cool and warm colors. This approach maintains an overall chromatic balance throughout the illustration. The end of the can opener, located on the right, is produced with stippling, using sienna, burnt sienna, and gray inks. The shadow on the front of the can opener, cast by the can, includes a slight stippling of red-violet ink. The cat's fur is primarily colored with sienna, burnt sienna, and gray inks. There are also accents of yellow, orange, red, and cobalt blue.

WORKS IN MARKERS

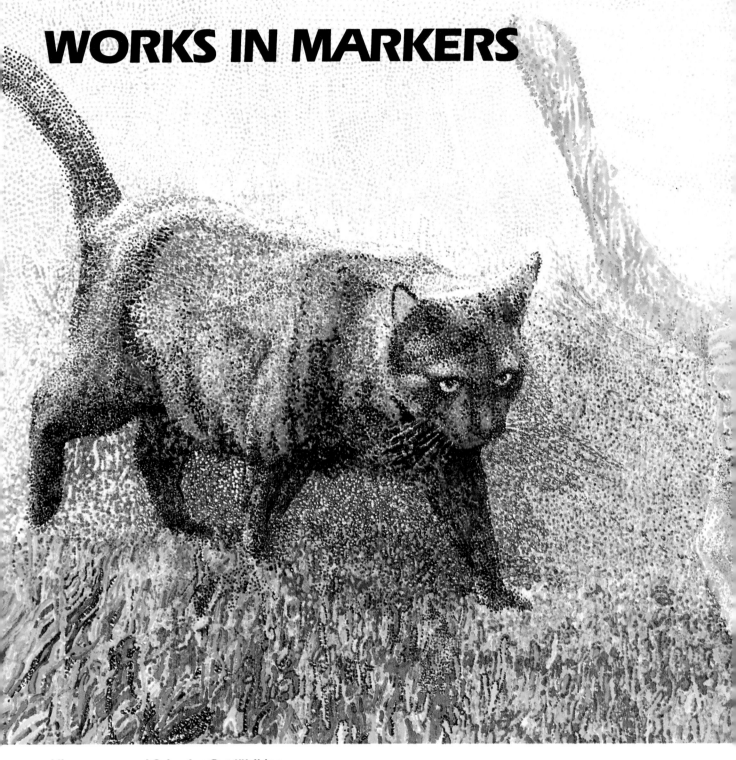

Hieronymus and Salvador Out Walking

Markers on cold press illustration board

Markers are an excellent medium for rendering textures. With its range of application—the minimal dots, bolder dashes, and solid workings of color—and the intense vibrancy of the color itself, markers give me every opportunity to build up texture. Unlike colored ink, markers can be used on a textured surface, such as cold press illustration board. So, not only can you create texture with the various techniques available, you also have the

advantage of working on a textured surface—which in itself adds another dimension of texture to your drawing.

In this drawing, I wanted to use lots of color, because rich color breathes life into a picture. However, in order to make cats look natural in a colorful environment, you should put some of the surrounding colors in the cats, and some of the cat's colors into the surroundings.

To increase the sense of movement

in this drawing, the cats are seen walking from left to right. This is the direction in which most people scan a picture. I also drew the cats walking in a diagonal downhill composition, which is considerably less static than a straight horizontal layout.

You'll also notice I drew a dark-value black cat, and a light-value red cat in the same environment. In order to give both cats a sense of prominence, I kept the surroundings at a

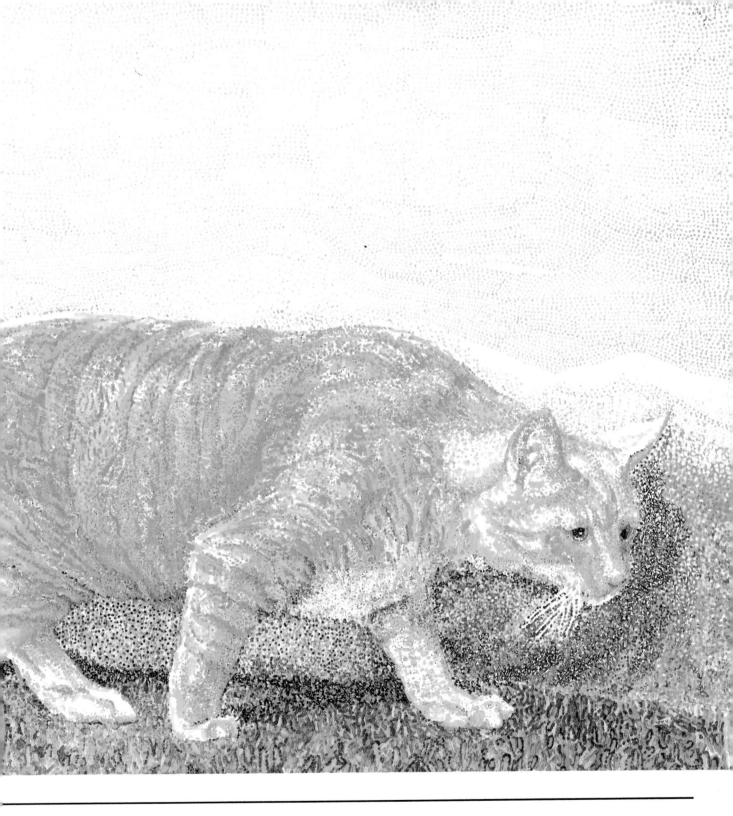

middle-value color level.

When you're creating a black cat with markers, you can use many different colors in his coat. In this picture, the black cat is in a full color context, with another cat that is also brightly colored. Because of all the chromatics in this picture, it was necessary to include several colors in the coat of the black cat; otherwise, the black cat would have looked like a foreign achromatic element in a chro-

matic environment.

When a black cat is in a three-quarter pose, it's helpful to add colors to its coat to prevent its dark features from disappearing against the black background of the body. Color added to the coat of a black cat will also produce the appearance of reflected light and color, and it offers a little spice to further animate the drawing. In fact, the variety of color of the cats' coats was what enabled me to take

such artistic liberty with the grass. The bright oranges and blues work well here because they create a natural context for the variegated cats.

I wanted to create an interplay between these two cats. I gave the black cat a feisty personality, while the red tabby seems slow and easy-going. By placing the two characters in the proper relationship, it appears as though the black cat is pursuing the red tabby.

Works in Markers

Cat and Gramophone

Markers on cold press illustration board

This illustration emulates the famous picture of the RCA dog and gramophone, but here I've used a Rex cat instead of a dog.

One of the features unique to the execution of this picture was the development of the reflective surfaces found on the gramophone horn and the floor. Since the horn is made of hard shiny metal, it required the most reflective handling in the picture. I accomplished this by rendering the horn with solid patches of color. This makes the surface appear smooth in contrast to the rest of the picture, which is heavily textured with stippling. I allowed the board to show through and produce shapes of stark white for the highlights. The white and color shapes are drawn to describe the contour of the horn. I used yellows and oranges to make it look like brass. The horn also reflects the colors of the floor. I made the floor less reflective than the horn by reducing the contrasts, and texturing the surface with lines and stipple.

The green used for the background makes it recede and creates a contrast. Bits of warm colors were included to keep the background from looking foreign in relationship to the rest of the picture.

Since the cat is white, it stands out the most and makes it the main focal point of the illustration. The cat was rendered with minimal stippling, which allowed me to describe the form while keeping the cat basically white in appearance.

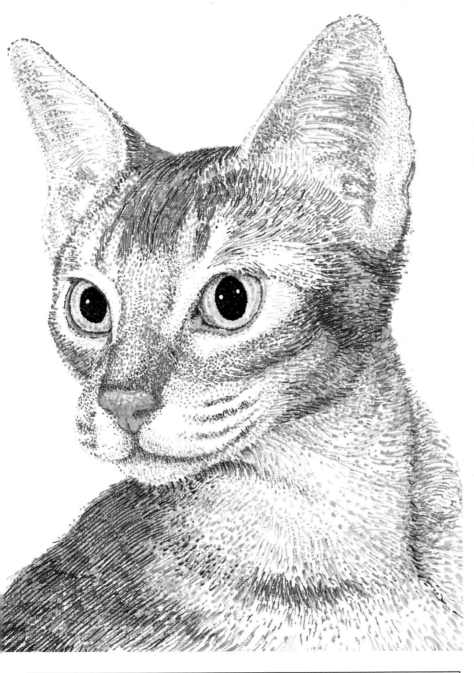

Abyssinian Portrait

Markers on cold press illustration board

I illustrated this portrait of an alert, intense Abyssinian with a variety of different markers. I initiated the drawing with a fine-tipped buff colored marker. Since this color has a pastel appearance, it was easy to come back and work over the initial sketch with stronger colors. The early stages were executed with stippling. As the illustration progressed, and it became more evident where I should add dominant color, I switched from stippling to bolder lines and strokes with the markers. If you look at the right side of the cat's face, back, and forehead, you can see how I developed bolder application of color. In these areas I mainly used yellow, yellow-orange, and burnt orange markers.

I left the background blank and used the white of the board to represent the white features of the cat. A light blue marker was used for light stippled shading on areas like the chin. I also used it here and there between the bright oranges; this helped balance the warmth of the color scheme.

The nose and inside of the ears are rendered with pink and orange stippling. I also added accents of mauve. Notice how I added sparkle to the pupils of the eyes by adding specks of red.

Reminder:

Marker drawings should progress from minimal stippling, neutral coloring, and light values to increasingly bolder marks, strokes, and dominant applications of color.

When using markers, a reflective surface is best achieved with solid patches of color.

Markers are ideal for creating the variety of textures found in cats' fur.

WORKS IN WATERCOLOR

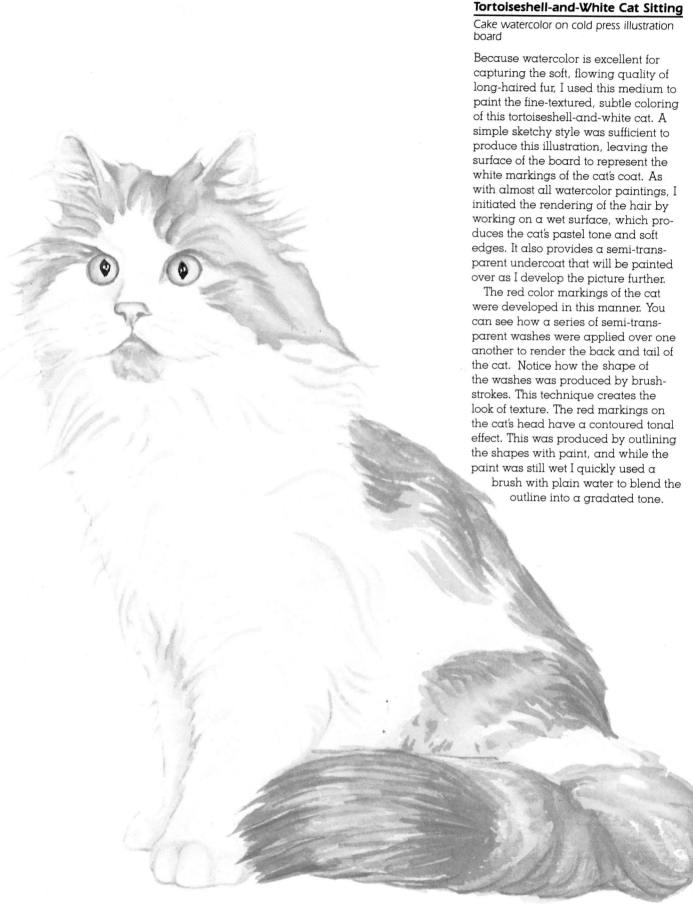

Tortoiseshell-and-White Cat Sitting
Cake watercolor on cold press illustration board

Because watercolor is excellent for capturing the soft, flowing quality of long-haired fur, I used this medium to paint the fine-textured, subtle coloring of this tortoiseshell-and-white cat. A simple sketchy style was sufficient to produce this illustration, leaving the surface of the board to represent the white markings of the cat's coat. As with almost all watercolor paintings, I initiated the rendering of the hair by working on a wet surface, which produces the cat's pastel tone and soft edges. It also provides a semi-transparent undercoat that will be painted over as I develop the picture further.

The red color markings of the cat were developed in this manner. You can see how a series of semi-transparent washes were applied over one another to render the back and tail of the cat. Notice how the shape of the washes was produced by brushstrokes. This technique creates the look of texture. The red markings on the cat's head have a contoured tonal effect. This was produced by outlining the shapes with paint, and while the paint was still wet I quickly used a brush with plain water to blend the outline into a gradated tone.

Cat and Mirror

Cake watercolor on cold press
illustration board

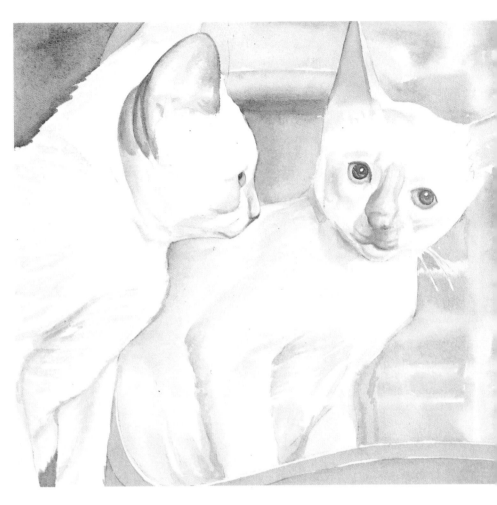

This simple sketch shows a Siamese kitten looking at its reflection in a mirror. The watercolor medium makes it easy to capture this soft, fluid look; it is also a good choice to capture the subtle, light-valued markings of a white cat.

Because the reflected image is meant to be the focal point in this drawing, I cropped the picture. The composition shows just enough of the real cat's profile to tell the story, while the reflection portrays most of the cat's features. Note the importance of including a slight indication of the frame; we need this background feature to explain that we're seeing the cat's likeness in a mirror.

Because I wanted to keep the overall tone of the painting very high key, I mixed pigment with a lot of water. The color scheme remains neutral because I used gray paint tinted with a little color for most of the illustration.

I applied the paint to a wet surface on the mirror to create a soft image and diffused highlights. This same approach was used to produce the softened shadows indicating the cat's fur. For the real cat's ear and outline, I used a slightly darker tone of the same gray mixture. I needed the darker color in order to indicate that the real cat is in front of the mirror and to separate it from the background. The upper left corner and the patch between the cat's legs also creates the different spatial planes needed for such a high-key painting.

Reminder:

The watercolor medium is ideal for capturing the fluid lines and muted tones characteristic of many cats' markings and coloring.

Textural differences are largely determined by the amount of clear water used to pre-moisten the painting surface.

A reflective image is best achieved by a combination of lighter values, blurred softer edges, and paler color.

To set off a light-colored subject against a white background, use neutral, pale tones for the cat's coloring.

Works in Watercolor

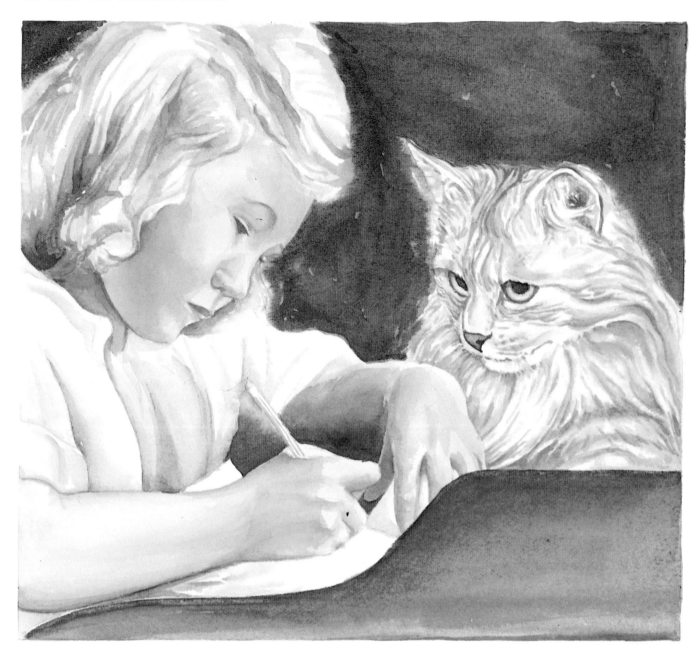

Cat with Girl Writing

Cake watercolor on cold press illustration board

Although this red tabby is not the primary subject of this illustration, his intense, rather humanlike interest in the little girl makes him a major element in the composition. After an initial sketch to indicate the major forms, I laid in the girl's flesh tone, using a mixture of yellow ochre, burnt sienna, orange, raw umber, and a touch of cobalt blue. I always work wet with the flesh tones so I can develop smooth layers of transparent washes and avoid producing a textured effect.

The girl's hair was created by applying umber and ochre pigment to a wet surface, leaving the white board to indicate highlight. I used the same approach for the cat's hair; however, I mainly used burnt sienna and ochre paint on the cat.

Before painting in the background, I dipped a brush in plain water and applied wet brushstrokes to the area immediately surrounding both the cat and the girl's hair. This technique produced light areas and allowed the background to spread and soften. This makes the hair look soft, semi-transparent, and natural around the edges.

I used a mixture of cobalt blue and raw umber for the background. The blue produces a coolness and neutrality that allows the background to recede. The umber adds enough warmth for the background to naturally fit in with the surrounding color scheme. Note that this illustration is composed of three spatial planes: the side of the desk provides a foreground; the girl and cat occupy the middleground; and the dark wash of cobalt blue and raw umber is the background.

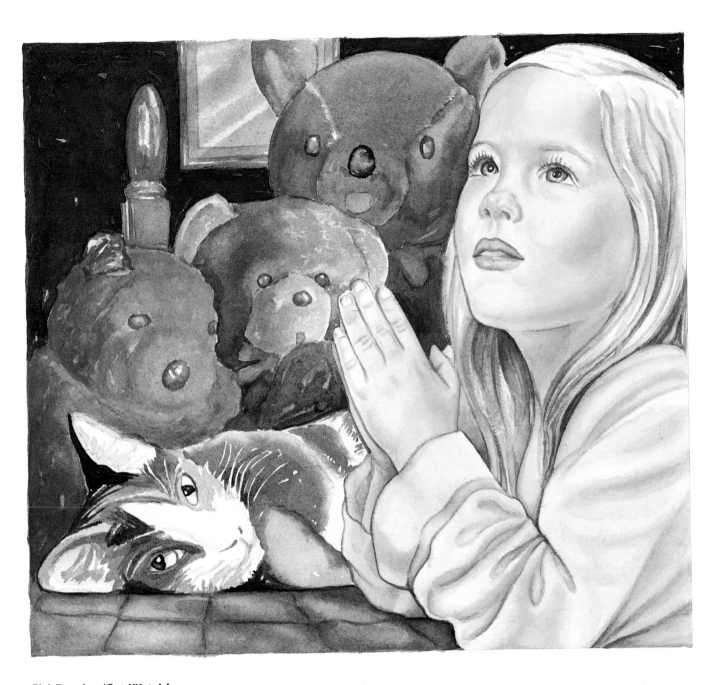

Girl Praying/Cat Watching

Cake watercolor on cold press illustration board

In this painting, I wanted the viewer to experience a momentary hesitation when deciding if the cat was real or stuffed. There are several different objects coexisting in this picture, so I used a few techniques to subtly separate them from one another.

In this illustration, I've relied on color to create the spatial planes: the blond hair, warm flesh tones, pink nightgown, foreground placement, and relative light value of the little girl allow her to come forward in the picture. The mauve and gray checkered squares of the bedspread take

the viewer's eye a step back into the drawing. The achromatic coloring of the cat separates it from the chromatic environment. Because the cat's position is horizontal, and the rest of the composition is vertical, another separation is created.

The back wall is made up of a dark blue and gray; its darkness and coolness make it recede. The wall coloring also contrasts and complements the warmer, lighter value objects in front of it. Furthermore, the objects that appear closer to the viewer overlap those behind.

Although all the objects presented here are visually separated by position, texture, color, and value, I was careful not to make them too different or they would have contrasted and competed with one another. When painting a picture with several objects, it's important to determine which are the most important elements in the composition and what should command most of the viewer's attention. In this case, the young girl and her pet were intended as the primary subjects; all other elements should be seen as secondary.

INDEX

Editorial concept by Mary Suffudy
Edited by Candace Winstanley Raney
Graphic production by Hector Campbell
Text set in 11-point Memphis Light